Whose Culture?

Whose Culture?

THE PROMISE OF MUSEUMS AND THE DEBATE OVER ANTIQUITIES

EDITED BY James Cuno

PRINCETON UNIVERSITY PRESS
PRINCETON AND OXFORD

FRONTISPIECE James McNeill Whistler (1834–1903), *The Artist in His Studio*, 1865/66. Oil on paper, mounted on panel (24 3/4 × 18 1/4 in.). The Art Institute of Chicago, Friends of American Art Collection, 1912.141.

Published by Princeton University Press, 41 William Street, Princeton, New Jersey 08540

In the United Kingdom: Princeton University Press, 6 Oxford Street, Woodstock, Oxfordshire OX20 1TW

Second printing, and first paperback printing, 2012
Paperback ISBN 978-0-691-15443-5

The Library of Congress has cataloged the cloth edition of this book as follows

Whose culture? : the promise of museums and the debate over antiquities / edited by James Cuno.
 p. cm.
 Includes bibliographical references and index.
 ISBN 978-0-691-13333-1 (hardcover : alk. paper)
 1. Museums—Acquisitions—Moral and ethical aspects.
2. Museum exhibits—Moral and ethical aspects. 3. Cultural property—Protection. 4. Cultural property—Repatriation. 5. Antiquities—Collection and preservation—Moral and ethical aspects. 6. Antiquities—Collection and preservation—Social aspects. 7. Excavations (Archaeology)—Moral and ethical aspects. 8. Museums—Philosophy. I. Cuno, James B.
 AM7.W47 2009
 069'.51—dc22 2008024834

British Library Cataloging-in-Publication Data is available

This book has been composed in Scala LF

Printed on acid-free paper. ∞

press.princeton.edu

Printed in the United States of America

10 9 8 7 6 5 4 3 2

In the present state of knowledge when we feel that there is a common link which connects the civilized nations of all ages, a Museum cannot satisfy public expectation, which contains only some more or less important specimens of Greek, Etruscan, or Roman art. . . . Such [an encyclopedic] collection would be the most convincing proof of the affinity of all civilized peoples, of the unity of mankind. We should see that the first beginning of art is the same with all nations; and though, from the peculiar circumstances of each, its development was carried out in different ways and under different forms toward perfection, yet we should be able to detect a close affinity and connexion between the masterpieces of every national art, clearly showing that the beautiful is the same in all ages and in all countries, and the imitative arts of all nations, so soon as they break the thralldom of conventionality, which protected them in their infancy, but hindered their further development, are the most noble offspring of human genius, whether in Japan or Athens, whether on the Nile or the Arno, on the Euphrates or the Tiber.

—F. Pulsky, "On the Progress and Decay of Art; and on the Arrangement of a National Museum," *The Museum of Classical Antiquities* 2 (1852)

Contents

Acknowledgments

In the spring of 2006, Timothy Potts, then director of the Kimbell Art Museum (now director of the Fitzwilliam Museum, Cambridge University), and I organized a conference titled "Museums and the Collecting of Antiquities: Past, Present, and Future." It was offered under the auspices of the Association of Art Museum Directors, open to the public, and held in the Celeste Bartos Forum of the New York Public Library. The discussion that day made it clear that a book was needed that would present the point of view of museum directors, curators, and university-based scholars regarding the value of the museum in the context of the current debate over the acquisition of antiquities. This is that book.

The authors of the essays included herein argue, from different points of view—directorial, curatorial, historical, legal, and philosophical—that museums have value as repositories of objects dedicated to the dissemination of knowledge and the dissolution of ignorance, where the artifacts of one culture and one time are preserved and displayed next to others without prejudice. This is the view of the encyclopedic museum, the origins of which lay in the Enlightenment ideal of universal knowledge. The encyclopedic museum encourages a broad understanding and appreciation of the historical interrelatedness of the world's diverse cultures and promotes inquiry and tolerance. And in the process, it preserves our common artistic legacy in the public domain for the benefit of the curious public. This is the *promise* of museums.

This view has been challenged recently as outmoded: the view of a past and misguided era of colonization, during which European nations

removed artifacts from other cultures for selfish reasons and at the expense both of the cultural sensitivities of "foreign" peoples and of the archaeological knowledge of the sites where these artifacts were found. Critics of the encyclopedic museum support nationalist retentionist cultural property laws—those that prohibit the private ownership and/or export of antiquities as a modern nation's cultural property—as a means of respecting the cultural interests of "local" peoples and to prevent the looting of archaeological sites.

The essays herein point out the flaws in this criticism and its unfortunate, even in some instances tragic, implication to our knowledge of the past and the promotion of a greater understanding and appreciation of similarities between cultures, indeed the fundamental truth that cultures have always been in contact with one another, that culture itself is a hybrid or mongrel form of human expression, and that more is to be gained from seeing representative examples of diverse cultures together "under one roof" than to segregate them within modern national borders.

It is the argument of this book that the promise of museums, encyclopedic and otherwise, requires them to acquire, preserve, and present objects for the benefit of the public. And this means even, and perhaps especially, antiquities with incomplete provenance or ownership histories and whose point of origin is unknown. For like all objects, they contain, each of them, information that is useful to our understanding of the past and the way culture works and has worked over the millennia human beings have made and ornamented things of value to ourselves and our communities. To declare such objects meaningless (as some scholars do) and fail to bring them into the public domain as public assets worth preserving is to put them at risk and to willfully ignore their many contributions to our greater understanding and appreciation of our common history.

Sadly, many scholars and even some museums are willing to turn their backs on such objects because they believe that acquiring them only encourages the looting of archaeological sites and contributes to the illicit trade in antiquities as cultural property. Elsewhere (*Who Owns Antiquity? Museums and the Battle over Our Ancient Heritage*, Princeton 2008), I argue that despite this position, archaeological sites continue to be destroyed—by

looters, warfare and sectarian violence, urban and commercial develop-
ment, natural disasters, and benign neglect—and that the real conse-
quence of this position is, ironically, further damage to the archaeological
record, acceptance of current gaps in our knowledge of the past, and, be-
cause this position allies with nationalist cultural property laws, perpetua-
tion of a false view of culture as national: modern nation-states claiming
identity with ancient cultures for current, political gain. This position ig-
nores the value (I call it "the promise") of museums for tactical and politi-
cal purposes. And in the bargain, we all, the public for whom encyclopedic
museum collections are built, stand to lose. We will learn less about the
past—our *common* ancient history as human beings—and we will be de-
prived of important opportunities to better understand the interrelated-
ness of cultures and peoples when, increasingly, the world is experiencing
a dramatic resurgence in nationalism and sectarian violence. That's the
risk. And a risk we must not take.

Many people deserve mention for their invaluable assistance to this
project. First, of course, Hanne Winarsky, our editor at Princeton Univer-
sity Press, who shepherded the manuscript through editing and publica-
tion with care and diligence. The anonymous, outside readers, and one in
particular, gave cogent criticism to earlier drafts of this manuscript. Such
readers are rarely acknowledged for the important contributions they
make to a book. In this case, the contributions were of the greatest impor-
tance and are gratefully received.

Millicent Gaudieri and Christine Anagnos, respectively former execu-
tive director and deputy director of the Association of Art Museum Direc-
tors (AAMD); Anita Difanis, AAMD's director of government affairs; Mary
Sue Sweeney Price, director of the Newark Museum and at the time of the
conference president of AAMD; and Paul LeClerc, president of the New
York Public Library, are acknowledged for their invaluable assistance with
the organization of the 2006 conference at the New York Public Library. The
conference was supported by grants from the National Endowment for the
Arts and the Samuel H. Kress Foundation, for which we were very thank-
ful indeed, as well as by grants from numerous AAMD member museums.

Greatest mention is reserved for the authors of this book. They gave
generously of their time in preparing their manuscripts for publication,

some from what were simply notes prepared for oral presentation at a conference, others from scratch, having been commissioned especially for this volume, and still others from previously published articles that had to be reconfigured to fit into the developing narrative of this particular publication. Sir John Boardman's essay is a revision of a lecture he delivered earlier at Oxford University and appears here revised and abridged from its original publication in E. Robson, L. Treadwell, and Chris Gosden, eds., *Who Owns Objects? The Ethics and Politics of Collecting Cultural Artefacts* (Oxford: Oxbow Books, 2006); Kwame Anthony Appiah's essay, "Whose Culture Is It, Anyway?" first appeared in the *New York Review of Books* and derives from a chapter in his book *Cosmopolitanism: Ethics in a World of Strangers* (New York: W. W. Norton, 2006); Derek Gillman's essay derives from the second chapter in his recent book, *The Idea of Cultural Heritage*, published by the Institute of Art and Law, University of Leicester, England, in 2006; and John Henry Merryman's contribution is a reprint of an essay he first published in 1995 under the same title in the journal *International Journal of Cultural Property*. All of these essays are published here by permission of their authors and with assistance from their original publishers.

—James Cuno

Introduction

James Cuno

ART INSTITUTE OF CHICAGO

W*HOSE CULTURE?* The modern nations' within whose borders antiquities—the ancient artifacts of peoples long disappeared—happen to have been found? Or the world's peoples', heirs to antiquity as the foundation of culture that has never known political borders but has always been fluid, mongrel, made from contact with new, strange, and wonderful things?

The Promise of Museums. As a repository of objects, dedicated to the promotion of tolerance and inquiry and the dissipation of ignorance, where the artifacts of one culture and one time are preserved and displayed next to those of other cultures and times without prejudice.

The Debate over Antiquities. (Nationalism) Antiquities are the cultural property of the nation, products of the collective genius of its nationals, important to their identity and self-esteem. They are of the nation and cannot be alienated from it. (Archaeologists) Antiquities are ancient artifacts of meaning only if properly excavated. The acquisition by museums of antiquities not properly excavated, whose archaeological circumstances are unknown, aids and abets the looting of antiquities and the destruction of archaeological sites and the knowledge they contain. (Museums) Antiquities, documented or otherwise, have a variety of meanings and deserve to be preserved in the public domain for the benefit of scholars and the delight of the public.

For decades, art museum directors and curators, archaeologists, and government authorities have been locked in a debate over the value of museums

1

and the acquisition of antiquities. The issues are numerous. In a recent book, I examined the history and implications of nationalist retentionist cultural property laws intent on prohibiting the international movement in antiquities. There I argued that such laws and related international conventions, although said to be intended to protect the archaeological record by outlawing looting of archaeological sites and the unregulated trade in antiquities, serve instead to support a state's nationalist political agenda: its claim on cultural continuity since antiquity—Egypt since the time of the Pharaohs, Iraq since Mesopotamia, Italy since Rome and Etruria, the People's Republic of China since the Qin Dynasty, Turkey since the Hittites, and so on—and thus a particular modern nation's sense of its own importance and uniqueness in the world; archaeology and antiquities at the service of modern nationalist identity politics.[1]

In this book, leading museum directors, curators, and university-based scholars defend the proposition that museums have value as a repository of objects dedicated to their preservation, the dissemination of knowledge, and the dissolution of ignorance. It is also proposed that such objects, even those ancient ones whose archaeological context and/or provenance (recent record of ownership) are unknown have much to teach us about the past, about art, about material properties and manufacture, about human aspirations, and about distant cultures and times, all of which have relevance to the times in which we live currently. In this respect, the acquisition, preservation, presentation, and publication of these objects—excavated or not, with or without provenance—is the museum's highest purpose.

Many in the archaeological establishment argue to the contrary: without knowledge of an antiquity's archaeological context it is meaningless, "just another pretty thing" as one often hears said dismissively. (The newsletter of the Illicit Antiquities Research Centre of University of Cambridge's McDonald Institute for Archaeological Research is titled simply, and pointedly, "Culture Without Context.") Archaeologists want to know precisely where an antiquity was found in order to understand how it was used. Context is everything for archaeologists, and only archaeological context matters. That an antiquity's archaeological context is but one of its

many contexts—and not even its *original* context—is not considered. That is, the many different ways an antiquity was used and changed hands in different circumstances before it was buried comprise each a separate context. And then the numerous ways in which it was used and housed subsequently—as *spolia* in the construction of walls and roads, as modified for different domestic purposes, as a collectible held privately or acquired by a public museum where its display among other objects may provoke scholarly reinterpretation or an aesthetic response—are also each a separate context.

But of course the archaeological context is, like any other, important, and anything that causes its destruction should be discouraged. Museums and archaeologists agree on this. The question however is how best to protect the archaeological context while also preserving antiquities whose contexts are unknown. Archaeological contexts are destroyed by acts of warfare, natural disaster, economic development, looting, pillaging, and accident. Of these, most attention has been focused on looting and its prevention.

Why focus on looting? Because it is believed possible to stop it. Nation-states are willing allies in this effort. They want to keep antiquities within their legal jurisdiction because they are valued for their contributions to archaeology, are vitally important to the economics of cultural tourism, are thought to enhance their citizens' national self-esteem, and advance their national political agendas. For all these reasons, they enact ownership and export laws to criminalize looting and join in bilateral treaties and international conventions seeking other nations' support to protect antiquities as a particular modern nation's cultural property.

Archaeologists hold that looting is caused by the market in antiquities, and the degree to which museums participate in the market, either by acquiring antiquities directly from or indirectly as gifts from private collectors, they are said to be encouraging looting and the destruction of the archaeological context. Archaeologists argue that museums should never acquire unexcavated antiquities whose recent history of ownership is not known. These are said certainly to have been looted, torn from their archaeological context. What then should happen to these objects? They do not say. All that such objects could teach us about the past is

lost or ignored. All the reasons they should be preserved in the public domain are left unconsidered. Instead, unexcavated and undocumented antiquities are sacrificed to the stated higher good of discouraging looting and trying to protect archaeological sites. And still archaeological sites are looted and archaeological context is lost to natural disaster, economic development, and warfare.

Museums are concerned with both the fate of the individual antiquity and the preservation of archaeological context. To this end, most museums in the developed world (the so-called art importing countries) have developed acquisition policies intended to remove incentives for looting archaeological sites. First, museums abide by all applicable national and international laws, bilateral agreements, and international conventions. And second, museums are encouraged to set a date before which an antiquity must be known to have been out of its likely country of origin before it can be acquired. These dates vary. For some museums, it is the date of the adoption of the 1970 UNESCO Convention on the Means of Prohibiting and Preventing the Illicit Import, Export, and Transfer of Ownership of Cultural Property.[2] For others it is the date of their national government's legislative implementation of the terms of the Convention (in the United States, this would be 1983; in France, for example, it is 1997). And for still others, it is simply a date judged sufficiently distant so as not to encourage the looting of archaeological sites: the further back the date, the longer a looter and his art-dealing accomplices would have to hold an object before profiting from its sale. U.S. art museums choose different dates. Some use 1970, others 1983, and others a rolling ten-year date. The latter is the recent suggested minimum proposed by the Association of Art Museum Directors (AAMD), a group comprising directors of the largest art museums in North America. Recently AAMD revisited this proposed minimum and set a fixed date (or "bright line" as it is called) of 1970, with allowance for exceptions for important objects that otherwise couldn't be acquired, resulting in the loss of benefits cited above.[3] But of course only a complete ban on the acquisition of undocumented antiquities will discourage looting. Any date other than today is a political compromise. And still archaeological sites will be destroyed by natural disaster, economic development, and warfare.

In any case, museums want to develop policies and practices that preserve undocumented antiquities and reasonably protect archaeological sites. Museums value the discrete object for all that can be learned from it and from seeing it among other objects from different cultures in the context of the museum's galleries. Unlike the archaeological establishment, museums do not believe that unexcavated antiquities—whose archaeological context has not been scientifically recorded, or which didn't come from an ancient archaeological context—are meaningless. Numerous examples of such "orphaned" antiquities can be cited; some are cited in this volume. Two additional examples are offered here.

The sublime Hellenistic sculptural group known as the *Laocoön* was found in Rome on January 14, 1506 (fig. I.1).[4] We know a lot about the circumstances of its finding. We know that a farmer digging in his vineyard on the Esquiline Hill found it accidentally (we even know the name of the farmer: Felice de' Freddi). We know that the architect and antiquarian Giuliano da Sangallo was called to view it and brought along Michelangelo. We also know that both men pronounced it the work described by Pliny as having once belonged to the Emperor Titus; Michelangelo is also said to have called it "a singular miracle of art." Yet we do not know precisely where it was found. That is, we do not know the *archaeological* circumstances of its find spot, with what other objects it was found, or at which stratum of its "site." The work was not excavated as we think of excavations today. It was found centuries before the development of archaeology as a science. It was not removed from the earth through stratigraphic excavation. It was simply dug up, "ripped" from its context as some might say today, found by accident, removed from the ground, taken away, acquired by Pope Julius II, and installed in the Vatican's Belevedere Statue Court with other antiquities.

By any measure even unexcavated the *Laocoön* is important for our understanding of Greek art, of the importance of Rome within the Mediterranean world, of the beauty and power of dramatic composition and expressive form, of the potential of working in marble, and surely, perhaps most importantly, of the history of taste. We know, for example, that it was immediately influential among humanists and artists.[5] It was engraved as early as 1509, used as a source by Raphael for his head of Homer

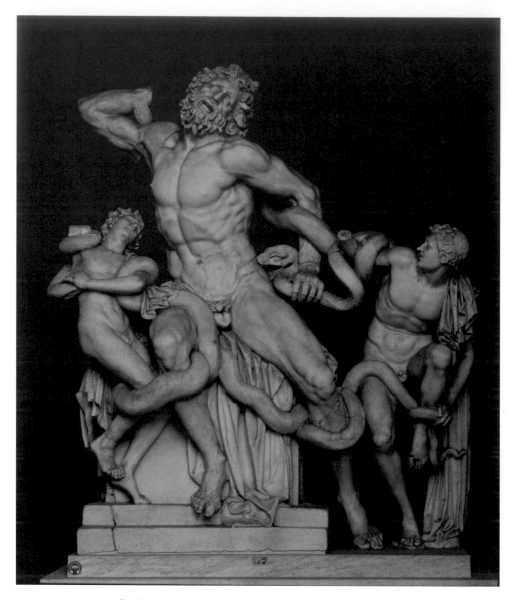

Fig. I.1. *Laocoön*, 1st century BC. Roman copy, perhaps after Agesander, Athenodorus, and Polydorus of Rhodes. White marble (h. 95 in.). Museo Pio Clementino Vatican Museums, Vatican State. Photograph © Archive Timothy McCarthy/Art Resource, NY.

in the *Parnassus* of 1511, copied in marble by Baccio Bandinelli in 1520, and reproduced in bronze under the direction of Primaticcio for the French king, Francis I. In about 1510 Bramante had four of Rome's leading sculptors copy it in large wax models. Raphael, who would later be appointed Commissioner of the Antiquities of Rome, judged Sansovino's copy the finest and it was cast in bronze and given as a gift to Cardinal Grimani before eventually ending up in France, itself. (The *Laocoön* would also go to France, briefly, as Napoleonic war booty.)

And in much of this, the *Laocoön* was not alone. From at least the early fifteenth century, antiquities were prized by Roman and Florentine private collectors, papal, ducal, and otherwise aristocratic. Pope Sixtus IV (1471–84) even donated his private collection "to the Roman people" for display near the papal palace. Other European courts followed suit and over the course of succeeding centuries plaster casts and prints of ancient works of art were the staple of courtly libraries.[6] It was in Dresden in the mid-eighteenth century that Winckelmann was inspired to write his seminal pamphlet of 1755, "Thoughts on the Imitation of Greek Works in Painting and Sculpture." There he wrote of the *Laocoön* as emblematic of expressive restraint in Greek sculpture, which he explained was related to similar devices in Greek literature (he thought the *Laocoön*'s emotion derived from a scene in Virgil's *Aeneid*). This in turn inspired Lessing to respond in an essay of his own, "From *Laocoön*, On the Limitations of Painting and Poetry" (1766), by arguing that the aesthetic value of sculpture lay more in its plastic dimensions and our spatial and psychological experience of them than on any reliance on literary sources or devices. The effect of these and other essays of the latter eighteenth century was to inspire a shift in European artistic taste toward a new and *modern* style inspired by antiquity. Indeed, the role played by antiquity, and of specific *unexcavated* and accidentally found (what today we would often call *looted*) antiquities, in inspiring the forging of new artistic styles in European culture is a commonplace. As Francis Haskell has written: "To study the history of attitudes to ancient art would be to study the history of European culture as a whole."[7]

Can it then be said that the *Laocoön* is in any way meaningless without our knowing the archaeological circumstances of its finding? Of course

not. And yet many archaeologist critics of museums would argue precisely this with regard to unexcavated and undocumented antiquities today. They would hold that without knowledge of its archaeological context an antiquity—like the *Laocoön*—is just a pretty object valued only for its *aesthetic* qualities, which they claim to be subjective and personal, unscientific, and of little general importance. And they would discourage museums from acquiring it and other "orphaned" objects similarly found alienated from their points of origin.

And what of antiquities with texts on them? Undoubtedly the most important example of an unexcavated object with text is the Rosetta Stone, now housed in the British Museum (fig. I.2). It is thought to have lain for centuries in its temple, perhaps in the city of Sais or elsewhere in the Nile Delta.[8] But at some point a fragment of it was taken and used as building material and through a series of events may have reached the city of Rosetta by the fifteenth century when it was used in the walls of a fort. It lay buried in the ruins of the fort for yet more centuries until the summer of 1799, when the French rebuilt the structure as part of their efforts to secure the Egyptian coastline against the British. (Once again, we know the name of the person who found the antiquity: Pierre François-Xavier Bouchard, a French officer of engineers.) Sensing that the stone was important, French officers sent it to the Institut d'Égypte in Cairo, where it remained until it fell into the hands of the British, who removed it to London in 1802, since which it has never left Britain.

The text inscribed on its surface is in three scripts: Egyptian hieroglyphs ("the writing of the divine words"), Egyptian demotic ("the writing of documents"), and ancient Greek ("the writing of the Ionians").[9] It documents the terms of an agreement between a synod of Egyptian priests and the Macedonian ruler of Egypt, Ptolemy V, on March 27, 196 BC and accounts for the generosity of the king (the latest manifestation of the ideal Pharaoh); his gifts to the temples; support for the troops; cutting of taxes; and completion of Alexandria, its library, and the Pharos lighthouse. It acknowledges that the priests agreed to commission a number of statues of the king, one of each to be placed in every temple, some even in the holiest of sacred places with images of the gods worshipped there. And it promises that a copy of the text in the three languages would be placed in

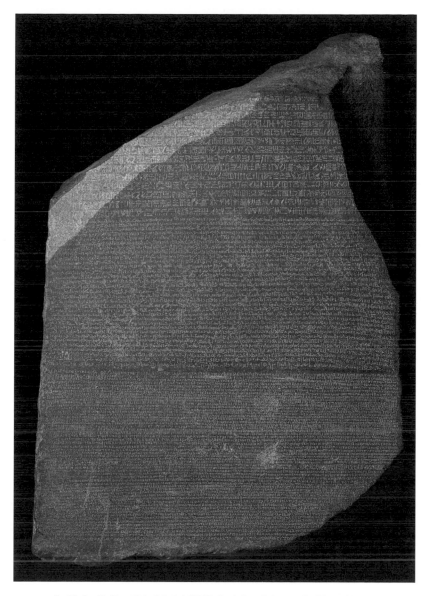

Fig. I.2. Rosetta Stone, Ptolemic Period, 196 BC. Egypt. Granodiorite stone (h. 45 in., w. 28
1/2 in.). The British Museum, Gift of George III. © The Trustees of the British Museum.

every temple of the first, second, and third division in the land "alongside the statue of the king who lives for ever." (The statue itself was to be called "Ptolemy who has guarded the Radiant Land" or "Ptolemy who has saved Egypt".) In its content, the Rosetta Stone is important. But in this, it is not unique. Other Egyptian texts of equal or greater importance exist. And there are even other copies of the stone's text, the so-called Decree of Memphis. No, the importance of the Rosetta Stone lies in its being deciphered. It unlocked the door to the ancient Egyptian language and allowed for the writing of the history of that ancient land. As John Ray has written, "It is the creator of the entire *Historie* of ancient Egypt, because it has enabled us to read the texts which led us to start writing that history."[10]

Does it matter that it had no archaeological context when it was found? Its known find spot cannot tell us anything about ancient Egypt (and its point of origin cannot be known for certain). It can only tell us about the rebuilding of older forts by the French under the constant threat of the British, whose navy under Nelson had destroyed Napoleon's fleet at the Battle of the Nile a year earlier. Those are the true physical circumstances of the stone's discovery. Its importance to our knowledge of ancient Egypt lay not at all in its archaeological context but solely in its text, and then not in the content of its text but in the relations between the text's languages. The practice of Egyptian archaeology is only meaningful today because of our knowledge of Egypt's history as made possible by an unexcavated antiquity that has been housed and studied in a British museum for over two hundred years.

The state of affairs in archaeology today, as reported in David Owen's contribution to this volume, is that if the Rosetta Stone were to come onto the art market with no known provenance (no knowledge of its finding circumstances, whether or not they were "archaeological"), archaeology's leading English-language journals would not publish its text. Those of the American Schools of Oriental Research (ASOR) have policies against serving "as the initial place of publication or pronouncement of any object acquired by an individual or institution after 30 December 1970" unless "the object was in a collection existing prior to 30 December 1970, or if it has been legally exported from the country of origin."[11] The 1973 policy of the Archaeological Institute of America (AIA) does not permit the initial

presentation or publication of "any object in a public or private collection acquired after December 1973, unless its existence can be documented prior to that date, or if it was legally exported from the country of origin." In 2004, in response to the Iraq war, AIA revised its policy to allow for an exception if, in the words of the publication policy, "in the view of the Editor, the aim of publication is to emphasize the loss of archaeological context." No exception can be made simply because of the scholarly value of the object; only if "one remind[s] us all of how much information and value is lost when an object is illegally removed from its archaeological context."[12] In addition, AIA's Principles for Museum Acquisitions of Antiquities urge museums "to specify a date before which an object must have been exported from its country of origin," and it recommends either "the date of the relevant legislation governing ownership and export of antiquities in the country of origin or the date of 1970" when the UNESCO Convention was adopted (in the United States, 1983).[13] If the Rosetta Stone were to appear on the market today undocumented, the U.S. archaeological establishment would either not allow its publication and/or presentation at professional conferences or allow it only if, in the case of AIA, it was used to emphasize the loss to the archaeological context represented by unprovenanced antiquities. In either case, any attempt by a museum to acquire the Rosetta Stone for the benefit of scholars and the interested public would be opposed by ASOR and AIA.

The Rosetta Stone, like the *Laocoön*, is an antiquity without archaeological context. Neither antiquity was *excavated*, as we understand the term today. Both were found by accident, removed without scientific documentation, and acquired, one by a public museum and the other by a private collector (who subsequently created his own museum). In today's terms, they are antiquities without context, of value for themselves, for what is integral to them and for the history of their reception over now some many centuries. And they continue to accrue value the longer they are in their museum settings, seen in splendid isolation as objects in themselves and as among other similar and dissimilar objects. Declaring them meaningless, as the current archaeologists' position would have us do, is simply wrong.

They would also be suspect for having been removed from their place or origin (of course each had at least one earlier place of origin,

where it "originated" before being removed to the post where it was sub-
sequently found). It is often argued that objects have greater meaning in
their "original" context. They are said to be of greater importance when
seen among other like objects from the same culture. National govern-
ments claim that they are of great importance to the identity and esteem
of the modern nation—that they are *of* the modern nation and thus that
the nation is incomplete without them. They argue for the return of such
objects (as the Egyptian government has of the Rosetta Stone) on national-
ist grounds. And they criticize the museums that hold these objects as in-
struments of foreign imperialism.

Like an earlier book also published by Princeton University Press,
Whose Muse? Art Museums and the Public Trust (2004), this book seeks to
take stock of an important (arguably the most important or at least the
most public) issue facing museums today.[14] The earlier book explored the
public purpose of art museums—why their public values them and en-
trusts their directors and curators in building their collections and de-
veloping their exhibition and educational programs—at a time when so
much that art museums were charged with doing was held in great suspi-
cion: organizing exhibitions of contemporary art thought pornographic or
sacrilegious to some; presenting exhibitions of private collections or de-
signer objects as apparent quids pro quo for multi-million-dollar gifts;
emphasizing the glamorous culture of beautiful and well-dressed wealthy
people as perhaps the primary public of art museums; allegedly possess-
ing works of art inappropriately, because they were really owned by
victims of the Nazis who forcible took the works from their Jewish owners
or because they were removed illegally from the jurisdiction of modern
nations.

This book considers the question of why museums, especially art
museums, should acquire antiquities, even unexcavated antiquities with
incomplete provenance. In many ways, this book is a mate to the earlier
one. The responsible acquisition of antiquities is something the public
has entrusted our museums to do. It is part of the public's trust in our
museums. The public wants to know that we have considered all of the
ethical and legal issues bearing on an acquisition of an ancient object

and that we are building our collections responsibly and for their benefit. They have become accustomed to reading about museums being challenged by foreign governments and archaeologists as acting irresponsibly and acquiring objects that likely or actually have been looted and/or removed illegally from "their" source countries. The governments of China, Italy, Greece, and Egypt have made claims against antiquities acquired long ago or recently by our museums and have called for their "return." And some high-profile museums—the Metropolitan Museum of Art; the J. Paul Getty Museum; and the Museum of Fine Arts, Boston; among others—have negotiated for the return of dozens of antiquities to Italy, where they are currently on display in Rome in an exhibition dramatically titled *Nostoi: Recovered Masterpieces* (*nostoi* referring to the lost epic relating the return home of Greek heroes after the Trojan War). And of course, the travails of the Getty Museum's former curator of antiquities, Marion True, indicted for conspiring to acquire looted antiquities for the museum, has been covered widely in the international press. (Photographs of her wearing dark sunglasses and shielding her face with her pocketbook outside the Rome courtroom have appeared in newspapers around the world and continue to circulate in cyberspace on Web sites, blogs, and Listservs.)

It is the purpose of this book to challenge the perception of museums as rapacious acquisitors of ill-gotten goods and to argue instead that our public museums build their antiquities collections responsibly and for the public's benefit. Some readers will be disappointed that not "all sides" of the debate are presented here. It is our view that other books already do this and well enough that we needn't repeat the "both sides of the argument" formula here.[15] And, perhaps more to the point, other books are partisan in opposition to the museum's position as we are presenting it and need to be responded to.

To cite just one example, Colin Renfrew's *Loot, Legitimacy, and Ownership* of 2000:

> Crisis is not too strong a word to use when we speak of the predicament which today faces the historic heritage in nearly every country on earth. The world's archaeological resource, which through the practice

of archaeology is our principal source of knowledge about the early
human past, is being destroyed at a formidable and increasing rate.
It is destroyed by looters in order to serve the lucrative market in il-
licit artifacts through which private collectors and, alas, some of the
major museums of the world, fulfill their desire to accumulate antiq-
uities. Such unprovenanced antiquities, ripped from their archaeo-
logical context without record (and without any hope of publication),
can tell us little that is new. . . . All the major and ancient museums
of the world have in earlier centuries obtained large parts of their col-
lections by means that would today be considered dubious. . . . [It is
an aim of this book] to invite museum curators to concede that they
betray their trust as serious students of the past when they acquire
unprovenanced antiquities or permit them to be displayed in their
galleries.[16]

Renfrew is a distinguished archaeologist, director of the University
of Cambridge's McDonald Institute for Archaeological Research. (That said,
he comes upon hard knocks in Sir John Boardman's contribution to this
volume.) Renfrew values the contribution of his specialty above all others
concerned with antiquities:

[Archaeology] gives primacy of place to information, to the knowledge
of the human past which can come about through the study of those
material remains. And for a century it has been appreciated that co-
herent information comes about only through the systematic study of
context—of the associations of things found within the ground where
they were abandoned or deliberately buried. The purpose of archaeo-
logical fieldwork today is the recovery, generally, through stratigraphic
excavation, of the contexts of discovery, permitting interpretation of
the economic, social and cognitive aspects of the diversity of cultures
of the human past.[17]

He acknowledges that antiquities might also be art—"beautiful, in-
teresting and evocative in their own right"—but separated from their con-
text of discovery "they have very little potential to add to our knowledge of

the past." Their value is simply ornamental, something to be admired, of some interest but of little *real* value.

It is the view of the authors of this book that antiquities (provenanced, and unprovenanced) in museums have value. To argue otherwise is to ignore the incalculable contributions made by museums over the years to our knowledge and appreciation of art, of different cultures, and of our common ancient past. The public trusts museums to make this case because the public benefits from contact with authentic artifacts of antiquity.

We must remember that we who work in public art museums work on behalf of the broad public interest in artistic artifacts. Some archaeologists dismiss art museums and art as being only of secondary value. Neil Brodie, for example, formerly Renfrew's colleague at the University of Cambridge's McDonald Institute for Archaeological Research and currently Director of Cultural Heritage Resource at Stanford University's Archaeology Center, has written:

> The art museum can be distinguished from other museums in that unlike a natural history or anthropology museum its purpose is not considered to be primarily educational; instead it is intended to allow contemplation of art in a space that is not cluttered with intrusive didactic aids. . . . The mission of the art museum was clearly stated in 1968 when the American Association of Museums published *America's Museums: The Belmont Report*, which claimed that art museums "aim to provide the esthetic and emotional pleasure which great works of art offer." This is a primary purpose of an art museum. It is assumed that a majority of the people who come regularly to our art museums come to be delighted, not to be taught, or preached at, or "improved" except by the works of art themselves.[18]

Brodie allows that "this distinction between the educational and the aesthetic purposes of museums may have blurred somewhat by the end of the twentieth century" (three decades after the *Belmont Report*), but he insists that it is still embedded in our art museum culture. And he dismisses the value of aesthetic purposes or the importance and relevance of being delighted by works of art. The public may value these purposes and

experiences, but he, a scholar archaeologist, does not. And more, he accepts the proposition (as fact) that art museums "tend to fill up with objects that are emblematic of high social status" and consecrate not just taste but the taste of the elite and powerful (all those donors and trustees of our art museums). "Thus if the museum display of antiquities alongside other artistic trappings of wealth and power is predicated largely or entirely upon the criterion of aesthetic merit, the message received by the visitor/consumer might be that the possession and transaction of equivalent pieces can form a legitimate route to social advancement or a socially approved sign of cultural attainment."[19] His contempt for art museums, their purpose and public, is barely concealed. He would rather have antiquities collections be built for archaeology and archaeologists; that is, for his kind of elite, the elite of specialization and specialists. (In a huff of still more condescension, he notes that while the term *antiquity* is no longer a common one in archaeological usage, "where the more mundane 'artifact' is preferred," it does convey "a sense of the archaeological artifact as collectible art object, and it is probably for this reason that 'antiquity' is commonly used in market and collecting circles"—presumably "artifact" is objective and *scientific* and is preferred usage among the knowledgeable elite.)

The authors of this book hold that public art museums are, and must be, responsible to a diverse public, who come to art museums for a variety of reasons but certainly to engage with the original work of art. Their particular interest in the work of art is not ours to question or dismiss. Our purpose is to provide them informed access to authentic works of art, to anticipate the range of questions they may have, and to try and help answer them through text labels, docent tours, scholarly lectures, podcasts, Web sites, and publications. We should never presume that they should be interested in only one aspect of an object's meaning, the one that we find meaningful. Rather we should acknowledge that we can't imagine all that interests them about individual works of art and cultural artifacts, and thus should encourage their wide-ranging and genuine curiosity about a whole host of things provoked by their coming into contact with original works of art. This is how the public values the art museum and is the basis of the public's trust in we who work in them and on the public's behalf.

The preservation of antiquities through acquisition and the building of encyclopedic museums is a matter of public trust. No less so now than during the era of the Enlightenment, visitors to museums entrust directors and curators to select works of art thought so important as to be brought into the public domain and preserved for the delight and education of peoples for of all of time. They want us to research and publish them and develop education programs around and stimulated by them. And they want to be encouraged to see qualities distinctive of them as individual works of art and to seek connections between them and other works throughout the museum's encyclopedic collections. Quite simply: they want museums to expand their world view and change their lives, to introduce them to the great wonder of the world's cultural diversity and interrelatedness and to help them see and feel that they are a part of this world, they and everyone else with whom they are connected by virtue of their humanity. This is a tall order indeed, and it must be pursued by museums responsibly and with vigor. Constraints placed on museums by the archaeological community and nationalist governments represent among the greatest challenges facing museums today as they endeavor to retain their public's trust in them, as Neil MacGregor has said of the British Museum, "truly the memory of mankind."

In *Who Owns Antiquity?: Museums and the Battle over Our Ancient Heritage*, I offered an example of how this works.[20] There I reviewed the qualities of six works of art in the collection of the Art Institute of Chicago: a Shang Dynasty bronze *fangding* (fig. I.3), a Western Zhou Dynasty bronze cauldron (fig. I.4), a 16th-century Benin brass plaque (fig. I.5), a 19th century ivory altar tusk from the court of Benin (fig. I.6), a 13th-century ivory casket from Sicily (fig. I.7), and a 14th century gilt silver monstrance (fig. I.8). I suggested that from even a brief consideration of these few objects in neighboring museum galleries we traveled halfway around the world and over thousands of years, from what is today China to Nigeria, Egypt, Sicily, and Germany. We saw how bronze is worked magnificently in two seemingly very different cultures; and how in each of the courts of the Zhou and Benin, objects were used to document courtly history and dynastic relations. We also saw how in these courts, as in medieval European Christian communities, precious objects were central to

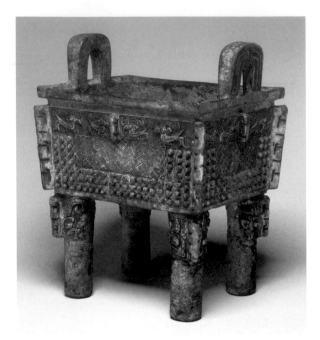

Fig. I.3. *Fangding*, Shang Dynasty, 12th/11th century BC. China. Bronze (8 9/16 x 6 3/4 x 5 1/2 in.). The Art Institute of Chicago, Avery Brundage, Russell Tyson, and Alyce and Edwin DeCosta and Water Heller Endowments; General Acquisitions Fund, 2004.701. Photograph by Robert Hashimoto.

ritual practices, and how these rituals venerated, sometimes included pieces of, or were buried with human bodies. We saw how objects move about the world through trade or because of economic hardship, looting, and violence. And we saw how different cultures use, reuse, and transform other cultures' objects or decorative motifs, either indifferently or because they add value to the object in its new cultural setting. And in each instance, we admired the beauty and workmanship of the object and the sophistication of the culture within which it was produced. Unsuspected connections were made between cultures, and great distances in space and time were overcome.

But we needn't stop here. Curiosity leads us to objects of more modern manufacture. Near to the Benin carved ivory altar is a nineteenth-century *kiti cha enzi* chair ("chair of power" or "grandee's chair"; fig. I.9).[21]

Fig. I.4. *Shi Wang Ding*, early 9th century BC. China. Western Zhou Dynasty. Bronze (19 1/4 x 16 7/8 in.). The Art Institute of Chicago, Major Acquisitions Centennial Fund, 2005.426. Photograph by Robert Hashimoto.

The chair was probably made sometime in Lamu, a small island archipelago off the northeast coast of Kenya in a region rich with Swahili cultural influences; although we can't be certain.

As a type, the *kiti cha enzi* chair has been said to have developed spontaneously in the region of Lamu and Zanzibar, from an earlier, simpler kind of Swahili chair, which continued to be made until around 1900. It has also been said that the chair was inspired by British colonial furniture, known as the campaign style, which flourished in India during the eighteenth and nineteenth centuries; these kinds of chairs "were high-backed, square in their overall design, had arms and footrests, and were invariably caned; some were even elaborated with inlays of wood, shell or ivory, much like the marquetry found on Queen Anne chairs." And it has been

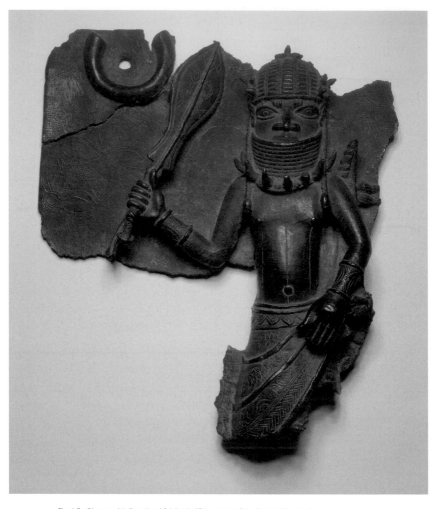

Fig. I.5. Plaque with Courtier, 16th/early 17th century. Edo, Court of Benin. Bronze
(13 3/8 x 11 3/8 x 1 7/8 in.). The Art Institute of Chicago, Samuel P. Avery Fund, 1933.782.

said that both the *kiti cha enzi* and earlier Swahili chairs probably derived
from "ongoing cultural cross-fertilization" with the same, distant Mamluk
Egyptian culture.[22]

The simple structure and elegantly minimal form of the Swahili
chair resonates with another piece of furniture recently acquired by the

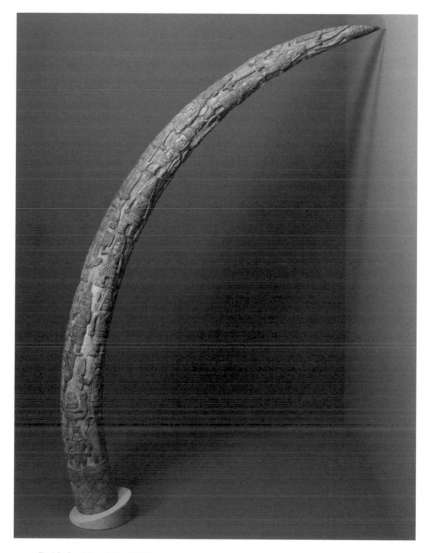

Fig. I.6. Royal Altar Tusk, 1850/1888. Edo, Court of Benin. Ivory (58 1/4 x 77 x 5 in.). The Art Institute of Chicago, Gift of Mr. And Mrs. Edwin Hokin, 1976.523 view 2.

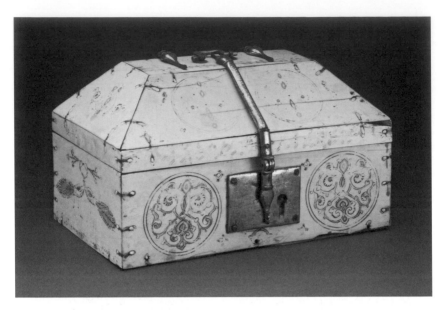

Fig. I.7. Casket, 1200/25. Sicily. Ivory, brass, tempera, and gold leaf (3 7/8 x 6 1/4 x 3 1/4 in.). The Art Institute of Chicago, Samuel P. Avery Endowment, 1926.389. Photograph by Robert Hashimoto.

Art Institute: a sideboard designed by the English designer Edward William Godwin around 1877 (fig. I.10).[23] Godwin's refined Arts and Crafts Movement style was heavily influenced by Asian art, especially that of Japan. We can see it here in the use of materials—ebonized mahogany (similar in appearance to Japanese, black lacquer) and silver plate—and in the elegant restraint of its form: a balance of solids and voids suspended in a network of parallel planes. A variant of this sideboard in the collection of the Victoria and Albert Museum, London, even includes embossed Japanese leather panels applied to its doors.

Japanese art was exhibited in Britain at the 1861 Industrial Exhibition in Bristol, and then again at the 1862 London International Exhibition. Godwin's interest in a Japanese aesthetic influenced both his designs for furniture—his "Anglo-Japanese Furniture" designs were featured in the catalogue of William Watt's Art Furniture Company, London, and illustrated in a *Building News* review of Watt's stand in the Paris Universal Exhibition in 1878—and the studio houses of his friends, Frank Miles and

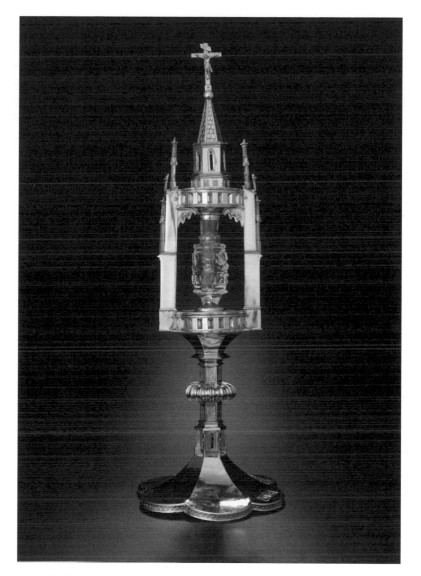

Fig. I.8. Monstrance with <u>Tooth</u> of St. John the Baptist, 1375/1400. Germany, Lower Saxony, Brunswick. Gilt silver (17 7/8 x 5 1/4 in.). Rock crystal, 900/1000. Egypt, Fatimid Dynasty. The Art Institute of Chicago, Gift of Mrs. Chauncey McCormick, 1962.91 side 1. Photograph by Robert Hashimoto.

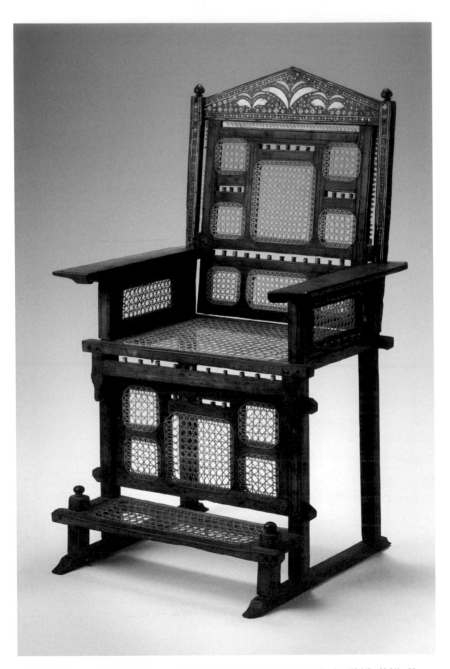

Fig. I.9. *Kiti cha enzi* Chair. 1900, Kenya, probably Lamu; Swahili. Wood, ivory, bone, and string (49 1/2 x 29 3/4 x 28 1/2 in.) The Art Institute of Chicago; restricted Gift of Marshall Field V, 2004.476. Photograph by Robert Hashimoto.

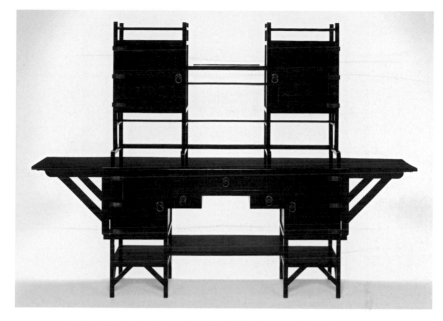

Fig. I.10. Sideboard, ca. 1877. Designed by Edward William Godwin (English, 1833–1886), made by William Watt, Art Furniture Warehouse, London. Ebonized mahogany with glass and silver-plated copper alloy (72 1/2 x 100 1/2 x 19 3/4 in.). The Art Institute of Chicago, Robert Allerton, Harry and Maribel G. Blum, Mary and Leigh Block, Mary Waller Langhorne, Mrs. Siegfried G. Schmidt, Tillie C. Cohn, Richard T. Crane Jr., Memorial, Eugene A. Davidson, Harriott A. Fox, Florence L. Notter, Kay and Frederick Krehbiel, European Decorative Arts Purchase, and living and June Seaman Endowments; through Prior Acquisition of the Reid Martin Estate.

James MacNeill Whistler. Whistler himself, of course, was deeply interested in and influenced by Japanese art. His painting, *The Artist in His Studio* of 1865–66 (fig. I.11), in the Art Institute's collection, is characteristic of his delight in simplified forms and references to Japanese precedents (the model in a kimono-like robe holding a Japanese fan). There is even the representation of his collection of Asian (probably Chinese) ceramics, mounted in the wall case to the left. The Arts and Crafts aesthetic generally was influenced by Japanese precedents. Frank Lloyd Wright was an active collector of Japanese prints. He even designed an elegant Arts and Crafts installation for a 1908 Art Institute exhibition of more than 650 Japanese prints, many of which were loaned from his own collection. And, in the way that culture works, the Arts and Crafts movements in the United States

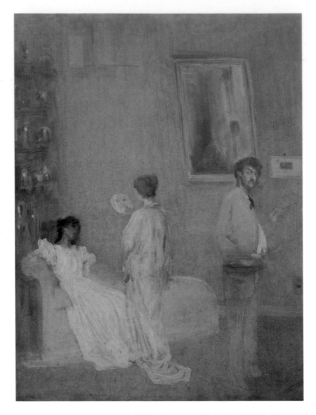

Fig. I.11. James McNeill Whistler (1834–1903), *The Artist in His Studio*, 1865/66. Oil on paper, mounted on panel (24 3/4 x 18 1/4 in.). The Art Institute of Chicago, Friends of American Art Collection, 1912.141.

and Europe were themselves influential in the formation of the Mingei or Folk Crafts Movement in Japan in the first decades of the twentieth century. Led by Yanagi Sōetsu, that movement was self-consciously hybrid, drawing upon both European and Japanese examples thereby asserting, as a recent scholar has written, "a strong nationalistic sense of cultural identity and yet [promoting] a form of international urban modernity through discovering, aestheticizing and commodifying tradition."[24]

This was true as well of Godwin's sideboard and the Swahili *kiti cha enzi* chair: both, while firmly rooted in their local cultures were enriched by their culture's centuries of contact with other cultures. And of course,

this is true of culture generally. Culture thrives, even *depends*, on contact with new and strange things. It is never static. It is forever changing. Salman Rushdie described his novel *Satanic Verses* as celebrating "hybridity, impurity, intermingling, the transformation that comes of new and unexpected combinations of human beings, cultures, ideas, politics, movies, songs. It rejoices in mongrelization and fears the absolutism of the Pure. Mélange, hotchpotch, a bit of this and that is how newness enters the world. It is the great possibility that mass migration gives the world, and I have tried to embrace it."[25] This is a perfect description of culture itself: always mongrel, impure, rich with generative potential. As Kwame Anthony Appiah has said, "Cultural purity is an oxymoron" (see his "Whose Culture Is It?" in this volume).

Culture is poorly served by politics. Modern nation-states claim culture for themselves. They nationalize it. They say it is important to their identity and they try to police it. They put national borders around it and claim, as the Italian government did in its recent request to the U.S. government for the imposition of import restrictions on a whole range of antiquities said to have been improperly removed from Italy's jurisdiction, "These materials [the hundreds of years of antiquities covered by the request] are of cultural significance because they derive from cultures that developed autonomously in the region of present day Italy that attained a high degree of political, technological, economic, and artistic achievement. . . . [T]he cultural patrimony represented by these materials is a source of identity and esteem for the modern Italian nation." No significant, lasting culture ever developed autonomously, least all that of ancient Rome. The ancient Romans embraced the culture of ancient Greece and modeled theirs on it. (Plutarch, himself Greek with only a passing knowledge of Latin, wrote his famous *Parallel Lives*, pairing famous Greek and Roman figures and chronicling their noble deeds and characters.) Nearly all of Roman visual culture—vase painting, marble and bronze sculpture—has Greek precedents. And of course the Greeks had colonized much of southern Italy and Sicily for hundreds of years before the rise of Rome (hence, the Latin term *Magna Graecia* for that part of Italy, "Greater Greece"; the Greeks called it *Megale Hellas*). And Greek culture itself bears the imprint of other cultures: Egypt and the lands eastward toward India,

all the lands and cultures with which the overland and seafaring power came into contact.

It is the nature of culture to be dynamic and ever changing. Yet national governments ignore this fact. They impose a national claim of distinction on culture, and they seek an ancient pedigree for that culture. They want to claim primacy as much as purity: ancient origins and uninterrupted identity. But this is only politics. Modern Egypt's claim of descent from pharaonic Egypt, or the People's Republic of China from the ancient Qin, or Iraq from Mesopotamia, or Italy from ancient Rome is nationalist fantasy based on the accident of geography and enforced by sovereignty. Just ask the Copts in Egypt, the Tibetans in China, or the Kurds in Iraq.

It is the promise of the encyclopedic museum to counter the nationalization of culture and its claim on antiquity. We have seen how it works in my brief account of a few works of art in the collection of the Art Institute. Compelled by common materials, forms, and functions, as well by their beauty, we experienced the promise of museums. And this experience—one that is available in all encyclopedic museums everywhere—is a reminder that despite the nationalist and sectarian pressures on us to limit our identities to certain narrow, political affiliations, we have much more to gain by seeking similarities between us than by relying on crude, reductive, falsely unifying cultural identities. As Nayan Chanda reminds us, "We benefit from all the world has to offer, but we think only in narrow terms of protecting the land and people within our national borders—the borders that have been established only in the modern era. The barbed wire, chain-link fences, security fences, and immigration and customs agents that separate us from the rest of the world . . . cannot change the fact that we are bound together through the invisible filament of history."[76]

This is why it is imperative that we continue building encyclopedic museum collections and provide safe harbor within them for unprovenanced antiquities. They, no less than the other objects in our collections, are important artifacts of human history, evidence of our common artistic legacy, deserving of our respect. They have equal claim on the Enlightenment ideal of the museum as a repository of things and knowledge, dedicated to the museum's role as a force for understanding, tolerance, and the dissipation of ignorance and superstition about the world, where the artifacts

of one time and one culture can be seen next to those of other times and other cultures without prejudice. Such is the *promise* of the museum. And such is the claim of this book.

The contributions to this book represent the points of view of leading museum professionals and university- and museum-based scholars, who, over the years, have either distinguished themselves in their specialized fields of work and research or contributed significantly to the discourse on the role of museums in contemporary society.

The origin of this book lay, most immediately, in a conference organized by AAMD in the spring of 2006 and cited in this book's Acknowledgements. Titled "Museums and the Collecting of Antiquities: Past, Present, and Future," the conference was organized in two parts. The first explored the value of museums and the value of antiquities, while the second comprised a lively debate on the subject of ancient culture and museums, "Saving Sites and Serving Knowledge." Over the course of a long day of papers and discussion, it became clear that the museum's position on the topic needed to be presented in book form. To preserve the character of that conference, I reprint here contributions by Neil MacGregor, Philippe de Montebello, and James Watt as they were delivered. These are complemented by essays either commissioned especially for this volume or reprinted from other books or journals. Necessarily, the tone of the contributions differs accordingly: the first are direct, written to be heard, while the second were written to be read and are accompanied by more substantial scholarly apparatus. Each is imbued with the personality of its author and his personal engagement with the subject of this book. In a few cases—David Owen and John Boardman, especially—the tone is even, at times, confrontational. Such is the nature of the debate: much is at stake, and each author has decades of professional expertise invested in his point of view.

The book is divided into three parts: "The Value of Museums," "The Value of Antiquities," and "Museums, Antiquities, and Cultural Property." In part one, Neil MacGregor, Philippe de Montebello, and Kwame Anthony Appiah consider the value and cultural politics of museums in the current climate of opinion. MacGregor writes from the perspective of director of

one the world's greatest encyclopedic museums, the British Museum, which was founded on Enlightenment ideals and dedicated to the preservation, research, and presentation of the art and artifacts of the world's many cultures. He has lectured widely on the role of museums in our world, and he writes here of his experience in formulating new programs and policies, especially with regard to broadening public access to the British Museum's great collections and to the museum's role in discovering new truths about our world. Philippe de Montebello, writing with more than thirty years' experience as director of the Metropolitan Museum of Art, and with considerable experience dealing and negotiating with claimant nations, argues with passion and intelligence that museums should acquire antiquities, provenanced and unprovenanced, for the contributions such acquisitions make to the preservation and further study of our common, ancient past. Kwame Anthony Appiah's essay first appeared in the *New York Review of Books* and derives from his 2006 book *Cosmopolitanism: Ethics in a World of Strangers* and lays the basis for the larger consideration of the politics of treating antiquities as a modern nation's cultural property. Always, this is at the cost of encouraging a broader understanding of the interrelatedness and diversity of culture and our common artistic legacy. As Appiah writes of ancient Nok sculptures claimed by Nigeria as part of its patrimony: "We don't know whether Nok sculptures were commissioned by kings or commoners; we don't know whether the people who made them and the people who paid for them thought of them as belonging to the kingdom, to a man, to a lineage, to the gods. One thing we know for sure, however, is that they didn't make them for Nigeria."

In part two, "The Value of Antiquities," James C. Y. Watt, Sir John Boardman, and David I. Owen consider what can be learned from antiquities even without knowing their specific archaeological contexts. James C. Y. Watt, for example, an eminent Chinese art historian with considerable experience in the archaeological field, notes the limitations of archaeology for our greater understanding of our ancient past. He argues that archaeology has yet to help us understand why ancient artists made certain forms in jade or decorated bronze objects a certain way, or even, perhaps most poignantly, what ancient Chinese music sounded like, even though we have

unearthed ancient Chinese instruments, and thus know what they sound like today. Sir John Boardman, drawing on examples from his esteemed career as an archaeologist and art historian of ancient Greek art, argues forcefully against a number of positions taken by archaeologists in their criticism of museums' acquiring unprovenanced antiquities, most notably the criticisms of the aforementioned Colin Renfrew. These include the familiar claim cited above that without knowledge of their archaeological contexts, antiquities have little, if any meaning; that they rightfully belong in their "countries of origin"; that scholarship based on unprovenanced antiquities should not be published or presented in public lectures; and that the trade—even the legitimate trade—in antiquities leads to looting and the loss of knowledge about the past. David I. Owen, drawing on his distinguished career as professor of Ancient Near Eastern studies and more than twenty years excavating in Turkey, Greece, and Israel, argues for the benefit of studying ancient Near Eastern cuneiform tablets for all that they can teach us, even if we do not know the archaeological circumstances of their unearthing. And he criticizes the policies and practices of the archaeological establishment that, as cited above, opposes the publication and acquisition by museums of unprovenanced antiquities at the expense of what they can teach about the ancient past. This is, he argues, a shameful disservice to scholarship and the advancement of knowledge.

Finally, part three, "Museums, Antiquities, and Cultural Property," offers museological, philosophical, and legal contexts within which to consider the more specific theses of the earlier papers. Michael F. Brown, a noted anthropologist who has written widely on the politics of—and ideological debates surrounding—the display and designation of indigenous (of "native") culture, considers the constraints on modern museums that seek to collect, present, and interpret tangible elements of cultural heritage, what is often called "cultural property." Since increasingly antiquities are defined as a nation's, or a people's, cultural property, Brown's reflections on the accusations of cultural appropriation of indigenous peoples' culture by nonindigenous scholars and institutions (i.e., museums), are highly relevant to a consideration of the role of and constraints on—encyclopedic museums seeking to collect and exhibit representative examples of

the world's artistic legacy, especially antiquities from so-called source countries, which often feel aggrieved as former colonial territories. Derek Gillman, executive director and president of the Barnes Foundation, has written widely on art museums and public policy. His contribution derives from his recently published book *The Idea of Cultural Heritage* (2006). Gillman considers three case studies for what they teach us about nationalist or culturalist claims on antiquities and works of art. He considers the philosophical principles by which one group (typically now a nation) claims identity with its heritage as exclusive to itself. And he asks the question on what basis can we accept that a cultural group has the character of a natural person and can be wounded by the loss of, or damage to, a national/personal symbol self-proclaimed as such, like the Bamiyan Buddhas, Parthenon/Elgin Marbles, or indeed the Lansdowne portrait of George Washington?

John Henry Merryman's paper, which is a reprinting of his seminal 1995 article "The Nation and the Object," proposes a "triad of regulatory imperatives" when considering constraints on the acquisition of antiquities. The first, and most basic, is preservation. How can we best protect the object and its context from impairment? Second, is the quest for knowledge. How can we best advance our search for valid information about the human past, for "the historical, scientific, cultural, and aesthetic truth that the object and its context can provide." And the third is access. How can we best assure that the object is "optimally accessible to scholars for study and to the public for education and enjoyment." He calls this triad "preservation, truth, and access." More than ten years later, these imperatives offer the best and most reasonable guide through the thicket of arguments around the acquisition of antiquities, provenanced and unprovenanced.

This book will not be the final word in the debate over antiquities. But we hope it will add a new angle to the frame within which the discussion henceforth takes place. Nothing is more important to the fate of the preservation and greater understanding of our world's common ancient past and antique legacy than we resolve the differences that divide the various parties in the dispute. Warfare and sectarian violence, which is destroying evidence of the past faster and more surely than the destruction

of archaeological sites by looters, is beyond our control. Differences among museum professionals, university- and museum-based scholars, archaeologists, their sympathizers, national politicians, and international agencies should not be.

NOTES

1. James Cuno, *Who Owns Antiquity? Museums and the Battle over Our Ancient Heritage* (Princeton, NJ: Princeton University Press, 2008). The debate has attracted considerable public attention, with accounts of or references to it appearing frequently in newspapers and magazines, public and university symposia, and specialist—even sensationalist—books and blogs and Web sites. Among only the most recent such studies are Kate Fitz Gibbon, ed., *Who Owns the Past? Cultural Policy, Cultural Property, and the Law* (New Brunswick, NJ: Rutgers University Press, 2005); Barbara T. Hoffman, ed., *Art and Cultural Heritage: Law, Policy, and Practice* (Cambridge: Cambridge University Press, 2006); and John H. Merryman, ed., *Imperialism, Art, and Restitution* (Cambridge: Cambridge University Press, 2006). Among the more sensational book-length publications are Roger Atwood, *Stealing History: Tomb Raiders, Smugglers, and the Looting of the Ancient World* (New York: St. Martin's Press, 2006); Matthew Bogdanos and William Patrick, *Thieves of Baghdad* (New York: Bloomsbury Publishing, 2005); Colin Renfrew, *Loot, Legitimacy, and Ownership: The Ethical Crisis in Archaeology* (London: Duckworth, 2000); and Peter Watson and Cecilia Todeschini, *The Medici Conspiracy: The Illicit Journey of Looted Antiquities, from Italy's Tomb Raiders to the World's Greatest Museums* (New York: Public Affairs, 2006). Also see Neil Brodie, Jennifer Doole, and Colin Renfrew, eds., *Trade in Illicit Antiquities: The Destruction of the World's Archaeological Heritage* (Cambridge: McDonald Institute for Archaeological Research, 2001).
2. The text of the 1970 UNESCO Convention can be found on UNESCO's Web site, www.unesco.org. It can also be found, together with a list of the states party to the Convention and the date that each state enacted its terms, on the U.S. Department of State Web site, http://exchanges.state .gov/culprop/it01fr01.html.
3. The texts of the relevant AAMD guidelines can be found on its Web site, www.aamd.org.
4. See Phyllis Pray Bober and Ruth Rubinstein, *Renaissance Artists and Antique Sculpture: A Handbook of Sources* (Oxford: Oxford University Press, 1986), 152–55; Francis Haskell and Nicholas Penny, *Taste and the Antique:*

The Lure of Classical Sculpture, 1500–1900 (New Haven, CT: Yale University Press, 1981), 243–47; and Leonard Barkan, *Unearthing the Past: Archaeology and Aesthetics in the Making of Renaissance Culture* (New Haven, CT: Yale University Press, 1999), 1–42.

5. My accounts of the history of its reception are taken from Bober and Rubinstein, *Renaissance Artists and Antique Sculpture*, 152–55, and Haskell and Penny, *Taste and the Antique*, 243–47. Also see Haskell and Penny, *Taste and the Antique*, 1–15.

6. See Haskell and Penny, *Taste and the Antique*, 16–52.

7. Ibid., xiii.

8. For a good account of the finding, decipherment, and importance of the Rosetta Stone, see John Ray, *The Rosetta Stone and the Rebirth of Ancient Egypt* (Cambridge, MA: Harvard University Press, 2007). A fuller account is Richard Parkinson's in his *Cracking Codes: The Rosetta Stone and Decipherment* (Berkeley: University of California Press, 1999).

9. This is how the scripts are described in the text itself. An English translation of the Stone's text can be found in Ray, *The Rosetta Stone*, 164–70.

10. Ibid., 144.

11. The full text of the ASOR policy can be found at www.asor.org/pubs/nea/instructions.html. In response to the destruction of Iraq during the current war, ASOR adopted a "limited exception" to its publication policy, effective November 20, 2004. This allows for the publication and presentation at ASOR meetings of undocumented cuneiform tablets from Iraq if the State Board of Antiquities and Heritage (SBAH) of Iraq gives its consent and if the materials are returned to Iraq and "are in the ownership and custody of the SBAH." Given the circumstances in Iraq as of the effective date of this exception, ASOR interprets "return to Iraq" to include "temporary placement of the material on loan with an academic research institution in the United States which is approved by the SBAH, does not acquire undocumented antiquities, and commits in writing to transfer such material to Iraq at any time upon request from the SBAH." Further "the ASOR Baghdad Committee can make a determination as to when conditions in Iraq permit the immediate return of materials to Iraq and this provision for temporary placement in a US institution would then no longer be applicable." See www.asor.org/textpolicy.htm for the full text of this "limited exception." Also see David Owen's paper in this volume for a review of the controversy surrounding ASOR's policy among Near Eastern archaeologists.

12. The texts of the AIA's 1973 policy and 2004 revision can be found at www.archaeological.org/webinfo.php?page=10352.

13. "Principles for Museum Acquisitions of Antiquities," available at www
 .archaeological.org/webinfo.php?page=10344.
14. James Cuno, ed., *Whose Muse? Art Museums and the Public Trust* (Princeton,
 NJ: Princeton University Press, 2004).
15. See especially, Merryman, ed., *Imperialism, Art, and Restitution*; Eleanor
 Robson, Luke Treadwell, and Chris Gosden, eds., *Who Owns Objects?: The
 Ethics and Politics of Collecting Cultural Artifacts* (Oxford: Oxbow Books,
 2006); and Robin F. Rhodes, ed., *The Acquisition and Exhibition of Classical
 Antiquities: Professional, Legal, and Ethical Perspectives* (South Bend, IN:
 University of Notre Dame Press, 2008).
16. Renfrew, *Loot, Legitimacy, and Ownership*, 9.
17. Ibid., 19.
18. Neil Brodie, "Introduction," in *Illicit Antiquities: The Theft of Culture and
 the Extinction of Archaeology*, ed. Neil Brodie and Kathryn Walker Tubb
 (London: Routledge, 2002), 1–22, at 10.
19. Brodie, "Introduction," in Brodie and Tubb, eds., *Illicit Antiquities*, 18.
20. A more complete treatment of this theme is in Cuno, *Who Owns Antiquity?*,
 ix–xxxii.
21. See Kathleen Bickford Berzock, "Chair (*Kiti Cha Enzi*)," in *Notable Acqui-
 sitions at the Art institute of Chicago*, 10.
22. See James de Vere Allen, "The *Kiti Cha Enze* and Other Swahili Chairs,"
 African Arts 22, no. 3 (1989): 54–63, 88.
23. See Ghenete Zelleke, "Sideboard," in *Notable Acquisitions at the Art Institute
 of Chicago*, 14. Also see Susan Weber Soros, *The Secular Furniture of E. W.
 Godwin, with a Catalogue Raisonné* (New Haven, CT: Yale University Press,
 1999), and Nancy B. Wilkinson, "E. W. Godwin and Japonisme in En-
 gland," in *E. W. Godwin: Aesthetic Movement Architect and Designer*, ed.
 Susan Weber Soros (New Haven, CT: Yale University Press, 1999), 87–88.
24. Yoko Kikuchi, "The Mingei Movement," in *International Arts and Crafts*,
 ed. Karen Livingstone and Linda Parry (London: Victoria and Albert Pub-
 lications, 2005), 296.
25. Salman Rushdie, *Imaginary Homelands: Essays and Criticism, 1981–1991*
 (London: Granta Books, 1991), 394, quoted in Kwame Anthony Appiah,
 Cosmopolitanism: Ethics in a World of Strangers (New York: W. W. Norton,
 206), 112.
26. Nayan Chanda, *Bound Together: How Traders, Preachers, Adventurers, and
 Warriors Shaped Globalization* (New Haven, CT: Yale University Press,
 2007), 319.

PART ONE

The Value of Museums

Encyclopedic museums, like the British Museum, with collections representative of the world's diverse, artistic production, encourage tolerance and inquiry. They are a legacy of the Enlightenment, and are dedicated to the principle that access to the full diversity of human artistic industry promotes the polymath ideal of discovering and understanding the whole of human knowledge, and improves and advances the condition of our species and the world we inhabit.

Some hold that recent nationalist, retentionist cultural property laws are challenging the very basis of encyclopedic art museums. When the United Nations was founded in 1946, there were fifty-one member nation-states. There are now 191. Most of these have retentionist cultural property laws: either ownership laws, in which antiquities found in the ground within the modern borders of the modern state are declared state property; export laws, in which specific kinds of objects, even if privately owned, cannot be exported from the modern nation-state without official permission; or hybrid laws, such as preemption rights by which the modern nation-state has a certain period of time within which to decide to buy the privately owned object or allow its export. Of these, the majority date since 1947; and of these, most date from 1970.

In addition, new nation-states have recently adopted international conventions, which further constrain the international movement of antiquities by defining them as "cultural property." Some have argued that in effect, these conventions condone and support the widespread practice of overretention or, even the hoarding of cultural property, and of antiquities as cultural property.

At the same time the practice of partage, by which archaeological finds are shared between the excavating team and the local, host nation, has all but stopped. Most new nation-states require that all archaeological finds remain where they were excavated as the new nation's "cultural property." This is in contrast to the practice of the first half of the twentieth-century, which allowed excavating teams to return to their host museums and universities, whether in the United States or Europe, with a share of the finds for further study and research.

The combination of retentionist cultural property laws, international conventions, and the halting of the practice of partage has discouraged the building of encyclopedic collections. This comes at a time when the world is increasingly divided along ideological, political, and cultural lines and thus challenges the very principles on which the encyclopedic museum, as an Enlightenment museum, were founded: that encyclopedic museum collections should be built to broaden and deepen our understanding of the world's cultures in all their differences, similarities, and interrelatedness.

Neil MacGregor explores the potential for the modern encyclopedic museum to fulfill the ambitions of its Enlightenment foundation: by using its collections to encourage people to rethink conventional hierarchies of power and importance and to challenge people to consider the historical and current realities of the world's diverse, complicated, and interrelated cultures. Philippe de Montebello argues that museums should acquire antiquities, even and perhaps especially unprovenanced antiquities, for the contributions they can make to the preservation and further study of our common, ancient past. He notes how such antiquities have been important even to archaeological research, leading archaeologists to sites they may otherwise have missed. He also considers the current constraints on museums wishing to acquire antiquities, and distinguishes between the constraints accepted by European museums and those accepted by U.S. museums. And Kwame Anthony Appiah discusses the implications of the current regime of international regulations on our understanding of our cosmopolitan identity of ourselves as human beings rather than as particular, narrowly defined nationals. He also considers the use and abuse of antiquities as cultural property claimed by national governments.

To Shape the Citizens of "That Great City, the World"

Neil MacGregor

T HE IDEA OF THE WORLD UNDER ONE ROOF, as in the encyclopedic museum, was one of the great possibilities of the eighteenth century and the great intellectual challenge to people who wanted to think differently about the world. The British Museum was established very specifically for everybody, for the whole world. Its founders had no doubt what its purpose was. It was established on the proposition that through the study of things gathered together from all over the world, truth would emerge. And not one perpetual truth, but truth as a living, changing thing, constantly remade as hierarchies are subverted, new information comes, and new understandings of societies emerge. Such emerging truth, it was believed, would result in greater tolerance of others and of difference itself.

In this view, the British Museum's collection was a means to knowledge, a path to a better understanding of the world, and a way of creating a new kind of citizen for the world. It is important to insist that the notion of "citizen" in this case was never a national one. The museum was only called the British Museum because it was not the king's museum; it belonged in a very real sense to the people, to citizens. Sir Hans Sloane—the donor of the museum's founding collection—first offered his collection to the British government. But he stipulated that if they wouldn't take it, it was to be offered to the Royal Academies of St. Petersburg, Paris, Berlin, and then Madrid, in that order. Whichever nation was able to meet two

conditions—that the collection would always be together for study and that it would always be open, free to anybody to visit—would be able to keep the collection. It so happened that Britain met these conditions and the collection is now in London, but it could just as easily have been in one of the other four great, international cities.

It is true Sloane wanted his collection first in London, but only because at the time London was the most cosmopolitan and biggest city in all of Europe. It was presumed that more—and more different—people could visit it in London than anywhere else. And that was most important to Sloane. He gave his collection for a purpose, more than to a place. The place was important only insofar as it advanced the purpose for which Sloane gathered and gave his collection of wonderful things. He wanted the museum to be where it would best be used by a large number of people, international people as much as possible. For in his mind, Sloane was a citizen not of just one country, but as Diderot says in his notable letter to Hume, a citizen of "that great city, the world." In the words of the first director, the British Museum was for the use of "learned and studious men [that meant women as well, of course] as well as natives and foreigners." And if you want a demonstration that this is a preimperial museum, it's important to point out that in this context, the "natives" in question here were natives of Britain.

It is also important to point out that the duties of the trustees of the museum were to hold its collection in trust for everybody: strangers as well as subjects of the king. It was a universal museum aimed at a universal audience, for the use of the whole world, based on the belief that its diverse collections would let us—its visitors—understand the world now, and not just its history. It is important to insist on this. The aim of the museum was an understanding of the world as it is today. The museum was to be a civic space in which a discussion could take place and in which we could understand a little better the world and our place in it.

Of course, the museum was to have objects of the familiar sort of classical antiquity, but not simply as familiar things—Grand Tour souvenirs— but for the purpose of sorting out the nature of these objects, their value was as evidence. It was important, for example, to discover that the so-called Piranesi Vase was only 20 percent Roman, the rest was entirely

Fig. 1.1. The Piranesi Vase, 2nd century AD. Italy. Marble, eighteenth century, incorporating Roman fragments (h. 9 ft.). The British Museum. © The Trustees of the British Museum.

eighteenth-century fabrication (fig. 1.1), and that the great Dr. Woodward's shield (fig. 1.2), thought to have been made by the Romans to celebrate their victory over the Gauls, was in fact made in Renaissance France. These things were in the museum—indeed the very purpose of the collection—as evidence of truth.

Fig. 1.2. Dr. Woodward's Shield, ca. 1540–50. France. Embossed iron (d. 14 in). The British Museum, bequeathed by Dr. John Wilkinson, 1818. © The Trustees of the British Museum.

The great achievement, I think, of the Enlightenment museum, the encyclopedic museum like the British Museum, was the notion that the context of the museum would allow truths to emerge that could not emerge if the objects were studied only in the context of objects like them; that is, among only objects from the same culture. It was of course important to study Greek and Roman things on their own terms and in terms of Greek and Roman culture, but it was also important to study them in the context of objects from China, for example, where evident, sophisticated notions of moral virtue make it clear that other highly sophisticated cultures

were as worthy of study and admiration as the more familiar cultures of
Greece and Rome. And not just other ancient cultures, but also newer
cultures, like that of Japan. If we want to understand how we think about
God and worship, the museum held, we need to think about how the
Japanese think about the same.

It was also essential from the beginning that the new, growing world
should be part of the changing context of the museum, its collection, and
their presentation. The museum had, by 1774, for example, the first Maori
object ever seen by Europeans, given to Captain Cook as a charm to bring
long life. Such objects were meant to demonstrate again that all societies
think and behave, effectively, in the same way. It is this, I think, that is
surely the great point of the founding of the British Museum as an ency-
clopedic museum. Its collections were seen to generate truths that insist
on the oneness of the world just as the world itself was beginning to real-
ize that it was irrevocably and irretrievably, interconnected. As Diderot, in
his introduction to the seventh volume of the *Encyclopédie* in the mid-1760s,
wrote about the endeavor to gather universal knowledge, it would be so
that our fellow men could be brought to love and tolerate one another and
recognize the superiority of a universal morality over a particular one.

That's what the context of the universal museum was meant to do.
And the notion of trustees and *trusteeship* was, I think, central to it. It is
worth focusing on this astonishing achievement of English and American
law: the notion of trusteeship, quite unknown in continental Europe, that
brings with it the notion of an obligation to hold the object for the benefit
of others, the whole world, natives as well as foreign, those living now and
not yet born. If today we talk about holding these objects in trust for all of
humanity, we are using the rhetoric of the eighteenth century. It is an En-
lightenment concept and term of law that gives rights to the beneficiaries—
the whole world—and gives obligations to the trustees, who work on behalf
of the world and its peoples.

What does this mean now? How can we now provide a context for
these collections that lets the objects speak about the oneness of the world
as we know it today? How can we subvert the habits of thought that keep us
from seeing other cultures except in categories of superiority and differ-
ence? What of the wonderful hand axes, the butchering tools, discovered

by Professor Leakey in the late 1920s in Tanzania in Olduvai Gorge? They are very beautiful things, wonderfully shaped and balanced, like works of art. And by the stratigraphy of the Great Rift Valley where they were found, Leakey was able to establish that they must be at least one-and-a-half to two million years old. This changed our whole understanding of the history of human making. It put the beginnings of that history—of civilization itself—firmly in Africa for the first time and demonstrated very clearly the idea of the oneness of humanity. Over subsequent millennia, objects like these—butchering tools—made their way out of Africa until they allowed our ancestors to butcher better and get that crucial protein advantage over other peoples. This let us conquer the world and build great cities like London, where visitors to the British Museum first saw, were first able to see, the truth of and connection to the origin of their culture, the world's culture of human making. This evidence thus revealed that humanity is one, that it all comes from Africa, and that our recent success is dependent on the much earlier successes of our African ancestors.

We in the British Museum have been very eager to lend these objects and objects like them to museums around the world. Earlier this year, they were in San Francisco at the Museum of the African Diaspora as a wonderful demonstration of a different African diaspora. At the moment, they are in Beijing as the starting point of an exhibition devoted to the history of world civilizations. And this illustrates something about the different roles a museum like the British Museum can play in the dialogue between Africa and the world. In the same week as the exhibition opened, the United Nations was debating whether or not to condemn the Sudanese government for genocide in Darfur. This raised a very different kind of issue for our museum. How could we present the larger story of Sudan when the whole world is thinking of only one aspect of that long story: the current political situation? There was huge public interest at the time in finding out more about Sudan, and of course huge interest among the very large Sudanese diaspora in Britain. We worked with the Sudanese diaspora groups to insure that large numbers of them could visit from outside London. And we organized debates, public debates, around key objects from Sudan in the British Museum's collection that put the

Fig. 1.3. Lyre, late 19th century. Sudan. Wood, skin, glass beads, shells, coins, gut, and iron (h. 39 3/4 in., w. 37 2/5 in., d. 7 4/5 in.). Donated to the British Museum in 1917 by Dr. Southgate. © The Trustees of the British Museum.

events of Darfur and the issues confronting Sudan today into a different and wider context.

At the center of one of the debates organized by the *Guardian* newspaper was this astonishing object (fig. 1.3). It is a lyre that was once used in ceremonies to banish depression and evil spirits and restore the listener, the patient, to full mental health. It was in such a ceremony that

David played his harp before Saul to banish his dark spirits: a tradition that goes unbroken to Mesopotamia of the third millennium BC and thus links the culture of Sudan to the ancient cultures with which, perhaps, our regular, modern visitors were more familiar. In Sudan, this lyre, or harp, gathered around 1900, shows an extraordinary phenomenon: it was made just north of Khartoum and what you see along the top bars are the thanks offerings, the gifts of the people who in the modern era used this essentially pagan, long pre-Christian, long pre-Islamic device of music to charm the evil spirits, and decorated their modern version of it with modern gifts: traditional African talismans, Koranic texts as amulets, rosaries, coinage from Egypt and Yemen as well as from Indonesia, and a large number of ha'pennies with Queen Victoria on them. What this object says is that in Sudan, at a particular moment, all these different communities— Christian, Islamic, traditional religious communities—from Sudan as well as from abroad once lived together in harmony and in peace, and in the modern era drew still upon practices and devices of ancient times. The debate among the Sudanese at our exhibition was whether a device like this—this emblem from their past—could still be meaningful for the Sudanese today? Could it actually represent the Sudan we and they would want to see in the future? This is one of the roles objects play in museums: they offer ways of changing the debate about the contemporary world through old, even ancient, objects, often seen in unexpected juxtaposition.

In the British Museum there is this terrifying head of Augustus (fig. 1.4); a slightly over life-sized head of the emperor, which was originally put up on the southern frontier of Roman Egypt to mark Roman dominion over the edge of the empire. We wanted, among other things in the public discussion of Sudan, to banish the notion that Sudan had always been in the shadow of Egypt, had always been, if you like, a victim nation. We wanted to remind everybody, and not least the Sudanese diaspora themselves, that the Sudanese, the Kushites, were the people who had invaded Egypt under the pharaohs and conquered the Romans and captured the statue of Augustus. The emperor's image was ritually decapitated and the head carried back to the Kushite capitol, Meroë. There it was buried under the steps of the temple of the king, so that every time he went into the temple he would tread on the head of the defeated Roman emperor.

Fig. 1.4. Head of Augustus. Roman, ca. 27–25 BC, found in Sudan. Bronze (h. 19 in.).
The British Museum. © The Trustees of the British Museum.

It was this act of ritual humiliation that of course preserved the object. Had it stayed intact in Egypt, it would have been melted down and we would never know it today.

In the context of the museum, there is the possibility of allowing people—all of us—to think and to imagine different histories from those

with which we were raised. The Sudanese exhibition was addressing all of us, in one way or another. It allowed the Sudanese diaspora to reappropriate their own history, their own culture, in a way that I think is impossible to do in Sudan. And it made the rest of us want to learn more about Sudan, its people and culture, and their relations with the world, with us and us with them, in very profound ways our many interrelated cultures.

Shortly after the Sudan exhibition, the museum of Mozambique approached us and asked if we would be willing to show an object from Mozambique to the people of Britain, in part because Mozambique had become recently a member of the British Commonwealth. There is a small Mozambique population in London and what they wanted us to show was this, an object that the British Museum acquired in 2002 and which is the result of one of the most extraordinary developments of contemporary Africa (fig. 1.5). At the end of the civil war in Mozambique, which like every other civil war in Africa was murderous and prolonged, the Anglican Bishop of South Mozambique set up a program of swords into plowshares, asking villagers to hand in weapons and in return they would be given tools. He had this brilliant idea that it wasn't enough just to take the guns out of circulation but that they must be visibly out of circulation. And so he commissioned sculptors to create this object and objects like it.

This is a throne of weapons. It is a part of a tradition in Africa of using the weapons of your defeated foe as a celebration of your victory. We bought it for the museum and brought it into our encyclopedic collection. We agreed that it was a very valuable document of African history and we wanted to show it in an enormous range of places around the United Kingdom as a focus of the current debate about Africa. We were confident we would again show the truth of that eighteenth-century idea that if you think about other cultures, what you really discover is yourself. And so the throne became a very remarkable focus for discussions everywhere we showed it. At first people asked, where did the looted guns come from? And since I can tell you with confidence that every gun was made in a European or an American factory, the first point of discussion was the fact that Mozambique could not have had a civil war without the rest of the world helping, as it were, by providing the weapons of war. And as

Fig. 1.5. Throne of Weapons, 2001. Mozambique. Various metals (h. 39 3/4 in., w. 24 in.).
The British Museum. © The Trustees of the British Museum.

an object in the dialogue between Africa and the rest of the world, this point is as eloquent as it is distressing.

We toured the throne to the obvious places: schools for example, where there were enormously strong responses—children making their own drawings or making weapons out of farm instruments. We toured it to public spaces and civic areas, such as a shopping center in Newcastle. And everywhere around the exhibition we organized debates about gun violence, reconciliation, about arms trades, and in some places, very acute and very disturbing discussions took place. It went to Belfast on Good Friday, for example. The idea of Africa having found a way of showing decommissioned weapons, and celebrating decommissioning, was a complicated discussion in Belfast as you can imagine: a powerful one that inverted all of the normal assumptions about who can learn from whom. And on the 11th of November, Remembrance Sunday, it was in Coventry Cathedral, the cathedral that was destroyed by German bombing, and every 11th of November is the focus of a ceremony of reconciliation between Britain and Germany. There again it had profound resonance. And perhaps most powerfully of all, it was in Pentonville Prison, where the response of prisoners who had been put in prison for having guns was deeply impressive.

I think this is exactly what our Enlightenment founders believed: that objects speak truths, and objects from other cultures tell us not only about distant peoples but about ourselves too, about our souls. In the Capital Museum at Beijing, we currently have an exhibition of two hundred objects that show the history of humanity, of cultures, outside China. It is an extraordinary thing for China to want to see these objects because while China has great museums it has no universal or encyclopedic museums. We showed objects from all of the great civilizations you would expect, beginning in Africa and including ancient Egypt, Greece, Rome, and more: this wonderful relief from Assyria, for example, one of the royal lion hunts showing this most powerful animal being killed by a royal arrow—not only an extraordinary piece of animal depiction, but also a statement of how one society saw and emblematized royal power (fig. 1.6). And we showed the Lewis Chessman of the twelfth–thirteenth century made in Norway showing the king enthroned, about to draw the sword; a wonderful

Fig. 1.6. The Dying Lion, ca. 645 BC. Nineveh, Northern Iraq. Alabaster (h. 6 1/2 in., w. 11 3/4 in.). The British Museum. © The Trustees of the British Museum.

example of Medieval Northern European carving, but also part of a tradition of kingship, an emblem of royal power of a kind with the Assyrian relief (fig. 1.7).

And the great emblem of Benin: the Oba of Benin, the king of Benin, shown with his two pages behind him (fig. 1.8). This object is, I think, the key argument for objects being taken out of context and put into different kinds of museums. The circumstances of the acquisition were, as you all know, hideous. The king of Benin had taken the British legation hostage. A punitive expedition was sent. And it was very brutal. This and other plaques had been installed on the front of the Oba's palace but had been taken down before the British arrived. With the sacking of the Benin capital by the British, they were taken from the Oba and sold in Europe for the benefit of the British hostages and the soldiers. They are now in the museums of Britain and Berlin; the biggest collections of them are now in Britain, Germany, Vienna, Paris, and the United States. These objects, I think, did more than anything else to change European perceptions of Africa. Europeans could not believe that brass-working of this sophistication could be of African origin. It simply was not possible. Frobenius, for example, the Berlin mathematician, went to great lengths to argue that such

Fig. 1.7. The Lewis Chessman, ca. 1150–1200. Norway. Alabaster (h. 4 in.). The British Museum.
© The Trustees of the British Museum.

plaques were proof that Atlantis must indeed have been just off the west coast of Africa as Plato once proposed, since brass plaques of this sophistication could only have been made by Greeks. When it became clear that they were African, a whole set of stereotypes collapsed; a whole set of hierarchies disintegrated.

Which is why you need context!

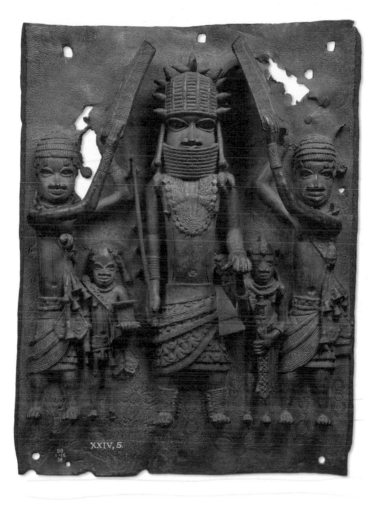

Fig. 1.8. Oba of Benin with Attendants, 16th century. Edo Peoples, Benin, Nigeria. Brass (h. 20 in., w. 14 1/2 in.). The British Museum. © The Trustees of the British Museum.

This is, I think, one of the great obligations of encyclopedic museums like the British Museum: to send exhibitions like this around the world, to allow the whole world to have access to a world's collection. There is at the moment, in Nairobi, an exhibition chosen from the British Museum, chosen entirely by the colleagues in the National Museum of

Kenya. It is called *Hazina*, meaning "fortune" or "wealth." Our colleagues in Kenya wanted to show how Kenya has for centuries been part of a network of cultural exchange in central Africa, toward the mouth of the Nile, toward Yemen and Oman, toward the Indian Ocean, and that these routes of exchange are far older than the Colonial interlude and indeed, survived it. We gave them free run of the museum's African collections. I think it is the first time that an exhibition has been organized by African colleagues from a European collection. What they chose to show were objects not from Kenya, but from all around Africa, from Somalia, Burundi, and the Kenya coast, objects from the southern Sudan and north Kenya, collected by slave traders from Khartoum coming into Kenya and Sudan from the north; and the whole Swahili, Islamic, Indian Ocean convention of games and music, which links Kenya with Madagascar, Mauritius, and the Gulf.

What this exhibition has done, in keeping with the founding principles of the British Museum, is to allow its collections to provoke people from one part of the world to think about the world itself. And it has done this because the museum holds its collections in trust "for natives as well as foreigners," and for all of time. This ideal must be an essential part of the discussion about context, about archaeology, about national laws as they pertain to museums' acquiring antiquities, as well as artifacts of a modern nation's cultural property. There are, I would argue, truths and insights that can be gathered only in this kind of context: the context of an encyclopedic museum. This ideal has nothing to do with national ownership, although inevitably it is aided by a past of national wealth and imperial power. That cannot be denied. But such wealth and powers is an inheritance that can—and should—very properly be put at the disposal of the whole world. And it is surely more important now than ever to insist that the world is one and that we who work in museums are doing something to shape the citizen of "that great city, the world."

This is the founding principle of the British Museum, *as an encyclopedic museum*, and the principle we seek to adhere to with everything we do, as we encourage confrontations with and discussions about our diverse collections and what they can tell us about themselves, about the past, and about us and our world today. This, I believe, is the great benefit, *and obligation*, of the encyclopedic museum, and something we need to encourage everywhere.

"And What Do You Propose Should Be Done with Those Objects?"

Philippe de Montebello

THE METROPOLITAN MUSEUM OF ART

I SHALL BEGIN BY QUOTING George F. Comfort of Syracuse University's College of Fine Arts, in a speech he gave in 1870, incidentally the year in which the Museum of Fine Arts in Boston and the Metropolitan were founded. It describes an encyclopedic museum.

> True art is cosmopolitan. It knows no country. It knows no age. Homer sang not for the Greeks alone but for all nations, and for all time. Beethoven is the musician not of the Germans alone but of all cultivated nations. And Raphael painted not for the Italians alone, but for all of whatever land or age, whose hearts are open to sympathy with the beautiful in art.

[handwritten marginal note: did you hear this from Him directly? I think not...]

An ideal museum must thus be cosmopolitan in its character and it must present the whole stream of our history and all nations and ages. A work of art serves as a link in the great aesthetic development of the human race. Much has happened in the world of museums since 1870, but I would not change a word of Professor Comfort's statement; nor has anything occurred in those years to cause us to think that the traditional mission of museums is no longer pertinent today.

A museum's mission is to acquire, conserve, display, and publish its collections. And with these goals is the museum's obligation to provide the broadest possible access to the works of art in its care, to encourage

their being studied and preserved for the benefit of current and future generations, and, through the display of works of ancient art, to continue to serve as an inspiration for young people who aspire perhaps to a profession in archaeology.

Access is a key word and concept when we speak of the value of museums. Works of art are vital pieces of history and the heritage of us all, and thus deserve as broad an audience as possible and need not be restricted only to the audiences of Europe and North America. They should be made available through well-thought-out programs of loans to all parts of the globe, and pointedly to those nations that do not happen to have the arts of other parts of the world.

In this respect, we should note that one of the first true encyclopedic collections was not in a Western capital at all, but in what was considered at the time to be in the East, in Constantinople (today's Istanbul) at the Topkapi Palace, where Sultan Mehmet II, the Ottoman conqueror of the Byzantine Empire, formed in the second half of the fifteenth century one of the greatest collections of Yuan and Ming porcelains; also great Persian manuscripts, even a number of Italian paintings, drawings, and prints. In the nineteenth century, the collections were further enriched in a global sense with Mesopotamian, Egyptian, Greek, and Roman antiquities, and a bit later when they were found in the twentieth century, with Hittite material. Like the British Museum, the Metropolitan Museum, the Louvre, and the State Hermitage Museum in St. Petersburg, the Topkapi is one of our great encyclopedic museums; and its origins date back some five hundred years, hundreds of years before the others.

The principle of presenting the art of all nations in all nations does not mean that existing encyclopedic collections should be dismembered and dispersed. The collections of the encyclopedic museums in the large Western capitals, as well as museums in Greece or in Italy or in Egypt—or indeed, Istanbul—are all rich and deep enough that a premium can begin to be placed on long-term loans and exchanges to achieve much wider access worldwide, than now exists. This is not to say that acquisition and ownership are things of the past. Museums are buildings with a physical reality and constraints, and the care of works of art is sometimes best achieved through stability. Installations call for vitrines, platforms, lighting,

labels, climate control, and so forth, and of course substantial resources. Museums cannot simply become turntables for incoming and outgoing loans. There is the need for predictability in what works of art may be available to staff in order to create intelligent presentations and well-planned educational programs. There are also gaps in all collections, which it is the role of the curator to try to fill in order to present a more complete and meaningful picture of a civilization, and opportunities will always present themselves, that if seized, will lift the level of quality of what is displayed. But still, a thoughtful program of loans between museums can be to the benefit of us all.

That said, it is nevertheless the collection that defines the museum: the better the collection is, the better the museum is and the better it is for all of us. Indeed, maintaining the integrity of collections is key to the value of museums. Thanks to their high concentration in both primary and study collections, works of art from many civilizations can be studied in depth and most importantly, in a cross-cultural, comparative context. In museums such as the British Museum and the Metropolitan Museum of Art, one can view, for example, classical works of the Augustan period and within a two to three minute walk, encounter contemporaneous objects produced under the distant Han Empire. This is a most rewarding collapsing of time and distance, and it can only occur in encyclopedic museums.

Likewise, it is in museums that there exists the flexibility and capability to recreate through different juxtapositions and accompanying explanations more than one context for works of art. It might even be argued, in some instances, that the museum can return an object to its original context, rather than to its "final" one, which is to say where it was most recently found. The case in point is the third millennium BC stele of Narâm-sîn, ruler of the Akkadian Empire in greater Mesopotamia, which is now in the Louvre Museum (fig. 2.1). In the twelfth century BC, Elamite rulers took the stele as booty from Sippar, which is north of Babylon in present-day Iraq and where it presumably had been seen and on view for hundreds of years. And then they brought it to their capital of Susa in modern-day Iran, which is where the French found it in 1898, and from there they removed it to the Louvre Museum. Today it is shown in the museum with

Fig. 2.1. Victory stele of Narâm-sîn. Akkadian Dynasty, reign of Narâm-sîn (2254–2218 BC). Susa, Iran; Sippar, Iraq. Morgan Excavations. Pink limestone (h. 78 in., w. 39 in.), Louvre Museum, Paris. RMN-les frères Chuzeville.

related material in the Mesopotamian galleries, which makes more sense—and is arguably more culturally accurate—than to have preserved it in a strictly political, Elamite context. It is shown with other examples of art from the culture in which it was made and where it was first put on display and for its original purpose. To have had it remain in Iran would have been a testament not to its origins—its original context—but to latter-day politics: to the context and culture of military conquest.

The ability to see and study works of art in museums is to be able to study the similarities among objects of the same culture as well as the differences among diverse cultures. One need not choose between these contexts. And as a result, one can better understand the uniqueness of each. This makes one wonder about the impassioned arguments put forth by some for keeping all ancient objects as near to their site of excavation as possible, for the purposes not only of satisfying local pride but also and mainly of keeping them in their archaeological context so that they are not condemned, as a prominent archaeologist sees it, to quote, "their sad life in a museum."

I must say, there does not seem to be any good scholarly reason—nor, as far as I can see, a public benefit—for excavated objects to be the exclusive preserve of one discipline: of archaeology or another, single discipline. As for the notion that it is best to keep antiquities in their archaeological context, it seems of dubious merit for several reasons. It is the case, after all, that objects from a particular excavation, once out of the ground—even when stored in the local museum when there is one—are already out of their archaeological context. Their primary value to the archaeologist—their historical record—is already noted and one hopes, promptly published.

When scholars try, with the aid of forensics, to assign alienated objects to a putative site, it can be even more problematic. This is the case with the Metropolitan's disputed Hellenistic silver, allegedly made in Morgantina. This theory has yet to gain full acceptance. One has to be absolutely sure before making a specific claim in such matters. After all, one is writing history: a form of scientific inquiry. And to me, this is the strongest argument for redoubling all efforts to preserve archaeological sites: we want to know, with certainty, the precise, archaeological context of

major objects of antiquity. But when the context has not been preserved, for a variety of reasons—due to chance finds or construction projects, natural disasters, or unfortunately the looting of sites—it is difficult, indeed rarely possible, to assign antiquities to specific sites with any confidence. One can only, at best, suggest a possible site, which of course pales against the supposed benefit of keeping the antiquity there: it is almost always only a presumed, possible site and not the confirmed site or "original" context.

As important as it may be, the archaeological context is only one of several contexts. It happens of course to have been the last context in the life of an object before it enters a private or public collection. To insist that it is the only context that really counts, which is what is meant when it is repeatedly asserted that an object without provenance has no meaning, is to invite examination of our ancient past through a rather narrow lens and one that does not put much of a premium on the aesthetic dimension of objects, which is hardly the least dimension of their merit.

It is indifference to the object on the part of some archaeologists—indifference to the object as opposed to the information it yields at its site of excavation—that provides one explanation for the incomprehensible restrictions placed on publications of such objects. We are talking, after all, of a *humanistic* discipline. And the categorical interdictions proposed or imposed on the acquisition of these objects, no matter their beauty and importance, compromises the potential benefit of the disciplinary inquiry. Allowing greater flexibility, greater mobility, and accessibility for excavated and unexcavated antiquities is not only possible but also desirable. We have to remember that many antiquities found in the ground were, after all, mobile in their lifetime: traded, sold, carried vast distances along caravans throughout Asia, around the Mediterranean, and in Africa. And there has always been a correlation between the movement of objects and the growth and transmission of knowledge. And this argues for the mobility of excavated objects, in breach of no laws and resulting in much greater access for far more people; it promises the prospect of new and more broadly shared knowledge, which is in keeping with the principles of the humanistic discipline of which museums are part.

Furthermore, the insistence for keeping objects at their excavation sites is contrary to the principle of encouraging broad access to works of art since most archaeological sites are, by dint of historical circumstance, in remote locations. Let me give you an example, a rather dispiriting one at that. As you well know, the Metropolitan Museum of Art returned to Turkey in 1993 a group of spectacular West Anatolian objects of precious metals: the so-called Lydian Treasure dating back to the sixth century BC. After considerable research, it was determined that it had been illegally removed from a site in or near Uşak in the 1960s. Because pieces of the Treasure have reportedly been recently stolen from the Uşak Museum, press attention has focused on the museum, its professionalism and visitation. An April 20, 2006 article in the Turkish press quotes the chief officer of the Uşak culture and tourism department as stating, and I quote, that "in the past five years, 769 people visited the museum in total."

So you LOAN IT OUT

But it is possible, if there is the will, to share archaeological material with distant museums for greater accessibility. Indeed, the recent exchanges proposed for the Metropolitan Museum's return to Italy of a Laconian kylix and the Euphronios krater are not simply for single objects "of equivalent beauty and importance." For each of these antiquities, the Italian government has offered instead of one equivalent piece, a fine excavated vase accompanied by the complete contents of its tomb group, more than fifty pieces in one case, including a number of other decorated and some undercoated vessels. And in the other case, the Italian government has offered the loan of some thirty antiquities. Many are modest in artistic terms, but when displayed as a group with appropriate text labels, they will serve to instruct our public about the nature of archaeological excavations. I think this is a most imaginative and compelling way to share archaeological material broadly, for which I am very grateful to my Italian colleagues. It was their initiative.

But elsewhere in our museum we have long presented objects from excavations, excavations organized and directed by members of the museum's staff. Notably in our Egyptian galleries and our Islamic galleries. In the latter, there will be, as once there was before the current renovation of

Fig. 2.2. Archaeological finds from Nishapur, Iran, excavated in the 1930s and 1940s, as exhibited in the Raymond and Beverly Sackler Gallery for Assyrian Art, April 2008. The Metropolitan Museum of Art. Image © The Metropolitan Museum of Art.

Fig. 2.3. Plaque with Griffins, 8th–7th century BC. Mesopotamia, Nimrud (ancient Kalhu). Ivory (h. 4 1/8 in., w. 4 5/8 in.). The Metropolitan Museum of Art, Rogers Fund, 1961 (61.197.1). Image © The Metropolitan Museum of Art.

the galleries, archaeological finds from Nishapur, Iran, excavated in the 1930s and 1940s and displayed as a group together (fig. 2.2). We also display, as a group, the Nimrud ivories excavated by the Metropolitan (fig. 2.3), along with our colleagues from the British Museum, and shared through the practice of partage with the museum in Baghdad. Tragically, most of these ivories have almost certainly been irretrievably damaged in Baghdad by poor storage conditions and their inaccessibility, which prevented their being removed and saved in time during the chaos that ensued after the coalition forces invaded Iraq in 2003.

Now although partage with transfer of title is no longer an option, in most source countries at least (there are a few that do), little notice has been paid to a farsighted clause in our agreement with Italy governing future excavations. Namely, were the Metropolitan Museum to collaborate with Italy on archaeological excavations, which is a distinct possibility, the finds, if they are significant, would be sent to the Metropolitan for conservation and then displayed as long-term loans in the museum's galleries. This is a new and welcome version of partage without transfer of title: a creative solution to the matter of accessibility, and one that will permit the objects to be studied initially in the archaeological context and then through the installation in the Metropolitan's encyclopedic collections, in a broader cross-cultural context.

Let me conclude with the subject of collecting antiquities. I want to try to inject some perspective on an issue that has deeply polarized the fields of archaeology and museum work and led to the most senseless and useless palavers among us. Where instead we should be united in a common cause, in a civil discourse in search of ways to try and stem the looting of archaeological sites and in the process act in concert to preserve our artistic and cultural heritage and ultimately to make it widely accessible to a very broad public, we are senselessly opposed to each other.

To this end, it will be essential to defuse the stridency of the rhetoric that has poisoned the atmosphere. And the best way to do so is to begin talking *with* and not *at* each other. I hope that some basic views, some profoundly held beliefs on both sides, may be reconciled in a calm and measured colloquy. (Of course, our positions may turn out not to be so divergent, after all.)

It will also be important to debunk at the start the exaggerated and often fanciful claims that have been and continue to be made, such as the claims that the trade in unprovenanced antiquities amounts to some multi-billions of U.S. dollars. Every serious survey of the art market and museum acquisitions points to a figure closer to $100 million to $150 million a year for all antiquities, provenanced and unprovenanced, which is a fraction of those billions.

Then there is the claim that if an object has an incomplete provenance, it must surely be looted. In far too many instances, that is probably

the case. But there are also chance finds, there are flash floods and earth-
quakes, building projects as I've said, and yes, lots of old collections. It is
not always easy to identify their full provenance, which incidentally is a
phenomenon that is not unique to antiquities. Very few Old Masters paint-
ings and sculptures in our collections—those dating from the Renaissance
through the baroque periods, just a few hundred years ago—can be traced
all the way back to their makers.

Finally, the contention that without knowledge of its find spot or
specific, archaeological context, an antiquity is meaningless, or as my Ital-
ian colleagues at the Ministry of Culture put it—they were describing the
Euphonios krater—"without its tomb group, an antiquity is a *cosa morta*."
Few, I expect who have marveled at the scale and majesty of the Euphronios
krater and the precision and elegance of line and its poignant depiction of
a Homeric epic of the death of Sarpedon would concede that it is a *cosa
morta* (fig. 2.4). Although having not been properly excavated, it is far
from meaningless. I should point out that it is signed by both the painter
and the potter and that most of the figures are clearly identified by name
on the vase, and that this is information independent of any knowledge
the tomb itself would have yielded, though it would have been clearly pref-
erable to know the totality of the krater's original, found context. This I do
not contest.

All great works of art have, in addition to their historical and other
learned contexts, an aesthetic context as well. As I've said earlier, this is
not the least important. Which is why an appreciation of the aesthetic
quality of works of art is at the heart of the museum's approach to its
collections, and, I daresay, most likely also to be the primary and most
exalted feature in the confrontation of the visitor with the work of art.

Yet museums also have pioneered much scholarship in ancillary
disciplines such as epigraphy, which I mention in order to remind us that
the study of cylinder seals and cuneiform tablets would not exist were it
not for the availability of thousands of unprovenanced antiquities pre-
served, for the most part, in our museums. Furthermore, in many areas, a
critical mass of excavated objects exists to allow for informed conjecture
about many pieces whose origins are not known. That is because the
pieces have intrinsic value and are not meaningless. And, for the life of me,

Fig. 2.4. Terra-cotta calyx-krater (bowl for mixing wine and water), ca. 515 BC; Archaic. Signed by Euxitheos, as potter; signed by Euphronios, as painter (h. 18 in., d. 21 3/4 in.). The Metropolitan Museum of Art, lent by the Republic of Italy (L.2006.10). Image © The Metropolitan Museum of Art.

I cannot see any reason why to acknowledge the deeper meaning of works of art, even beyond what is learned from its archaeological find spot, is such anathema. It is as if holding that view, acknowledging that fact, were somehow to condone or even encourage the looting of archaeological sites. *L'un n'empêche pas l'autre.* One can study unprovenanced objects and at the same time deplore the looting of archaeological sites, and forcefully assert that crucial information about such objects, let alone about history, has been lost in the process of looting and that we are the poorer for it.

One among many examples of this is the Ghandaran ivory that is now in the museum in Pompeii. It was found in one of the city's villas and

attests to the distances such objects have traveled in antiquity. Had this Ghandaran ivory, which most likely came to Pompeii from what is now Afghanistan, simply come up on market, everyone would instantly have presumed that it came straight out of Afghanistan or Pakistan and not ever that it could have been found in southern Italy.

which is why context is essential!

What we in museums find so inexplicable and objectionable in the discourse against museums is the dismissal of the object, as such, the innocent, yet intrinsically valuable object. I've already said, and don't mind repeating, that to acknowledge the possible value to knowledge of an object's internal evidence does not mean that one condones the practice of looting sites. And I actually know archaeologists who refuse to even look at such an object. Can one really trust the scholarship of those who allow politics and ideology to trump their intellectual curiosity like that? It seems to me that one keeps one's opprobrium for the looter or the circumstances of the event, but not for the looted object itself. To turn away from it in moral indignation is foolish, and in the end can lead to the suppression of knowledge.

Let me cite but one example of the potential value of unprovenanced objects, the case of these strikingly realistic third millennium copper alloy lion foundation figures from Mesopotamia that were purchased on the art market in 1948 by the Louvre and the Metropolitan, fortunately (fig. 2.5). *O tempora o mores*. It would be hard to dismiss these lions as meaningless, since their inscriptions provided the earliest evidence that the city of Urkesh known in later mythological texts as the home of the chief Hurrian deity, Nergal, god of the underworld, had in fact existed, and as an important Hurrian center; even the name of the Hurrian ruler, Tishatal, is provided on the inscription.

The lions, though, in and of themselves did not provide the clue for where the ancient city of Urkesh might be found. And here the tale has its ironic side. We all want to drive out the black market in looted antiquities. But it will take time and an international well-coordinated effort to do this, if it's at all possible. For now though, what we have achieved through strict purchasing guidelines, international conventions, and the courts' criminal actions, is to drive the market for unprovenanced antiquities underground, with the result that valuable provenance information that

Fig. 2.5. Foundation peg in the shape of the forepart of a lion, Akkadian, Tish-atal of Urkish, 2200–2100 BC. Syria, probably Tell Mozan (ancient Urkish) (h. 4 1/2 in.). The Metropolitan Museum of Art. Purchase, Joseph Pulitzer Bequest, 1948 (48.180). Image © The Metropolitan Museum of Art.

was once available in a more permissive environment is now carefully suppressed by the vendors. And I make this point not to condone such traffic; it's just an observation.

So what led archaeologists to Tel Mozan, where they found the remains of the ancient city of Urkesh? *The knowledge that the lions were said by the vendor who sold them to have been purchased in a nearby town*. This led to a consideration of one site, which, however, since the mound associated with it was not large enough to contain ancient Urkesh, led Professor Giorgio Bucellatti and his team to another site, at Tel Mozan, where they excavated and found Urkesh. And all thanks to the information provided by the vendor of the unprovenenced and unexcavated Hurrian foundation figures.

The past is the past. *Autres temps, autres moeurs*. But what about the present? Today governments are, in fact have for some time, moved rapidly to restrict purchases of antiquities found on their soil. The United Kingdom, Germany, and U.S. museum organizations have all issued guidelines for their member museums. The U.K. and German museums now require for any purchase, with the exception of minor objects in the United Kingdom, provenance that goes back to 1970, the date of the UNESCO Convention. Our association in the United States (Association of Art Museum Directors, or AAMD) previously used a prohibition for acquisition by purchase or gift of any antiquity that cannot be shown to have been out of its country of origin for at least ten years with no exception. We now accept 1970 as a way to help insure that no material incentive is provided to potential looters. The AAMD guidelines allow for the possibility of considering the acquisition of truly exceptional antiquities, if it is thought that by rejecting them the loss to humanity's cultural heritage is likely greater than the fiduciary risk taken by the institution—but still applying the 1970 rule.

It might be of interest to know that the idea behind sanctioning the acquisition of truly magisterial works of art, even of unprovenanced antiquities, actually had been expressed some years ago by the most hawkish anticollecting body, namely the International Council of Museums (ICOM), which includes in its code of professional ethics the following: "in exceptional cases, items without provenance may have such an inherently outstanding contribution to make to knowledge, that it would be in the public interest to preserve them."

Now in making the case for the continuing acquisition according to AAMD guidelines and of course entirely within the law, I must reiterate that museums do not hoard. The objects they buy, they conserve, put on display, promptly publish, and illustrate both in print and electronic media for greatest possible access, and thus bring into the public domain. This way potentially suspicious objects can be more easily found by a potential claimant nation than if they were not acquired by museums but remained, instead, in private circulation. And as recent events at the Metropolitan Museum have shown, serious claims will be dealt with responsibly.

It must be said that these above-mentioned national guidelines have been extremely effective. We now see a markedly diminished supply of antiquities for sale. And as a result, acquisitions today by museums in Europe and North America are but a fraction of what they once were. On a global scale, now, quite simply, acquisitions of antiquities by these museums are inconsequential quantitatively, representing as they do only a tiny fraction of the estimated global market in antiquities, even if one uses the lowest of the numbers cited.

Frankly, the refusal to acquire an important antiquity merely because its provenance cannot be traced beyond, say, an auction in mid-1970 benefits no one. It will remain unknown, unpublished, inaccessible, and most likely will be driven underground and not, I'm afraid through some stroke of providential luck, back *into the ground* out of which it might have come.

So to those who say, do not buy unprovenanced antiquities, no matter how unique, brilliantly conceived, and masterfully crafted they may be, I would ask, as I have done repeatedly, "And what do you propose should be done with those objects?"

Of course it is to be deplored that works of ancient art are removed clandestinely from their sites. Much knowledge is lost as a result. But we should not compound that loss by helping the works of art disappear. It would be a violation of our raison d'être and an incalculable loss for scholars, the public, and history itself. And it would contradict the very purpose of museums, the purpose museums have avidly and admirably pursued for more than two hundred years. And that would be a tragedy.

Whose Culture Is It?

Kwame Anthony Appiah

PRINCETON UNIVERSITY

1.

"There is no document of Civilization," Walter Benjamin maintained, in his most often-quoted line, "that is not at the same time a document of barbarism." He was writing—some sixty-five years ago—with particular reference to the spoils of *victory* carried in a triumphal procession: "They are called cultural treasures," he said, but they had origins he could not "contemplate without horror."

Benjamin's provocation has now become a commonplace. These days, museum curators have grown uneasily self-conscious about the origins of such cultural treasures, especially those that are archaeological in nature or that come from the global south. A former curator of the Getty Museum is now on trial in Rome, charged with illegally removing objects from Italy, while Italian authorities are negotiating about the status of other objects from both the Getty and the Metropolitan Museum. Greece is formally suing the Getty for the recovery of four objects. The government of Peru has recently demanded that Yale University return five thousand artifacts that were taken from Machu Picchu in the early 1900s—and all these developments are just from the past several months. The great international collectors and curators, once celebrated for their perceptiveness and perseverance, are now regularly deplored as traffickers in, or receivers of, stolen goods. Our encyclopedic museums, once seen as redoubts of cultural appreciation, are now suspected strong-rooms of plunder and pillage.

And the history of plunder—the barbarism beneath the civility—is often real enough, as I'm reminded whenever I visit my hometown in the

Asante region of Ghana. In the nineteenth century, the kings of Asante—like kings everywhere—enhanced their glory by gathering objects from all around their kingdom and around the world. When the British general Sir Garnet Wolseley traveled to West Africa and destroyed the Asante capital, Kumasi, in a "punitive expedition" in 1874, he authorized the looting of the palace of King Kofi Karikari, which included an extraordinary treasury of art and artifacts. A couple of decades later, Major Robert Stephenson Smyth Baden-Powell (yes, the founder of the Boy Scouts) was dispatched once more to Kumasi, this time to demand that the new king, Prempeh, submit to British rule. Baden-Powell described this mission in his book, *The Downfall of Prempeh: A Diary of Life with the Native Levy in Ashanti, 1895–96.*

Once the King and his Queen Mother had made their submission, the British troops entered the palace, and, as Baden-Powell put it, "the work of collecting valuables and property was proceeded with." He continued:

> There could be no more interesting, no more tempting work than this. To poke about in a barbarian king's palace, whose wealth has been reported very great, was enough to make it so. Perhaps one of the most striking features about it was that the work of collecting the treasures was entrusted to a company of British soldiers, and that it was done most honestly and well, without a single case of looting. Here was a man with an armful of gold-hilted swords, there was one with a box full of gold trinkets and rings, another with a spirit-case full of bottles of brandy, yet in no instance was there any attempt at looting.

Baden-Powell clearly believed that the inventorying and removal of these treasures under the orders of a British officer was a legitimate transfer of property. It wasn't looting; it was collecting.

The scandals in Africa did not cease with the end of European empires. Mali can pass a law against digging up and exporting the wonderful sculpture made in the old city of Djenne-jeno. But it can't enforce the law. And it certainly can't afford to fund thousands of archaeological digs. The result is that many fine Djenne-jeno terra-cottas were dug up anyway in

the 1980s, after the discoveries of the archaeologists Roderick and Susan Mcintosh and their team were published. The terra-cottas were sold to collectors in Europe and North America who rightly admired them. Because they were removed from archaeological sites illegally, much of what we would most like to know about this culture—much that we could have found out had the sites been preserved by careful archaeology—may now never be known.

Once the governments of the United States and Mali, guided by archaeologists, created laws specifically aimed at stopping the smuggling of stolen art, the open market for Djenne-jeno sculpture largely ceased. But people have estimated that in the meantime, perhaps a thousand pieces—some of them now valued at hundreds of thousands of dollars—left Mali illegally. In view of these enormously high prices, you can see why so many Malians were willing to help export their "national heritage."

Modern thefts have not, of course, been limited to the pillaging of archaeological sites. Hundreds of millions of dollars worth of art has been stolen from the museums of Nigeria alone, almost always with the complicity of insiders. And Ekpo Eyo, who once headed the National Museum of Nigeria, has rightly pointed out that dealers in New York and London have been less than eager to assist in their retrieval. Since many of these collections were well known to experts on Nigerian art, it shouldn't have taken the dealers long to recognize what was going on.

In these circumstances—and with this history—it has been natural to protest against the pillaging of "cultural patrimony."[1] Through a number of declarations from UNESCO and other international bodies, a doctrine has evolved concerning the ownership of many forms of cultural property. In the simplest terms, it is that cultural property should be regarded as the property of its culture. If you belong to that culture, such work is, in the suggestive shorthand, your cultural patrimony. If not, not.

Part of what makes the phrase "cultural patrimony" so powerful, I suspect, is that it conflates, in confusing ways, the two primary uses of that confusing word "culture." On the one hand, cultural patrimony refers to cultural artifacts: works of art, religious relics, manuscripts, crafts, musical instruments, and the like. Here "culture" is whatever people make and invest with significance through their creative work. Since significance

is something produced through conventions, which are never individual and rarely universal, interpreting culture in this sense requires some knowledge of its social and historical context.

On the other hand, "cultural patrimony" refers to the products of a culture: the group from whose conventions the object derives its significance. Here the objects are understood to belong to a particular group, heirs to a transhistorical identity. The cultural patrimony of Nigeria, then, is not just Nigeria's contribution to human culture—its contribution, as the French might say, to a civilization of the universal. Rather, it comprises all the artifacts produced by Nigerians, conceived of as a historically persisting people, and while the rest of us may admire Nigeria's patrimony, it belongs, in the end, to them.

But what does it mean, exactly, for something to belong to a people? Most of Nigeria's cultural patrimony was produced before the modern Nigerian state existed. We don't know whether the terra-cotta Nok sculptures, made sometime between about 800 BC and AD 200, were commissioned by kings or commoners; we don't know whether the people who made them and the people who paid for them thought of them as belonging to the kingdom, to a man, to a lineage, or to the gods. One thing we know for sure, however, is they didn't make them for Nigeria.

Indeed, a great deal of what people wish to protect as "cultural patrimony" was made before the modern system of nations came into being, by members of societies that no longer exist. People die when their bodies die. Cultures, by contrast, can die without physical extinction. So there's no reason to think that the Nok have no descendants. But if Nok civilization came to an end and its people became something else, why should they have a special claim on those objects, buried in the forest and forgotten for so long? And even if they do have a special claim, what has that got to do with Nigeria, where, let us suppose, most of those descendants now live?

Perhaps the matter of biological descent is a distraction: proponents of the patrimony argument would surely be undeterred if it turned out that the Nok sculptures were made by eunuchs. They could reply that the Nok sculptures were found on the territory of Nigeria. And it is, indeed, a perfectly reasonable property rule that where something of value is dug up and nobody can establish an existing claim on it, the government gets

to decide what to do with it. It's an equally sensible idea that, when an object is of cultural value, the government has a special obligation to pre-serve it. The Nigerian government will therefore naturally try to preserve such objects for Nigerians. But if they are of cultural value—as the Nok sculptures undoubtedly are—it strikes me that it would be better for them to think of themselves as trustees for humanity. While the government of Nigeria reasonably exercises trusteeship, the Nok sculptures belong in the deepest sense to all of us. "Belong" here is a metaphor, of course. I just mean that the Nok sculptures are of potential value to all human beings.

boo.

So, basically culture isn't static unless we want it to be ...

2.

That idea is expressed in the preamble of the Convention for the Protec-tion of Cultural Property in the Event of Armed Conflict of May 14, 1954, which was issued by a conference called by UNESCO:

> Being convinced that damage to cultural property belonging to any people whatsoever means damage to the cultural heritage of all man-kind, since each people makes its contribution to the culture of the world.

Framing the problem that way—as an issue for all mankind—should make it plain that it is the value of the cultural property to people and not to peoples that matters. It isn't peoples who experience and value art; it's men and women. Once you see that, then there's no reason why a Span-ish museum couldn't or shouldn't preserve a Norse goblet, legally ac-quired, let's imagine, at a Dublin auction, after the salvage of a Viking shipwreck off Ireland. It's a contribution to the cultural heritage of the world. But at any particular time it has to be in one place. Why shouldn't Spaniards be able to experience Viking craftsmanship? After all, there is no lack of Viking objects in Norway. The logic of "cultural patrimony," however, would call for the goblet to be shipped back to Norway (or, at any rate, to Scandinavia); that's whose cultural patrimony it is.

And in various ways, we've inched closer to that position in the years since the Hague Convention. The Convention on the Means of Prohibiting

and Preventing the Illicit Import, Export, and Transfer of Ownership of Cultural Property, adopted by the UNESCO General Conference in Paris in 1970, stipulated that "cultural property constitutes one of the basic elements of civilization and national culture, and that its true value can be appreciated only in relation to the fullest possible information regarding its origin, history and traditional setting"; and that "it is essential for every State to become increasingly alive to the moral obligations to respect its own cultural heritage."

A state's cultural heritage, it further decreed, included both work "created by the individual or collective genius of nationals of the State" and "cultural property found within the national territory." The Convention emphasized, accordingly, the importance of "prohibiting and preventing the illicit import, export, and transfer of ownership of cultural property." A number of countries now declare all antiquities that originate within their borders to be state property, which cannot be freely exported. In Italy, private citizens are free to own "cultural property," but not to send it abroad.[2]

That notion of "origination" is interestingly elastic. Among the objects that the Italian government has persuaded the Getty to repatriate is a 2,300-year-old painted Greek vase and an Etruscan candelabrum. (There are at least forty more objects at that museum that the Italians are after.) When the Metropolitan Museum in New York seemed close to a deal with the Italians to return a two-and-a-half-millennium-old terra-cotta vase from Greece, known as the Euphronios krater, Rocco Buttiglione of the Italian Culture Ministry declared that the ministry's aim was "to give back to the Italian people what belongs to our culture, to our tradition and what stands within the rights of the Italian people." I confess I hear the sound of Greeks and Etruscans turning over in their dusty graves; patrimony, here, equals imperialism plus time.

Plainly, special legal problems are posed by objects, like Nok art, where there is, as lawyers might say, no continuity of title. If we don't know who last owned a thing, we need a rule about what should happen to it now. Where objects have this special status as a valuable "contribution to the culture of the world," the rule should be one that protects that object and makes it available to people who will benefit from experiencing it.

Who determines Significance?

So the rule of "finders, keepers," which may make sense for objects of less significance, will not do. Still, a sensible regime will reward those who find such objects, and give them an incentive to report not only what they have found but also where and how they found it.

For an object from an archaeological site, after all, value comes often as much from knowing where it came out of the ground, what else was around it, how it lay in the earth. *Context, suck it.* Since these articles seldom have current owners, someone needs to regulate the process of removing them from the ground and decide where they should go. It seems to me reasonable that the decision about those objects should be made by the government *agreed.* in whose soil they are found. But the right conclusion for them is not obviously that they should always stay in the country where they were buried. *won't crap.* Many Egyptians—overwhelmingly Muslims who regard the religion of the Pharaohs as idolatrous—nevertheless insist that all the antiquities ever exported from Egypt's borders are really theirs. You do not need to endorse Napoleon's depredations in northern Africa to think that there is something to be said for allowing people in other countries the chance to see, close up, the arts of one of the world's great civilizations. And it's a painful irony that one reason we've lost information about cultural antiquities is the very regulation intended to preserve it. If, for example, I sell you a figure from Djenne-jeno with evidence that it came out of the ground in a certain place after the regulations came into force, then I am giving the authorities in the United States, who are committed to the restitution of objects taken illegally out of Mali, the very evidence they need.

Suppose that from the beginning, Mali had been encouraged and helped by UNESCO to exercise its trusteeship of the Djenne-jeno terracottas by licensing digs and educating people to recognize that objects removed carefully from the earth with accurate records of location are of greater value, even to collectors, than objects without this essential element of provenance. Suppose they had required that objects be recorded and registered before leaving, and stipulated that if the national museum wished to keep an object, it would have to pay a market price for it, the acquisition fund being supported by a tax on the price of the exported objects.

The digs encouraged by such a system would have been less well conducted and less informative than proper, professionally administered

digs by accredited archaeologists. Some people would still have avoided the rules. But mightn't all this have been better than what actually happened? Suppose, further, that the Malians had decided that in order to maintain and build their collections they should auction off some works they own. The partisans of cultural patrimony, instead of praising them for committing needed resources to protecting the national collection, would have excoriated them for betraying their heritage.

The problem for Mali is not that it doesn't have enough Malian art. The problem is that it doesn't have enough money. In the short run, allowing Mali to stop the export of much of the art in its territory has the positive effect of making sure that there is some world-class art in Mali for Malians to experience. But an experience limited to Malian art—or, anyway, art made on territory that's now part of Mali—makes no more sense for a Malian than it does for anyone else. New technologies mean that Malians can now see, in however imperfectly reproduced a form, great art from around the planet; and such reproduction will likely improve. If UNESCO had spent as much effort to make it possible for great art to get into Mali as it has done to stop great art getting out, it would have been serving better the interests that Malians, like all people, have in a cosmopolitan aesthetic experience.

3.

How would the concept of cultural patrimony apply to cultural objects whose current owners acquired them legally in the normal way? You live in Ibadan, in the heart of Yorubaland in Nigeria. It's the early 1960s. You buy a painted carving from a young man—an actor, painter, sculptor, all-around artist—who calls himself Twin Seven Seven. Your family thinks it's a strange way to spend money. Time passes, and he comes to be seen as one of Nigeria's most important modern artists. More cultural patrimony for Nigeria, right? And if it's Nigeria's, it's not yours. So why can't the Nigerian government just take it, as the natural trustees of the Nigerian people, whose property it is?

The Nigerian government would not in fact exercise its power in this way. (When antiquities are involved, though, a number of other states

will do so.) It is also committed, after all, to the idea of private property. Of course, if you were interested in selling, it might provide the resources for a public museum to buy it from you (though the government of Nigeria probably thinks it has more pressing calls on its treasury). So far cultural property is just like any other property.

Suppose, though, the government didn't want to pay. There's something else it could do. If you sold your artwork, and the buyer, whatever his nationality, wanted to take the painting out of Nigeria, it could refuse permission to export it. The effect of the international regulations is to say that Nigerian cultural patrimony can be kept in Nigeria. An Italian law (passed, by the way, under Mussolini) permits its government to deny export to any artwork currently owned by an Italian, even if it's a Jasper Johns painting of the American flag. But then most countries require export licenses for significant cultural property (generally excepting the work of living artists). So much for being the cultural patrimony of humankind.

Such cases are particularly troublesome, because Twin Seven Seven. wouldn't have been the creator that he was if he'd been unaware of and unaffected by the work of artists in other places. If the argument for cultural patrimony is that the art belongs to the culture that gives it its significance, most art doesn't belong to a national culture at all. Much of the greatest art is flamboyantly international; much ignores nationality altogether. A great deal of early modern European art was court art or was church art. It was made not for nations or peoples but for princes or popes or *ad majorem gloriam dei*. And the artists who made it came from all over Europe. More importantly, in a line often ascribed to Picasso, good artists copy, great ones steal; and they steal from everywhere. Does Picasso himself—a Spaniard—get to be part of the cultural patrimony of the Republic of the Congo, home of the Vili people, one of whose carvings Matisse showed him at the Paris apartment of the American Gertrude Stein?

The problem was already there in the preamble to the 1954 Hague Convention that I quoted a little while back: "*each* people makes its contribution to the culture of the world." That sounds like whenever someone makes a contribution, his or her "people" makes a contribution, too. And there's something odd, to my mind, about thinking of Hindu temple sculpture or Michelangelo's and Raphael's frescoes in the Vatican as the

contribution of a people, rather than the contribution of the artists who made (and, if you like, the patrons who paid for) them. I've gazed in wonder at Michelangelo's work in the Sistine Chapel and I will grant that Their Holinesses Popes Julius II, Leo X, Clement VIII, and Paul III, who paid him, made a contribution, too. But which *people* exactly made that contribution? The people of the Papal States? The people of Michelangelo's native Caprese? The Italians?

This is clearly the wrong way to think about the matter. The right way is to take not a national but a transnational perspective: to ask what system of international rules about objects of this sort will respect the many legitimate human interests at stake. The reason many sculptures and paintings were made and bought was that they should be looked at and lived with. Each of us has an interest in being able, should we choose, to live with art—an interest that is not limited to the art of our own "people." And if an object acquires a wider significance, as part, say, of the oeuvre of a major artist, then other people will have a more substantial interest in being able to experience it. The object's aesthetic value is not fully captured by its value as private property. So you might think there was a case for giving people an incentive to share it. In America such incentives abound. You can get a tax deduction by giving a painting to a museum. You get social prestige from lending your works of art to shows, where they can be labeled "from the collection of . . ." And, finally, you might earn a good sum by selling it at auction, while both allowing the curious a temporary look at it and providing for a new owner the pleasures you have already known. If it is good to share art in these ways with others, why should the sharing cease at national borders?

Here is a cautionary tale about the international system we have created. In the years following the establishment of the Taliban regime in Afghanistan, curators at Afghan's National Museum, in Kabul, grew increasingly worried about the security of the country's non-Islamic antiquities. They had heard the mounting threats made by Islamic hard-liners who considered all figurative works to be blasphemous, and they confided their concerns to colleagues in other countries, begging them to take such artifacts out of Afghanistan for safekeeping. They knew about the destruction of an ancient Buddhist temple and its artworks by fundamentalist soldiers.

They knew that centuries-old illuminated manuscripts kept in a library north of Kabul had been burned by Taliban zealots. They had heard the rumblings about a new wave of iconoclasm, and they took them seriously.

Finally, in 1999, Paul Bucherer, a Swiss scholar who was the director of the Fondation Bibliotheca Afghanica, negotiated an arrangement with more moderate Taliban officials, including the then Taliban minister for information and culture, along with President Rabbani of the Northern Alliance. The endangered artifacts would be shipped to a museum in Switzerland that had been set up specifically for the purpose of keeping these works out of harm's way while the danger persisted. In the fall of 2000, Dr. Bucherer, with the help of Afghan museum officials, had crated up these endangered artifacts, ready to be shipped to Switzerland for temporary safekeeping. Switzerland, as a signatory of UNESCO treaties, simply required UNESCO approval to receive the shipment.

But while Paul Bucherer and his Afghan colleagues had managed to negotiate around the Taliban hard-liners, they hadn't counted on the UNESCO hard-liners. And UNESCO refused to authorize the shipments. Various explanations were offered, but the objection came down to the 1970 UNESCO agreement on the illicit traffic of cultural objects, and its strictures against involving moving objects from their country of origin. Indeed, at a UNESCO meeting that winter, experts in Central Asian antiquities actually denounced Dr. Bucherer for trying to destroy Afghan culture.[3]

People I know who have visited the National Museum in Kabul recount what the staff members there have told them. Museum workers were ordered by Taliban inspectors to open drawers of antiquities, in the wake of Mullah Omar's February 2001 edict against pre-Islamic art. Here were drawers of extraordinary Bactrian artifacts and Ghandara heads and figurines. My friends recall the dead look in a curator's eyes as he described how the Taliban inspectors responded to these extraordinary artifacts by taking out mallets and pulverizing them in front of him.

Would the ideologues of cultural nativism, those experts who insist that archaeological artifacts are meaningless outside their land of origin, find solace in the fact that Afghan hands destroyed these works, on Afghan soil?

Only in March 2001, after the notorious demolition of the Bamiyan Buddhas, did UNESCO officials relent. Fortunately, Afghan curators, with nobody to turn to, took it on themselves to hide some of the most valuable archaeological finds.[4] These curators, including Omara Khan Massoudi, who is now director of the National Museum, did heroic work, and, today, UNESCO is helping with the restoration of damaged art. The problem in Afghanistan under the Taliban wasn't so much the behavior of UNESCO bureaucrats as the conception of their task imposed upon them by the community of nations. The threat comes from the idea that even endangered art—endangered by a state whose government threatens it precisely because they don't think it is a proper part of their own heritage—nevertheless properly belongs in the state whose cultural patrimony it is.

This is the ideology of the system to which the United States committed itself with the Senate's ratification in 1972 of the UNESCO Convention on the Means of Prohibiting and Preventing the Illicit Import, Export, and Transfer of Ownership of Cultural Property. (Characteristically, perhaps, it took another decade for this decision to turn into an actual act of Congress.) UNESCO, like all UN bodies, is the creature of the system of nations; while it speaks of World Heritage Sites, it is nevertheless bound to conceive them as ultimately at the disposal of nations. Because what it unites are nations, not human beings, it is impotent when what humanity needs is not what some state has decided to do. We will do well to recognize that iconoclasm is as much an expression of nationalism as idolatry: the human community needs to find ways to protect our common heritage from the iconoclasts, even when they are the masters of nations.

When we're trying to interpret the concept of cultural property, we ignore at our peril what lawyers, at least, know: property is an institution, created largely by laws, which are best designed by thinking about how they can serve the human interests of those whose behavior they govern. If the laws are international laws, then they govern everyone. And the human interests in question are the interests of all of humankind. However self-serving it may seem, the British Museum's claim to be a repository of the heritage not of Britain but of the world strikes me as exactly right. Part of the obligation, though, is to make those collections more widely

available not just in London but elsewhere, through traveling collections, through publications, and through the World Wide Web.

It has been too easy to lose sight of the global constituency. The American legal scholar John Henry Merryman once offered some examples of how laws and treaties relating to cultural property have betrayed a properly cosmopolitan (he uses the word *internationalist*) perspective. "Though we readily deplore the theft of paintings from Italian churches," he wrote, "if a painting is rotting in a church from lack of resources to care for it, and the priest sells it for money to repair the roof and in the hope that the purchaser will *give* the painting the care it needs, then the problem begins to look different."[5]

So when I lament the modern thefts from Nigerian museums or Malian archaeological sites or the imperial ones from Asante, it's because the property rights that were trampled upon in these cases flow from laws that I think are reasonable. I am not for sending *every* object "home." Many of the Asante art objects now in Europe, America, and Japan were sold or given by people who had the right to dispose of them under the laws that then prevailed, laws that were perfectly reasonable. It may be a fine gesture to return things to the descendants of their makers—or to offer it to them for sale—but it certainly isn't a duty. You might also show your respect for the culture it came from by holding on to it because you value it yourself. Furthermore, because cultural property has a value for all of us, we should make sure that those to whom it is returned are in a position to act as responsible trustees. Repatriation of some objects to poor countries with necessarily small museum budgets might just lead to their decay. Were I advising a poor community pressing for the return of many ritual objects, I might urge them to consider whether leaving some of them to be respectfully displayed in other countries might not be part of their contribution to cross-cultural understanding as well as a way to ensure their survival for later generations.

To be sure, there are various cases where repatriation makes sense. We won't, however, need the concept of cultural patrimony to understand them. Consider, for example, objects whose meaning would be deeply enriched by being returned to the setting from which they were taken—site-specific art of one kind or another. Here there is an aesthetic argument

for return. Or consider objects of contemporary ritual significance that
were acquired legally from people around the world in the course of Euro-
pean colonial expansion. If an object is central to the cultural or religious
life of a community, there is a human reason for it to find its place back
with them. *as opposed to what?*

But the clearest cases for repatriation are those where objects were
stolen from people whose names we often know; people whose heirs, like
the King of Asante, would like them back. As someone who grew up in
Kumasi, I confess I was pleased when some of this stolen art was re-
turned, thus enriching the new palace museum for locals and for tourists.
Still, I don't think we should demand everything back, even everything
that was stolen; not least because we haven't the remotest chance of get-
ting it. Don't waste your time insisting on getting what you can't get.
There must be an Akan proverb with that message.

There is, however, a more important reason: I actually want muse-
ums in Europe to be able to show the riches of the society they plundered
in the years when my grandfather was a young man. And I'd rather that
we negotiated not just the return of objects to the palace museum in
Ghana, but also a decent collection of art from around the world. Perhaps
the greatest of the many ironies of the sacking of Kumasi in 1874 is that it
deprived my hometown of a collection that was, in fact, splendidly cosmo-
politan. As Sir Garnet Wolseley prepared to loot and then blow up the
Aban, the large stone building in the city's center, European and Ameri-
can journalists were allowed to wander through it. The British *Daily Tele-
graph* described it as "the museum, for museum it should be called, where
the art treasures of the monarchy were stored." The London *Times*'s Win-
wood Reade wrote that each of its rooms "was a perfect Old Curiosity
Shop." "Books in many languages," he continued, "Bohemian glass,
clocks, silver plate, old furniture, Persian rugs, Kidderminster carpets, pic-
tures and engravings, numberless chests and coffers. . . . With these were
many specimens of Moorish and Ashantee handicraft."

We shouldn't become overly sentimental about these matters. Many
of the treasures in the Aban were no doubt war booty as well. Still it will
be a long time before Kumasi has a collection as rich in our own material
culture and in works from other places as the collections destroyed by

Sir Garnet Wolseley and the founder of the Boy Scouts. The Aban had been completed in 1822. And how had the Asante king hit upon the project in the first place? Apparently, he had been deeply impressed by what he'd heard about the British Museum.[6]

We understand the urge to bring these objects "home." A Norwegian thinks of the Norsemen as her ancestors. She wants not just to know what their swords look like but to stand close to an actual sword, wielded in actual battles, forged by a particular smith. Some of the heirs to the kingdom of Benin, the people of southwest Nigeria, want the bronze their ancestors cast, shaped, handled, wondered at. They would like to wonder at—if we will not let them touch—that very thing. The connection people feel to cultural objects that are symbolically theirs, because they were produced from within a world of meaning created by their ancestors—the connection to art through identity—is powerful. It should be acknowledged. But we should remind ourselves of other connections.

One connection—the one neglected in talk of cultural patrimony—is the connection not through identity but despite difference. We can respond to art that is not ours; indeed, we can only fully respond to "our" art if we move beyond thinking of it as ours and start to respond to it as art. But equally important is the human connection. My people—human beings—made the Great Wall of China, the Sistine Chapel, the Chrysler Building: these things were made by creatures like me, through the exercise of skill and imagination. I do not have those skills and my imagination spins different dreams. Nevertheless, that potential is also in me. The connection through a local identity is as imaginary as the connection through humanity. The Nigerian's link to the Benin bronze, like mine, is a connection made in the imagination; but to say this isn't to pronounce either of them unreal. They are surely among the realest connections we have.

NOTES

1. I owe a great deal to the cogent (and cosmopolitan!) outline of the development of the relevant international law in John Henry Merryman's classic paper "Two Ways of Thinking about Cultural Property," *American Journal of International Law* (October 1986): 831–53.

2. James Cuno, "U.S. Art Museums and Cultural Property," *Connecticut Journal of International Law* 16, no. 2 (2001): 189–96.
3. See www.theartnewspaper.comjnewsjarticle.asp?idart=7995; Carla Power, "Saving the Antiquities," *Newsweek*, May 14, 2001, 54.
4. Carlotta Gall, "Afghan Artifacts, Feared Lost, Are Discovered Safe in Storage," *New York Times*, November 18, 2004.
5. Merryman, "Two Ways of Thinking about Cultural Property," 852.
6. The quotations from the *Daily Telegraph*, London *Times*, and *New York Herald*, as well as the information about Osei Bonsu, are all from Ivor Wilks, *Asante in the Nineteenth Century: The Structure and Evolution of a Political Order* (New York: Cambridge University Press, 1975), 200–201.

PART TWO

The Value of Antiquities

Archaeologists often argue that antiquities have no meaning outside their archaeological contexts. If we don't know where they were found, they argue, antiquities are meaningless and only of aesthetic value, which they judge to be subjective and inferior to the "objective" value of the excavated antique artifact. But of course antiquities have all kinds of meanings outside their specific, archaeological contexts: aesthetic, technological, iconographic, even, in the case of those with writing on them, epigraphic.

Museums are dedicated to the preservation of objects and to providing them a new, different kind of context, one that both emphasizes their aesthetic qualities and the importance of comparing them with other objects with which they share a moment in time or a sense of place. The latter was discussed in the previous section of this book, "The Value of Museums." This section focuses on the objects themselves and on what can be learned from them even if we do not know their archaeological contexts.

James C. Y. Watt reflects on the possibilities and limitations of what can be learned about ancient Chinese art from its archaeological context. He argues, for example, that no amount of archaeological evidence can tell us why ancient people invested so much in the making and collecting of beautiful things, or how Chinese music sounded, even if we have unearthed through archaeological excavation ancient musical instruments. He does not dismiss the importance of archaeological research. He only emphasizes that it is not enough if we wish to learn all we can about our ancient past.

Drawing on his decades of experience as an archaeologist and art historian of ancient Greek art, Sir John Boardman criticizes many archaeological practices as injurious to our knowledge of antiquity and argues

against the criticisms of museums' acquiring unprovenanced antiquities as unenforceable, prejudiced in favor of prehistorical studies, and a disservice to scholarship. He emphasizes the value of museums as repositories for the preservation and presentation of antiquities and considers the benefits to knowledge of acquiring and studying undocumented antiquities.

David I. Owen focuses on the legacy of unprovenanced antiquities of ancient Near Eastern origin with regard to what they have contributed to our understanding of those early civilizations. He also considers a recent controversy over scholar organizations' policies regarding publishing or not publishing articles that cite knowledge gained from studying unprovenanced antiquities. The U.S. archaeological establishment is opposed to serving as the initial publisher of antiquities whose first known whereabouts date since 1973. Owen and other archaeologists and historians are critical of this position for its disregard for all that the texts on cuneiform tablets can teach and have taught us about the ancient Near East, whether or not those tablets were excavated. The tenor of Owen's response betrays the heat of the debate between archaeologists and historians of the ancient Near East over the study and publication of unprovenanced cuneiform tablets.

Antiquities and the Importance—and Limitations—of Archaeological Contexts

James C. Y. Watt

THE METROPOLITAN MUSEUM OF ART

ONE OF THE KEY WORDS in the pronouncements of certain professional archaeologists quoted in the popular press is *context*. It is said that without archaeological context all information relating to an excavated object is lost, "regardless of its artistic merit." This is a harsh position worthy of *ha.* the early Church Fathers. It is rather like saying: "there is no redemption for the unbaptized, whomever they are and wherever they are."

Here I present some thoughts and reflections on the study of antiquities in the context of the quest for information. I shall address the subject with reference to an area of which I am acquainted: Chinese archaeology. My remarks are based on two propositions.

The first proposition is that the earlier the historical period in question, the more important the archaeological context. In prehistoric archaeology, for example, context is paramount. But for historic sites, importance of the archaeological record diminishes rapidly with time. This is to say that what archaeological excavation can tell us about any civilization has to be *what about* balanced with the written record: the more recent the date of the site, the *discrepancies* more insignificant the archaeological data as compared with the available *b/w the two?* literature of the time. This is particularly the case in areas with a highly developed literate culture, surviving in literary, historical, and philosophical writing, such as the Mediterranean world and China.

Fig. 4.1. *Cong*, Neolithic Period, Liangzhu culture (3200–2000 B.C.), ca. 2400 BC. Nephrite
(h. 10 in.). The Metropolitan Museum of Art. Purchase, Sir Joseph Hotung Gift, 2004, 2004.52.
Image © The Metropolitan Museum of Art.

Even for prehistoric sites, the archaeological context can only provide limited information, particularly in the study of individual objects. Take for example this jade object, a *cong* (fig. 4.1), from the Liangzhu culture that flourished in the Lower Yangzi (Yangtse) in eastern China, dating from about 2500 BC. Excavations have revealed that in some burials they were placed end to end around the body of the deceased. In a prehistoric burial, archaeologists can derive a lot of information from the excavation of such sites by the examination and analysis of its contents, including any organic and inorganic remains, natural and man-made objects such as bones and teeth, pollens and fibers. All of this information, combined with a study of the environment at the time of the burial, the flora and fauna, the climate, the geological formation, and so on, makes it possible to create a hypothesis of the kind of society that existed, of which the deceased, buried here was a member. It is also possible to theorize as to the position of this person in the society.

This is of great academic interest. But when we seek to learn something of what is obviously the most significant object in the burial, the *cong*, we come up against the limitations of knowledge that can be derived from what can broadly be called archaeological studies. In the first place, no amount of archaeological method or theorizing based on the scientific examination of the excavated evidence can tell us why some people would want to produce objects such as the *cong*. Whatever the purpose, the motivation had to be strong, as it would take a long time—months—of dedicated labor for a skilled lapidary to make even one of these objects with no metal tools, let alone twenty-odd pieces for a special person. Second, we cannot know why some people were buried surrounded by *congs*. Even if we know everything about the structure of the society, its economy and technological level, we are still at a loss as to why this particular form was made, for what purpose it was intended. Or perhaps we should ask why an object with no obvious practical function was created. This question has led some scholars early in the twentieth century to speculate that the tube was used together with a notched disc as an astronomical instrument to observe the stars. But no one takes this theory seriously anymore.

Now let us examine this *cong* more closely (fig. 4.2). We see that on the corners are incised patterns that look like masks stacked one on top of

Fig. 4.2. *Cong*, Metropolitan Museum of Art, detail of fig. 4.1.

the other. Perhaps this has something to do with ancestor worship, a kind of totem pole perhaps, or just primitive doodles. We shall never know for sure. But if we remove ourselves from academic sophistry and look at the *cong* in the way that everybody looks at what other people make, we find we can respond to this object at a very basic level of appreciation, which is to say that we respond to it in the way we respond to a work of art. (This is a response that even archaeologists are capable of experiencing, if only in an unguarded moment.) Once we arrive at this point, all archaeological considerations fall away and context becomes irrelevant. We are face to face with the ancients.

Among the hundreds of objects in the Metropolitan Museum's exhibition of art treasures from the National Palace Museum in Taipei—*Possessing the Past: Treasures from the National Palace Museum, Taipei*, 1996—the two Neolithic objects, the *cong* and the *bi* (figs. 4.3–4.4), aroused as much interest and marvel from the visitor as any other works of art ranging from masterpieces of eleventh-century landscape painting to delicate porcelains of the eighteenth century. The archaeologist who defines knowledge as that which can be arrived at only by the application of a specialized academic discipline, denies the validity of any other approach to the study and appreciation of antiquity. Jade was the Neolithic material par excellence. It is such a tough substance that it can only be shaped by grinding and polishing, techniques developed in the Neolithic period. From that time forward, the love of jade, independent of any other "context," never left the Chinese people.

We have an early illustration of this in the finds from a tomb of the late Shang period (ca. twelfth century BC). It is the tomb of Fu Hao, or Lady Hao, a consort of King Wu Ding. Although of relatively small size when compared with royal tombs of an earlier period, it is the only major burial of the Shang period found intact. Among the hundreds of jade articles found in this tomb, we can find examples dating from the Neolithic down to the date of the tomb; some of them from a culture hundreds of miles away from Anyang, the last capital of the Shang dynasty and the site of the burial. This piece (fig. 4.5) from the tomb of Fu Hao is typical of jade artifacts found at sites of the Hongshan culture in northeast China, which date back at least several hundred years before the time of Fu Hao.

Fig. 4.3. *Ts'ung*, Neolithic period (3rd millennium BC). Nephrite (h. 18 5/8 in.). National Palace Museum, Taiwan, Republic of China. Photograph by Bruce White.

Fig. 4.4. *Bi* disc, Neolithic period (3rd millennium BC). Nephrite (d. 15 1/2 in.). National Palace Museum, Taiwan, Republic of China. Photograph by Bruce White.

Thus, by connecting the jade artifact in the tomb of Fu Hao to much earlier artifacts through stylistic and technical analysis, the archaeological context has identified for us an early collector, a woman who gathered about her artifacts of a much earlier period.

Lady Hao was no daughter of the Enlightenment, nor did she need a few ancient jades to enhance her status or her personal wealth. And since the Neolithic jades could not have had any ritual or social significance in

Fig. 4.5. Hook-shaped jade, Late Shang Dynasty (ca. 1600–1100 B.C.). Jade (l. 3.6 in.).
Excavated from the Fuhao tomb, Anyang, Henan Province, 1976. Image source: *Yinxu yuqi*
[Jades from the Yin Ruins], Beijing: Wenwu chubanshe, 1982, plate 28. The Institute of
Archaeology, Chinese Academy of Social Science, Beijing.

Fu Hao's time, it is a fair assumption that she collected the jades for the love of the stone. In this respect, she was behaving in no way differently from anyone who collected jade in more recent times, without worrying about the source of the material, or when and where and by whom and under what social conditions the pieces were carved, or how they came on the market. So far as we can determine, she likely collected the much earlier jades because she wanted to and liked them.

What the Fu Hao example demonstrates is that collecting is an activity as old as civilization itself, long before a branch study that grew out of the activity of collecting—archaeology—claimed complete jurisdiction over how we collect, who is allowed to collect, and what attitude anybody should adopt toward an antiquity and antiquities.

We now look at a bronze wine vessel used for ritual purposes in the time of Fu Hao (fig. 4.6). We know it is a wine vessel from early literature and from inscriptions found on similar bronzes. What archaeological excavations tell us is that the wine was indeed made from black millet (as we already learned from the literature). For many people, the sight of this object from antiquity inspires a certain degree of awe. Perhaps that is what the ancient ritual vessel was designed to inspire. We know that rituals at this time involved animal sacrifice. (We do not need archaeology to know this.) But what of the animal mask that is the most prominent motif on the vessel (fig. 4.7) As pointed out by the structural anthropologist Claude Lévi-Strauss, who took his cue from the work of other anthropologists on the art of American Indians of the Northwest Coast, the "mask" is in fact composed of two profiles of an animal joined at the nose. At a purely technical level, this can be seen as one way of solving the problem of putting a three-dimensional object on a two-dimensional surface, a method that has been called *split representation*. And, as with Northwest Coast art, in the use of split representation—by wrapping the split animal around the vessel—the animal is integrated with the vessel: the vessel becomes the animal and vice versa. This is part of the secret of the power of the image. In this connection, one could quote a saying attributed to Confucius: "the vessel contains rite."

Now look at the ground patterns and the detailed structure of the mask. These square spirals and *hysterisis* curves are nothing more than the

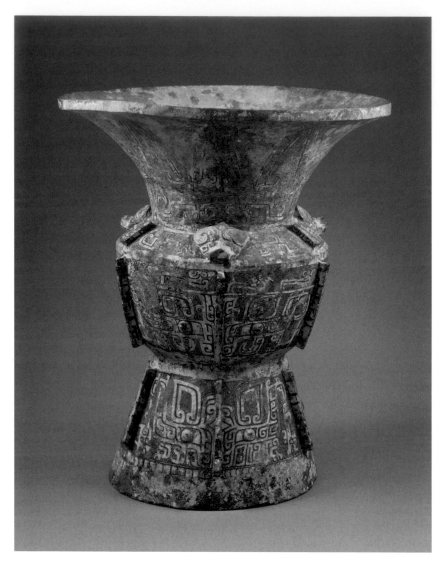

Fig. 4.6. *Zun*. Ritual wine jar, Shang Dynasty (ca. 1600–1046 BC), 13th century BC. Bronze inlaid with black pigment (h. 15 5/8 in., d. 14 in.). The Metropolitan Museum of Art, Rogers Fund, 1943, 43.25.1. Image © The Metropolitan Museum of Art.

Fig. 4.7. *Zun.* Metropolitan Museum of Art, detail of fig. 4.6.

pictograms for thunder and lightning: a point made by the late Alexander Soper at the Institute of Fine Arts in New York, many years ago. Now, look at a bronze *ding*-tripod (fig. 4.8), a food vessel in this instance, dating from the tenth century BC, in the early Zhou dynasty, which followed the Shang. This is a majestic vessel, not only on account of its size, but also on the stateliness of its form. When we read the inscription on the inside of the *ding*, we become even more impressed. For it is one of the longest inscriptions on archaic bronzes known thus far, and is composed in resonant rhyming prose: imperial pronouncements from the throne of the newly founded Zhou dynasty, full of the confidence of a conquering race.

On the surface of the *ding*, we notice that the powerful animal mask has been reduced to a token band, as the rulers did not feel they necessarily owed their success to the ancestor gods. Indeed, the Duke of Zhou, who was regent before the second king of Zhou came of age, would pray to the ancestor gods thus: "I place these jades before you. If you grant my wish, I shall offer them to you. But if you don't, I shall take them away."

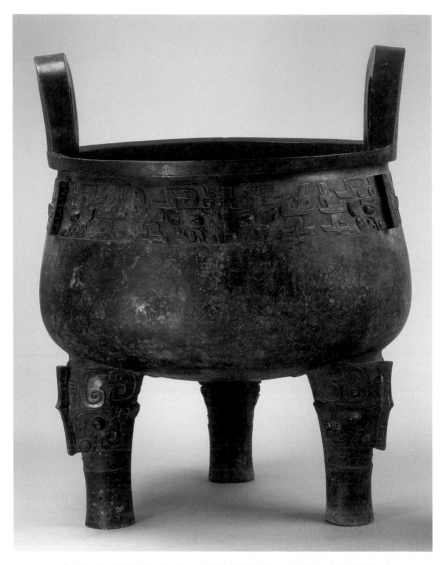

Fig. 4.8. *Ding*, Early Western Zhou Dynasty (1046–771 B.C). Bronze (h. 40.1 in., d. (rim) 30.6 in., d. (belly) 32.3 in., depth 19.4 in.). National Museum of China, Beijing.

This imperial confidence is fully expressed in the bronze, in the context of its form, the inscription and the literature surviving from that period. There is very little more information we can gain if we know exactly where the bronze was found. In any case, the inscription tells us where this king was on the occasion of the ceremony when he made the pronouncement recorded on the bronze.

One of the most important archaeological discoveries in recent years is the excavation in 1978 of the tomb of the Marquis of Zeng in Hubei Province. This massive burial yielded a wealth of information on the material culture and the complex history of the region in the fifth century BC. In spite of the impressive scale of the burial, the State of Zeng was only a minor principality existing within the overwhelming cultural and political sphere of influence of the great state of Chu, known for its advanced material culture and the arts. The artistic expression of Chu, surviving in literature, painting, and other visual arts, suggests a strong shamanistic strain in its society. We may thus expect a highly developed culture of music and dance. The most important groups of finds in this tomb are the musical instruments in two ensembles, one for large "orchestral" performances and another for "chamber music." Of the instruments, the most spectacular is a set of bell chimes suspended from elaborate frames of cast bronze and lacquer-painted wooden beams (fig. 4.9). The set of sixty-five lentoid-shaped bells, each producing two notes at intervals of a minor or major third, cover a range of three octaves rising by semitones. Each of the bells is inscribed with a detailed annotation of its pitch and its position in the musical scale. Unfortunately, with this rich material evidence, we are still unable to recover the music itself, which is what we are most eager to learn about. All we are left with is the timbre of the bell. This brings us a small step closer to the ancients, but we shall never hear the music. This is another example of the limitations of archaeology. The closer we come to the workings of the human spirit, the less is the information afforded by archaeological evidence.

There are, of course, occasions when the geographical location of a find is significant. We can quote as an example a gold ornament, an openwork plaque with the image of a winged rider decorated with granulation. There are two noticeable aspects of this ornament. The first is the image

Fig. 4.9. Set of bronze bell chimes, Early Warring States (476–221 B.C.). Bronze (bells); wood and bronze (frame: l. 12.9 yards, h. 3 yards). Excavated from the tomb of the Marquis of Zeng (433 B.C.), Sui County, Hubei Province, 1978. The Hubei Provincial Museum, Wuhan.

Fig. 4.10. Ornament with winged figure on a chimera, Eastern Jin Dynasty (317–420) or earlier. Gold (h. 1 in.). Excavated from the tomb of Zhang Zhen, Suzhou Jiangsu Province, 1979. Nanjing Museum, Jiangsu Province.

of the winged rider on a dragonlike animal, an image that occurred on metalwork from the steppes of southern Kazakhstan as well as in interior China beginning at about the same time, about the first century BC (fig. 4.10). The second aspect is the working technique. The use of granulation, ultimately of Mediterranean origin, came into China by the agency of nomadic peoples of northern Asia, probably the confederation known as the Xiongnu, in about the third century BC. The fact that this object was found in an early fifth-century tomb as far south as Suzhou in south China tells a complex story of the transmission of images and skills over long distances and time. But this is not the whole story. There is another

aspect to this object, which no amount of archaeological data can provide. And that is the significance of the winged figure in Chinese culture in the final years before the fall of the Han empire and the ensuing period of political and social chaos.

If we pick up an anthology of Chinese poetry of the third and fourth centuries, we find that one of the most common themes of the literature of the period is that of the immortal, visualized as a human who in shamanistic fashion has grown wings and flies heavenward. Here, we have a work of art that, quite apart from its artistic or archaeological interest, speaks to us of the aspiration of an age some of us today may find particularly sympathetic.

I now come to the second of my two propositions: after arriving at a critical point in the accumulation of archaeological data of a certain type of site of a certain period, further excavation data becomes superfluous. Take, for example, the Tang horse (fig. 4.11). We know it has to come from a Tang tomb. And we know practically everything there is to be known about a Tang tomb and its typical contents, except for the precious objects that had long ago all disappeared over centuries of continual "looting." We can date and place each Tang horse accurately because of the vast amount of knowledge, both historical and archaeological, accumulated over the years from the study of tombs. (It is said by Chinese archaeologists that for each of the three hundred years of the Tang dynasty [AD 618–907], there is at least one known dated tomb.) We know what the tombs look like, from the grandest to the humblest, and from the beginning to the end of the dynasty, and we know the general disposition of the burial goods in the tombs. What these horses, in huge numbers, tell us is the universal affection of the Chinese people in the metropolitan areas of the Tang empire for the "heavenly steed" that came from Ferghana, celebrated also in paintings and poetry.

As far as the Tang horse is concerned, its archaeological context adds little information in general. Of course, it is nice to know which horse came out of the tomb of which prince or princess, especially if we know something about the historical person whose tomb it is. In this particular case, it is that of Li Xian, the unfortunate crown prince, who was a gentle and scholarly man, exiled and put to death on the orders of his own

Fig. 4.11. Horse and groom, 706. Clay (horse: l. 28 1/3 in., w. 17 7/10 in., h. 27 3/4 in.; groom: l. 6 1/2 in., w. 8 7/10 in., h. 23 2/5 in.). Excavated from the tomb of the crown prince Li Xian, 1972. Image provided by The Qian Mausoleum Museum, Shaanxi Province.

mother. For some viewers, this knowledge may induce a certain degree of poignancy at the sight of this group of horse and groom.

To return to where I began, I show you a twelfth-century ceramic version of the Neolithic jade (fig. 4.12). In itself, it is an object of beauty, but it is much more. Such objects were made in homage to antiquity, expressed in an artistic language of its time. In this case not in words or music, but in a medium that was at the time at the peak of its development. And this revival or "recreation" of an ancient form was part of the result of the intense antiquarian studies of a group of brilliant scholar-collectors in the late eleventh century AD, who sought to understand the roots of Chinese civilization as the basis for the renewal of social institutions. I need not add that among this group are all the great writers and artists of the period.

Fig. 4.12. *Ts'ung*-shaped vase. Southern Sung Dynasty (1127–1279). Porcelain, Lung-ch'üan ware (10 x 3 5/8 in.). National Palace Museum, Taiwan, Republic of China. Photograph by Brucc White.

Antiquities on their own instruct all of us who seek to learn about ourselves, our own past, our own civilization(s), our own worth. They serve to enhance our awareness of our humanity. And by making a direct connection between us and moments of creativity in times past, they inspire us to express in our own language that something in us that echoes through the ages. Antiquities are precious, not because of their material value, not because of the implications of social standing, and not only because they provide the raw data for academic archaeological inquiry. The direct aesthetic appreciation of antiquities is vital to what we can learn of antiquities and antiquity, as for the perpetuation of civilizations. We would lose much if these objects were simply reduced to the status of scientific data.

Archaeologists, Collectors, and Museums

Sir John Boardman

UNIVERSITY OF OXFORD

THIS ESSAY IS A RESPONSE to Colin Renfrew's recent book on the "ethical crisis in archaeology."[1] I am grateful for the opportunity to try to formulate my views on the collecting issue. I have long sensed that there was something wrong about the course of legislation for the control of antiquities, and its effects on scholarship and public museums, not just collectors. I can now better define these worries and perceive the serious dangers of the situation that has developed, not apropos of deliberately plundered antiquities but of the safety of all antiquities per se, of accessibility to scholarship and the public at large, of freedom of scholarship, as well as of ordinary justice, all of which seem threatened by well-meaning but unrealistic legislation that is harming more than it helps.

This paper addresses issues ignored in anticollecting arguments, which have been so influential among academics, the media, and government but should be the concern of any serious scholar and of the museum-going public. Part of the problem is that the archaeologists loudest in their protests are atypical within their profession and indifferent to many of the already apparent results of their campaign, now sanctioned by law, while the public is fed biased propaganda.

It is easy to be moved by pictures of looted sites, monuments, and museums; they represent a tragic loss (if often only temporary), the result of deliberate plundering. It hardly needs arguing that thefts from sites and museums, and the promotion of such theft, are criminal activities; and unlike most thefts, since they deal in objects that have a greater relevance to our understanding of the heritage of man than a diamond necklace or

107

gold bullion, there is more of lasting value at stake. But probably a major proportion of the "suspect" antiquities on the market was not first acquired specifically for the market at all or is of relatively low monetary value. To go to the other extreme and believe that the only material for an understanding of man's history that we should handle or regard must be from controlled excavation by professionals, or known before 1970, puts us all in the hands of archaeologists whose own agenda may sometimes be suspect. We cannot automatically assume that they are on the side of the angels, and my own observation of a profession to which I have belonged for over half a century, in the field, museum, and classroom, has not led me to any great admiration for some of its procedures and motivation. Indeed I am not sure that I have encountered any scholarly group so prone to arrogance, and I know that this is a view fairly widely shared in the academic community. It has also become clear to me that some archaeologists are not the best people to make dispassionate judgments about relics of antiquity.

I start with a quite simple observation, that theft from a museum or registered site is criminal activity. It can be prosecuted as such in many countries, and should be. But some countries that profess concern turn a blind eye on such thefts, and archaeologists and museum officials have often demonstrably connived in the loss of antiquities without being investigated. Others have concern only for what they consider their national heritage to be, and have no particular concern for the global heritage of man, which is far more important to most of us (a point made in the Hague Convention of 1954).

This is quite an important issue. Are we being oversensitive to antiquities, overeager to preserve every morsel of the past, and to what end? Which is the cheaper, human history or human life? The robbing, destruction, and collecting of antiquities has been as endemic in the history of man as genocide, and far less harmful. We rightly criticized the Taliban for destroying the Bamiyan Buddhas in Afghanistan, but they appear to have done this through profound religious repugnance at such idols. And who are we to blame them for this rather extreme exercise of their deeply felt faith? The major loss in this case is probably to the tourist trade: Buddhists themselves have a very sensibly detached attitude to the value of mere objects, and tourists ought to in any case be more impressed by the

majesty of the Bamiyan valley and the great Hindu Kush massif behind it than by the big doll-like figures that had been tucked into niches at its foot, hardly masterpieces of Buddhist art (and, yes, I had seen them before they were destroyed). The act of the Taliban was exactly that of Moses with the Golden Calf made by the idolatrous Aaron, which he "burnt with fire, and ground to powder and scattered upon the water." No doubt the calf might have been judged a distinguished example of animal sculpture for its day, but we do not question Moses's motivation or deed. And there are many later instances of iconoclasm in Britain, too. On Renfrew's terms Moses should appear as an offender in the destruction of man's heritage. Scholarship cannot take precedence over everything.

So who do these archaeologists think they are, as absolute guardians of the world's heritage? Here, a slight digression: some twenty-five years ago I conducted an investigation for the British Academy into excavations financed by public money over a period of five years, ending five years before the time of the investigation, to see what had become of the publication of their excavation reports. An unpublished site is even more of a destroyed site than the Bamiyan Buddhas, since no public record whatever is left. The results of my investigation were depressing. Although the British record was better than many—more with regard to their excavations overseas than at home—I would judge that, over the last fifty years, far less than 25 percent of material and results of professional archaeological excavations has been properly published, and the rest will never get beyond preliminary reports, if that.[2]

Many excavators still release for public consideration little more than prestige objects that enhance their personal or departmental reputation; the rest of their finds are squirreled away for their eyes only, if at all, with the odds against eventual publication. Robert Cook described the process as a form of necrophilia.[3] The first publication by photo of many objects stolen from the Corinth Museum some years back happened only *after* they had been stolen! And they were located thanks initially to an Oxford database that did not discriminate against anything possibly stolen in its recording of antiquities for scholarship. In the matter of access by scholars to excavated material the source countries are, sadly, often the least cooperative, also the least willing to release surplus or duplicate material

for the inspection of scholars and the public elsewhere: partage, a common practice in days gone by that effectively preserved much that would otherwise have been lost.

It could be argued that more destruction of information about man's heritage has been done, and is being done, by archaeologists—with no sanctions applied to their misbehavior—than by collectors. By contrast, collectors and museums are generally eager to have their holdings seen and admired by others, and the more the better. Collectors are more focused even than many museum staff, and this shows in the range and quality of their collections, notably the specialist ones; and many, like George Ortiz, are scholars. Archaeologists are supported by public money, yet seem unaccountable to the public, unresponsive to sharing their knowledge and experience of their finds with the public, on whom they rely, or to allowing their finds to be dispersed more generally for public or even scholarly appraisal. It might seem far more appropriate for an institute in Cambridge, largely dependent on public money, to spend its time investigating misdemeanors committed in the name of scholarship than to conduct a witch hunt of collectors and to bully museums in what seems an almost paranoid attack on people and objects.[4]

Except in some areas of prehistory and for all wholly ideological studies, museums and collections have done and continue to do more for scholarly understanding of man's past than much excavation. Their role is now decried, and it has been very seriously diminished thanks to thoughtless legislation, mainly devised by politicians or archaeologists who seem indifferent to the real needs of museums, scholars, and the public. When I was an assistant keeper in the Ashmolean Museum I would go to Sotheby's and rescue, never for more than about £20, unprovenanced objects that I regarded as either unique or worthy of closer scholarly examination and display. I have in mind a small clay vase in the shape of a coiled snake, sixth century BC, and with an inscription on it, which, together with its form, made clear that it was from Boeotia in central Greece. If I had not got it for Oxford, for £14 I think, it might now be lost from sight on someone's mantelpiece or in the attic.

I recall as a student walking around Boeotia in central Greece, being put up in the really rather impoverished villages—this was at a time when

the wartime occupation and following civil war were barely over—with the informality and generous hospitality for which Greece was so well known. In one village my host pulled from under the bed a sack full of Classical clay figurines, found in his fields, which he gave to his children to play with; he gave me one or two. It seemed a very natural and proper use of the past and I find it difficult to blame a farmer for taking such a view of finds on his land. He dare not today. Nor dare any museum acquire such casual undocumented finds. They cannot now take the opportunities that I could, to save for scholarship and enhance collections with the minor antiquities on which much of our serious work and new perceptions depend. And the dismay is felt outside Britain equally.[5]

Most new antiquities on any market are come by through accident or as result of major public works, not design. In Athens, when a new road was cut near the Kerameikos, I saw the ditches beside it full of broken marble monuments. In Chios town it was the usual practice for builders to take their rubble, often full of antiquities, to dump beside the roads out of town, rather than have their work halted; a universal practice, I expect. From such practices many objects may be collected and reach a market, often for a modest price. All products of such activity are now to be treated on a par with the results of deliberate plunder, the most important of which never reach any open market at all and so are immune to antiquities legislation and seem often immune to laws concerning theft. This seems to me an appalling lapse in legislative judgment.

If current legislation is truly effective, anyone anywhere who now comes on a hoard of coins or Roman silver will do best simply to melt them down. What good does that do for scholarship and the heritage of humanity? The likelihood that such finds would have been made in the course of controlled excavation is probably virtually nil. Is it so grave an offense that they should pass into the possession of those who understand them, collectors or museums, even if necessarily via a trade? And such a regime of suppression of the trade can only lead to driving it underground. It is doing so already, since it can never totally suppress it, so that many scholars will never get to see important evidence, however acquired, such as cuneiform tablets. They will simply decay and disappear, denied proper conservation.

The complainers are simply not living in the same real world as the rest of us. And the high-minded attitude, in which mainly philistine governments acquiesce because it seems correct, is both harming scholarship and attacking a very natural human interest in collecting, by individuals or museums. Antiquities have been found by accident as well as design ever since antiquity, and will continue to be. I was not much of a walker, but I have myself picked up in Greek fields objects of individual and still unique scholarly importance, now placed in museums (the earliest example of a painted inscription on Attic pottery; the only evidence for the presence and appearance of a temple on a Boeotian site). I dare not now. The allegation that casual field walking never uncovers objects of significance and value is quite simply wrong.

On one side, we have collectors and public museums, and we really do have to consider the two together since they suffer equally, and with them the scholars who are fuelled and inspired by what is in museums and collections. On the other side, we have a group of archaeologists and legislators opposed to the trade in antiquities and the collecting of unprovenanced objects. The archaeologists are generally prehistorians like Renfrew, who regard the activity of scholars of historic periods with a certain disdain, or perhaps envy, despite the fact that they have much to learn from disciplines that are so much more fully informed, and from a wider range of sources. They are a minority, but vocal, in the archaeological community worldwide. They have no interest in and therefore sympathy for objects as monuments of antiquity per se, which can tell so much, whether or not their find spot is known—in effect, the holdings of most collections, whether private or public, including the major part of the holdings of most public museums. They can afford to be dismissive of that absorbing interest in objects that over years of scholarship have given everyone, including the public, an insight into the lives and achievements of people otherwise only known from their texts. These have enabled scholars to rebuild a view of antiquity only partly dependent on excavated material.

Renfrew had an unguarded moment years ago when he published a whole collection of unprovenanced Cycladic idols.[6] He has said he was "sorry," a difficult word for a politician today, but scholars were grateful

for the revelation of the material, even if his colleagues then settled down to disputing how much of it was forged, or how it might be better understood through processes of stylistic analysis not much practiced in prehistory. What he had done was the result of a natural scholarly reaction to a body of material, which seemed to deserve to be better known to scholars. I wonder sometimes if it has not been a misplaced guilty conscience that has led him to take up this new anticollecting cause so vehemently, while his political (in national committees and the House of Lords) rather than academic role placed him in a good position to catch the ear of government.

Meanwhile, many well-meaning people, no doubt some reading these words, have been misled into thinking not only that this legislation is just and worthwhile, but also that it is the only way to combat the plundering of sites. They do not realize that the legislation is in fact abetting the loss of objects to scholarly and public perusal, and even encouraging a measure of censorship of scholarship itself.

Our museums are full of objects that speak for themselves, to the public and to scholars, without knowledge of their full or even any provenance. To claim that an object without context is worthless is pure nonsense. Renfrew showed us a famous Greek vase in New York, the interest of which is 98 percent in its sheer existence (we know who made it, when, and where) with only a 2 percent loss in knowledge of what Etruscan grave it came from. It is very far from being unique in this respect; recall my clay snake vase in Oxford. And let me cite a famous object that indeed has an excavated provenance, but one that is almost completely worthless— the famous Celtic Gundestrup cauldron, found in a Danish bog, in circumstances that tell us nothing whatever about its date or significance, beyond the fact that it got to Denmark at some time or other.[7] Its message has to be culled from acute analysis of form and content of figure work, such as is commonly practiced on collection and museum objects, and the one thing that is clear is that it was never made in Denmark. If it had appeared on the market now, Renfrew would condemn all who handled it, some periodicals would refuse to publish pictures of it, and no museum would have dared to touch it. Moreover, it would be denied necessary conservation. It is sad that Renfrew's team and some of like mind are unaware of the scholarly value of "works of art" of the historic period,

whether acquired by wealth, stealth, or regular excavation; sadder, that they have been able to persuade other politicians, at a national and international level, that their crusade is a holy one, and that there are enough folk about today who have no professional understanding of what is at stake and are moved by some sort of misplaced compassion, though for whom or what is not clear.

What suffers is scholarship, our understanding of man's heritage, and public education and enjoyment. And we are clearly losing more than we are saving by pursuing this course. A major threat to scholarship in all this is the censorship practiced by those scholars and others convinced of the wickedness of collecting. Distinguished scholars have had their lectures in Cambridge cancelled because someone has thought some material involved had not been properly, in their terms, acquired. Elsewhere international and other conferences forbid allusion to "suspect" material. The Archaeological Institute of America will not publish or review scholarly work deemed to be contaminated by such material. This is pure censorship. The German Archaeological Institute now takes the same line, admitting that it has to safeguard its status with countries where it excavates.[8] I suppose in these days, when we no longer trust our politicians to tell us the truth, censorship may seem a slight offense. I was brought up to believe that censorship is worse than theft, and especially so where scholarship is concerned.

But, yes, there has grown up an ugly private market in major antiquities deliberately looted. This is criminal and should be treated as such. Where a site is deliberately targeted for the market, and especially if any collector is involved in contracting such work, criminality is at work and should be dealt with as such. I have mentioned the problems about doing this already, but they must be faced at all levels, legal, moral, and scholarly. Renfrew argues that because this is difficult the only thing to do is to attack the ultimate recipient, collector or museum, whatever the nature of the object involved and despite lack of clear proof. Renfrew is a collector himself, even if no longer of sensitive antiquities. I should say that I am not a collector; but I have been an excavator.

The argument holds that since robbing cannot be controlled at its source, it must be controlled, blindly, at its eventual home in a collection,

public or private, and indiscriminately so, regardless of evidence. But this is topsy-turvy. Surely (and the example is the international trade of illegal drugs) it is more appropriate and more effective to target the sources of criminal activity, and especially those middlemen who handle the material long before it arrives in the pockets of street dealers. In terms of the antiquities trade this suggests the need for a far more serious approach by source countries, often with the policing of their own officials, and a far more determined international effort to bring to justice the middlemen and anyone who sponsors such activities, something quite beyond the imagination of UNESCO.

I am sure there are a few quite unscrupulous collectors, but not *what?* many and not publicly known. And I know there have been and may still be some unscrupulous dealers. And I know there have even been unscrupulous auction houses, though this is quite exceptional. All scholars should be grateful for the high standards of publication the dealers and auctioneers now observe. And most of us will be happy to see and study the objects wherever they are to be found: at least they are not under seal in some site museum awaiting a publication that may never happen, nor have they been consigned to the melting pot, or decayed through lack of proper care and declared "tainted."

It is a commonplace by now that the major museums of the world would be nothing without the generosity of private collections. The enterprise and focused expertise of the private individual was the inspiration and fuel for those who saw that public museums were the way to enlighten the public. At a different level, small teaching collections such as are made in universities around the world—and I mean at a level considerably lower that that of the Ashmolean or Fitzwilliam museums, but collections in archaeology or history departments such as one meets everywhere in America, Europe, and Australia—have been built up and continue to be built up where they can, wholly by recourse to an antiquities market, primarily as a result of gifts from private individuals. This is not a market conducted in back-street warehouses, but openly in many cities, through antiquity shops or auctions, often at very modest prices. It is fed still very largely by objects acquired by individuals many years ago and kept in the family, or from collections, which are being broken up. Many may indeed

come from finds, which were, strictly speaking, illegally made, since no archaeologist participated. But my experience of even these objects is that they can be the source of academically important discoveries. University collections are often the only opportunity a student has to observe and handle real objects of antiquity, and they can be a major source of inspiration as well as an encouragement for research.

In fact, in the rape of objects occasioned by recent world events, it has often been the collectors who have saved the record. Take Afghanistan. By refusing to look at pieces found in a country where the rule of law has never been much more than shaky, the lawgivers and some archaeologists have ensured that much has been destroyed and melted down. An initiative in Switzerland to buy such pieces from the market, and save them against better times when they might be returned, received no official blessing, and UNESCO proved simply an excuse for people to look the other way while the record of antiquity was being dispersed. To rescue from such a market may be a matter of purchasing what are technically stolen goods; but not to do so amounts to criminal neglect. Fortunately, some collectors were not inhibited by these attitudes and much has been saved for the public and scholars to learn from, although not in our public museums—yet.

Indeed, some academic subjects have proved to be academically viable only through the activity of collectors and those who study the collections. This is especially true in numismatics where the subject has depended almost wholly on the expertise and judgment of private collectors who have never been slow to share their knowledge and information. It is similar for cuneiform tablets and engraved seals. Seals and coin hoards are very seldom from controlled excavations; I would guess that I am rather a rarity among archaeologists in that I have actually excavated a coin hoard with my own hands—and published it. I have recently been engaged with a similar subject—the bronzes made in north China mainly for their powerful nomad neighbors in the last centuries BC. The entire study depends on collections, starting with Peter the Great of Russia down to the present day. The serious scholarship has been in the hands of those studying and publishing the collections. Excavation in China in the last fifty years has been important, but the Chinese publication record leaves

as much or more to be desired as the British record, and the value of excavation information has to be sought in the work of the publishers of collections who have gone to China to look for it.

So where do we stand with the collectors and a very few wealthy private museums? No sympathy, I think, for those who collect antiquities simply as a sideshow to making money, as investments, rather like buying racehorses. Their interest is prestige, and the objects are acquired for their rarity or assumed aesthetic appeal rather than their scholarly importance. But many collectors, blessed with wealth, are also blessed with perception and scholarly expertise, which they wish to share with the public and scholars. These are often the rescuers of things that would otherwise be lost from sight or in the melting pot. I, and many others, have learned from George Ortiz's and other collectors' expertise and understanding of their purchases. Several major collectors are also benefactors of archaeological projects conducted by universities; such is their zeal for antiquity per se. And there are the smaller collectors, and indeed public and departmental teaching museums, whose intentions cannot be faulted, I believe, on any grounds. Renfrew seems incapable of making any distinction among all these, while the blanket ban that he and his allies have succeeded in imposing is both unrealistic and not at all in the interests of scholarship and the protection of global heritage; nor is it just. The results of extending the notion of Human Rights to Animal Rights, and now Object Rights, must have undesirable and unjust consequences. We need legislation for the world as it is, not as some might like it to be.

We are left with a few basic questions to reflect upon.

Are we overvaluing the record of antiquity, even over that of deep religious conviction, to the point that serious scholarship is threatened by restrictive practices, while the public is also starved of new and evocative material, through ineffectual legislation, now endorsed by self-regarding scholars and politically correct governments who are indifferent to scholarship?

Can we really condone the censorship of scholarship?

What can be made of a law that regards objects with no apparent pedigree, or rather those who handle and study them, to be guilty until proved innocent? This is not natural justice. Objects cannot be "tainted"

or "illicit," but only be so described by scholars who do not understand them, or by legislators. Objects are testaments of antiquity, whether handled by a thief or scholar; their integrity must be respected and their safety assured. To suggest that they should even be destroyed rather than kept in a museum betrays an appalling vacuum of scholarly integrity and responsibility, even philistinism. *could have chosen a better phrase...*

Should we not simply admit the impossibility of controlling the antiques trade, and indeed the undesirability of so doing except where proven stolen goods are involved, as in any other trade? It is in the interests of scholarship, the protection of antiquities, and ordinary justice that such a trade should flourish, however regulated, to serve public as well as private collections. By now there is good self-regulation in most countries (e.g., the Antiquities Dealers Association and an Art Loss Register). It would be easy to devise a monetary ceiling for objects in the trade, which do not seriously call for criminal investigation or ostracism.

Why should anyone have to think twice about buying for a museum an object that they think should be saved for scholarship and public enjoyment? Surely objects found casually or deliberately but perhaps illicitly should be channeled toward museums and collectors who will look after them, and not away from them. The staffs of the British Museum and many other museums feel deeply frustrated now in exercise of their role as guardians of man's heritage for scholars and the public, while collectors, whose interests and experience may be more focused, are to be totally excluded. I read that there has been a drastic slump in museum acquisitions over recent years thanks to the collecting legislation, yet the flow of antiquities to the market at all levels of value and interest is unabated, a fair measure of the futility of the lawmaking. It simply means that more is lost to public and scholarly view. And the big prizes from wholly illegal site-plunder never reach the open market at all. *says who?*

 Why should my own right to collect what I wish be restricted by such an arbitrary cut-off point as insisting on an object pedigree before 1970?

Could anything be more inane than legislation that seeks to cover everything from ancient Egyptian statues to Victorian postage stamps?

The unease that we naturally feel in handling objects of uncertain background should be one that we must accept in the interests of the

preservation and study of antiquity. It is no worse than the unease we all feel at the dubious ethical basis of much that we observe on a daily basis in the working of the law, commerce, industrialism, business, and politics. Is it not the price we must pay in an imperfect modern world for any sort of progress? But in this case, in paying it we at least preserve and do not destroy.

I am committed over a fairly long career to the attempt to understand antiquity through its material remains in conjunction with all other evidence available, but now I, and many others similarly committed, feel that our subject is under threat for no good reason, and from those who should know better. The justifiable rage of many at criminal plunder and marketing of antiquities is merely leading to thoughtless censorship and restrictive practice in the profession they believe they are protecting, as well as the probable, sometimes certain, loss of much that they profess to safeguard.

Briefly, the results of current legislation are:

1. Failure in effective control of looting from sites and museums (largely the fault of source countries).
2. The destruction (melting down by finders) or total neglect (by some archaeologists) of heritage antiquities, which are illogically deemed to be "tainted."
3. Absolute restriction on the collection of many antiquities that deserve protection and study, by museums or private persons.
4. The censorship of original scholarship.
5. The stifling of a legitimate trade.
6. The denial of the right of persons or museums to acquire antiquities that are not demonstrably stolen or the result of plunder, since most are only so deemed, not proved.

The situation is not one that is generally recognized or acknowledged, and it is time to speak out. It has been distorted by emotive accounts of willful destruction and theft, and has been contrived by some archaeologists and legislators, but it is not in the interests of either scholarship or the preservation of our global heritage.

CONTEXTS AND CONTEXTS

It comes down to a very fundamental division in museums. There are
art museums and there are what can generally be called natural his-
tory or history museums. For the latter the context is very important
for the objects. It's all about the history and reconstructing the history
via the artifacts. The art museums have the concept that it is the
object, the aesthetic, that's primary.[9]

The observation is, of course wrong, at any level of interpretation, but it
demonstrates the argument, often proposed by some archaeologists, that
an object is historically worthless if its context of discovery is unknown;
some would say unless they had actually seen it excavated. One's under-
standing of the pursuit of the past through archaeology has to be extremely
limited to hold such views, indeed blinkered. But the slogan that "context
is everything" has an allure for some, especially those out of sympathy
with any form of "collecting," despite the fact that collecting is an activity
far older than "archaeology." It is, historically speaking, the cornerstone
still of most of our understanding of antiquity as it has developed over the
last 250 years. And museum collections not primarily based on excavated
material remain the major resource for teaching, understanding, and
much research.

The quoted statement seems also to imply that the "aesthetic" is to
some degree unscientific. My own view, that art history is a branch of ar-
chaeology that many archaeologists have not the stomach to tackle, may
not be widely shared, but it enables others and me not to ignore any rigor-
ously academic "aesthetic" approach to antiquity and its historical value. I
have had enough experience excavating, publishing excavation reports,
and, especially, trying to understand the excavations of others from pub-
lished reports, to know that an excavated context, as reported, can be very
equivocal. For the majority of excavated pieces precise information is
never available. The scandal of unpublished and inadequately published
material from excavations is one that archaeologists, quick to decry collect-
ing, are willing to acknowledge but do nothing about, while the fact that it

is some way regarded as "my material" will often encourage an excavator from withholding information—an attitude shared by no museum that I know outside source countries, and very few private collectors.

Moreover, "excavated context" is seldom easy to define, even when it is a simple burial.

Objects whose source in the ground (which is not, after all, their true place of origin in antiquity) may not be known are given a real context by scholarship. Moreover, most objects whose source in the ground *is* known also depend on the intellectual context supplied for them by scholarship, of whatever source, often not archaeological at all or in any way dependent on excavation. Think of cuneiform tablets, any inscribed objects, any objects for which expertise of an art-historical nature is required to elucidate their meaning and origin. Authenticity may often be an issue but can usually be resolved by science or by application of the sort of expertise involved in reading cuneiform or deciphering iconography or individual style. Archaeologists who decry the value of stylistic and iconographic analyses are usually hampered by their unwillingness or inability to practice them themselves. Yet the analysis of form and shape is in no way different from the practices of early archaeology on everything from flint implements to major architecture, practices on which modern archaeological research is still based.

A good example of a puzzlingly important artifact, a crucial one for Celtic archaeology, is the Gundestrup bowl, already mentioned above. There are many comparable examples. The excavated context of the Persepolis Fortification Tablets is roughly recorded. Their immense historical value depends totally on the tablets themselves and study of their texts and the iconography of the sealings upon them. Had they appeared from nowhere on the market their value would not be lessened, yet any comparable hoard that appeared, from nowhere, today, would be in danger of being denied proper study and publication, denied conservation, possibly even, if some have their way, destroyed.

The concept of "context" has been prominent in the recent discussion about the sending of the Euphronios krater to Italy from the Metropolitan Museum in New York. It was made in Athens for a pagan (in our terms) society whose cultural heritage is nevertheless claimed by a Christian

Orthodox country. Its decoration declares the religious beliefs of its mak-
ers (the roles of Sleep and Death, and a god). It was never publicly exhib-
ited in antiquity (at best in a shop), but must have quickly joined a consign-
ment to ancient Athens' best customer for quality vases: Etruria, another
pagan society now in a Christian Orthodox (of different persuasion) coun-
try. There it may not have lingered long above ground before joining the
prestigious furniture of an elite tomb. Two thousand years later Christian
(no doubt) excavators illegally (according to the current law) removed it and
sent it on its way to New York, where it has pleased and instructed thou-
sands of visitors who rightly regard it as part of their cultural heritage, on
the same grounds as might Greece or Italy, where such finds are common-
place. No need at this stage to consider closely the rights or wrongs of any
modern nation claiming ownership on whatever grounds—production,
deposition in a tomb, exhibition—since each process is a product of com-
merce in the service of customers. What of the loss of context? In Greece,
in a potters' yard, it might be imagined. In the Etruscan tomb it might
also be imagined but more store might be set by details of the tomb in
which it was laid.

The latter is claimed most expressly by the Archaeological Institute
of America's recent president, Jane Waldbaum, who asked: "Who was the
owner? . . . Was he a local warrior who identified with the hero depicted
on the vessel? What else could have been found with it? Was it part of a
set of related vessels? If so were they all made and decorated by the same
artists or by different ones? Had they been used in a ritual meal or other
funerary ceremony, as indicated by other artifacts or traces of organic
materials found in the tomb? Were there paintings on the walls of the
tomb and did they relate to the funerary scene on the vase?"[10]

Experience with other Etruscan tombs suggests that none of these
questions could be answered by knowledge of all details of any one burial.
Answers, if there are any to be had, depend on knowledge of far more,
and of more than just burials, and the questions themselves beg many
other questions. They have been and continue to be debated endlessly.
Yes; it would be good to know the details of the krater find and cofinds
and we mourn their loss, but we might mourn even more the loss of the
krater itself, which is, in its own right, a historical monument, even an art-
historical monument, which any archaeologist should be able to recognize,

appreciate, and learn from. If, for instance, the krater had been found in a temple votive deposit, much the same questions might have been asked of it and with no better likelihood of answers despite total knowledge of excavated context; or rather, answers would have depended on much more than detail of context in the ground, and mainly not dependent on observed excavation at all. It might, for instance, simply have been "found" with a dedicatory inscription.

On its own, as an object that just appeared, it has much to tell, and we have much that we can tell about it. The eye and science will attest that it is a genuine antiquity, and tell where it was made. Inscriptions on it tell the name of the artist. The subject matter is understood from inscriptions and knowledge of comparable scenes. What the subjects meant to maker, merchants, or buyer is open to speculation and would not have been materially helped by knowing its excavated context unless the circumstances were quite exceptional and unprecedented. All indications so far from the many finds of such vases with a provenance outside Greece suggest that the significance of shape and decoration was primarily determined by commercial considerations. What is important is that its context in terms of our knowledge of ancient vases, their marketing and use, in terms of religion, mythology, and pottery-use, is abundantly clear to us.

A good excavated context is indeed a valuable starting point, but not always. And to deny validity to objects not excavated simply rules out of consideration centuries of scholarship and the expertise of scholars of many disciplines. It could lead to diminishing the role of our public museums as educators of the public and repositories of ancient objects. We live in a world where ideals can never be realized. While the law must be upheld, the foundations on which some laws are based need questioning, especially since it is clear that, over time and space, very differing views on what should be legally permissible in such matters have prevailed, and that these have little to do with "right and wrong." Understanding and enjoyment of our past and our future may be at stake.

NOTES

1. Colin Renfrew, *Loot, Legitimacy, and Ownership: The Ethical Crisis in Archaeology* (London: Duckworth, 2000). My essay was first published in

E. Robson, L. Treadwell, and Chris Gosden, eds., *Who Owns Objects? The Ethics and Politics of Collecting Cultural Artefacts* (Oxford: Oxbow Books, 2006), and is here reprinted, modified, and abridged for the current publication.

2. See S. Stoddart and C. Malone, Editorial, *Antiquity* 75 (2001): 233–40.

3. R. M. Cook, "Excavations and the Antiques Trade," in *Periplous: Papers on Classical Art and Archaeology Presented to Sir John Boardman*, ed. G. R. Tsetskhladze, A. J. N. W. Prag, and A. M. Snodgrass (London: Thames and Hudson), 68–69.

4. The McDonald Institute for Archaeological Research.

5. W. Geominy, "Antikenmuseen in der Zwickmühle," in *Bewahren als Problem: Schutz archäologischer Kulturgüter*, ed. M. Flashar (Freiburg: Rombach, 2000), 91–100.

6. Colin Renfrew, *The Cycladic Spirit: Masterpieces from the Nicholas P. Goulandris Collection* (New York: Harry N. Abrams, in association with the Nicholas P. Goulandris Foundation, Museum of Cycladic Art, Athens, 1991).

7. See A. Willemoes, *Hvad nyt om Gundestrupkarret, Nationalmuseets Arbejdsmark* (Copenhagen, 1978), and A. K. Berquist and T. F. Taylor, "The Origin of the Gundestrup Cauldron," *Antiquity* 61 (1987): 10–24.

8. H. Kyrieleis, "Die Position des Deutschen Archäologischen Instituts," in Flashar, ed., *Bewahren als Problem*, 163–66.

9. Ellen Herscher, former director of international programs for the American Association of Museums and past chair of the Archaeological Institute of America's cultural property legislation and policy committee, in *Archaeology* 59, no. 2 (2006): 14.

10. Jane C. Waldbaum, "From the President: Untold Stories," *Archaeology* 59, no. 4 (2006): 4.

Censoring Knowledge: The Case for the Publication of Unprovenanced Cuneiform Tablets

David I. Owen

CORNELL UNIVERSITY

> To decline the publication of all unprovenanced material
> would be an unforgivable scholarly mistake, to the detriment
> of all future generations, to whom such information may be
> lost forever.[1]

> Failure to produce a full published excavation report is simply
> tantamount to wanton destruction of an archaeological site. . . .
> The excavation of a site is never warranted unless
> comprehensive publication is undertaken, nor is the excavation
> complete until publication . . . is ended.[2]

It IS, PERHAPS, ironic to be arguing the value of publishing unprovenanced cuneiform records. It should be self-evident that a scholar's role is to promote knowledge, not to censor it, to publish new finds, not to ignore them, and to preserve those finds, not to relegate them to oblivion. Yet here I am arguing this very issue. The general assertion made by many archaeologists that artifacts without provenance have little historic value has impacted heavily on the publication of cuneiform tablets, many of which have become available in recent years primarily, but not exclusively, as a result of the two Gulf wars. Archaeological societies have instituted bans on the publication of cuneiform texts in their sponsored journals and have lobbied not just to suppress or censor publications but even not to make references to such texts in print or in conference presentations.

For well over a century scholars have been recording and publishing unprovenanced cuneiform texts—clearly the majority of all texts published—on which is based much, if not most, of our detailed knowledge of the history, literature, religion, and culture of ancient Mesopotamia, Syria, Anatolia, and Egypt. In the aftermath of the two Iraq wars and the elimination of the brutal suppression that characterized the Saddam Hussein regime, looted artifacts, including many cuneiform texts, began appearing on eBay in increasing numbers and sold via Web sites and antiquities shops. Many were acquired by private collectors. A substantial number of these artifacts, particularly cuneiform texts, contain highly significant historical, cultural, literary, lexical, religious, and economic information that is either new to the field or contributes much to earlier knowledge that was based on both provenanced and unprovenanced finds.

Cuneiform texts are indispensable tools not just to philologists and historians but also to archaeologists. They restore the flesh on the bones they excavate and provide greater understanding of the mute structures they uncover. I am addressing this issue because the tragic situation that has developed with the antiquities of Iraq has resulted in an unprecedented reaction by certain archaeologists who now advocate the censorship and suppression of knowledge in a futile, if well-intentioned, attempt to stem the looting of archaeological sites. Censorship, albeit with the best of intentions, is simply not acceptable, particularly, but of course not exclusively, to the world of scholarship.

ON THE PUBLICATION OF UNPROVENANCED CUNEIFORM TEXTS

Current cuneiform text publications make it obvious how crucial it is that unprovenanced tablets, which have appeared in various Internet sites and in private collections, be recorded and published as quickly as possible before they disappear.[3] They fill gaps in the historical, lexical, social, and economic knowledge of the Ur III and other periods and sometimes provide significant additions to archival groups already known from both excavated and unprovenanced finds. Furthermore, the publication and

analyses of these texts provide important clues that facilitate the identification of archival groups now scattered as well as to the location and identification of sites that may yet be located and excavated. It is a primary responsibility of scholars to ensure that such artifacts and the information they contain be preserved, recorded, and disseminated—not ignored, hidden, or stored in some inaccessible repository. It is no secret that once texts are confiscated and held either by the authorities or returned to museums, they are placed in a kind of limbo, usually without access by scholars, and are rarely, if ever, published. Ironically, texts in the public domain often do get published or are otherwise recorded by scholars. Thus, had I not recognized the coherence of specific groups of scattered tablets, crucial information would simply have been lost or remained inaccessible.

The current efforts in the United States, United Kingdom, and Germany to suppress the publication of unprovenanced inscriptions (and artifacts) are, in my opinion, ill conceived and harmful. They compound the tragic loss that has befallen Iraq's cultural heritage before, between, and after the two Gulf wars. This suppression of knowledge is unacceptable, particularly to someone who has devoted much of his career to publishing primarily unprovenanced inscriptions in museums, universities, and private collections.[4] Given the current conditions in Iraq, it is incumbent upon scholars to rescue, conserve, record, *and publish any and* all artifacts that have been torn from their original contexts by looters. In this way, and only in this way, can we insure that this small percentage of intact remains will not be added to the lengthy list of those already lost or destroyed.

My publications (and others as well) represent a concerted effort to reconstruct archival groups from widely diverse sources before many of the scattered tablets disappear forever. The fact that it is acceptable to publish unprovenanced texts in museum collections or those confiscated by the authorities, while texts in the public domain are banned by various journals and organizations, defies logic.[5] The uncompromising and unsubstantiated position that lack of context negates the historical value of artifacts certainly does not hold true for inscriptions. Inscriptions regularly provide substantial information even without archaeological context while recognizing, of course, that context provides an additional and significant,

often unique, dimension of evidence.[6] The publication of these inscrip-
tions should, in no way, suggest or imply that I support or condone either
looting or the illegal antiquities trade. It is only a personal attempt to sal-
vage some of the pitiful remnants of our collective, not just Iraq's, cultural
heritage left intact by looters.[7] Those who oppose such publication offer
no viable solutions, only empty rhetoric.

So extreme have these positions become that one archaeologist has
gone so far as to equate those who publish unprovenanced finds with
drug dealers, murderers, and supporters of terrorists, and another has
even advocated the killing of looters.[8] The recent article by Laura de la
Torre is replete with exaggerated statistics without any sources other than
unsubstantiated rumors attributed to the usual purveyors of misinforma-
tion.[9] Archaeological societies have used their influence to create restric-
tions on publications. They have lobbied governments to impose Draconian
laws, and have otherwise restricted publication and even debate. Further-
more, the banning of reports on unprovenanced artifacts by archaeologi-
cal organizations has severely restricted the discussion and dissemination
of highly important historical, literary, and cultural materials to the detri-
ment of scholarship.[10] Even anniversary and memorial volumes have re-
jected articles that attempt to publish or even refer to unprovenanced arti-
facts, as though this will somehow reduce the looting of, and trade in,
antiquities.[11] None of this has been shown to diminish the level of looting
and destruction of archaeological sites or to curtail the illegal trade in an-
tiquities. The only result has been the loss of significant data for the study
of Mesopotamian civilization.[12]

Furthermore, the use of unsubstantiated rumors[13] in the form of
distorted facts[14] and character assassination[15] as tools to further self-serving
goals have polarized the field of ancient Near Eastern studies, intimidated
younger scholars, and deterred collectors from opening their collections
for study and publication. Most offensive has been the hypocrisy charac-
terized by the nearly total lack of criticism by archaeologists of the govern-
ments (sometimes fascist and totalitarian) and departments of antiquities
with which they work for fear that their permits or visas would be rejected
or cancelled. The failure to condemn or even openly discuss human rights
abuses, widespread corruption, unqualified officials, and an appalling record

of unpublished excavated sites only highlights the single-issue perspective presented by archaeological societies. In addition, the destruction of archaeological sites due to the accelerated construction of dams, roads, urban expansion, deep plowing, and military installations has surely resulted in an even greater cultural heritage loss than has been created by looting.[17] However, these relevant and significant issues, for the most part, have been ignored or overshadowed by the heated discussion over looting and the publication of unprovenanced artifacts. It is particularly ironic that those who often do not publish their own excavations are the very ones who are most committed to stopping the publication of inscriptions and other unprovenanced artifacts.[18] One might expect that the world of scholarship would reflect a more rational and intelligent approach. Unfortunately, it has not.

The publication of inscriptions in professional, scholarly journals must be separated from the issue of antiquities trade, legal or otherwise. The argument that scholarly publications somehow enhance the value of artifacts while glossy, popular, archaeological publications with titles featuring words like "gold" and "treasure" to glamorize discoveries and to attract more funding somehow do not, is ludicrous. Are we to discourage these publications because they emphasize the priceless nature of these discoveries? Surely not. Publication assures the registration of unprovenanced artifacts and the dissemination of information about artifacts that otherwise will make no contribution to history. Anyone visiting a museum, whether in Baghdad, Cairo, New York, or anywhere else, is dazzled by the wealth on display. Surely it is not a publication in some arcane scholarly journal that emphasizes that antiquities have monetary value. By the time a scholar publishes a tablet from a private collection the value of that tablet has already been established and the tablet is rarely, if ever, resold. Thus its value has nothing whatsoever to do with scholarly publication in journals or elsewhere. Publication does not hurt the value of a tablet but neither does it substantially increase the value if the tablet had been correctly identified in the first place, although there might be a slight increase in its prestige value. Sometimes the publication of a tablet in a private collection may well reduce its value when its proper identification reveals it to be a common economic record or is revealed to be something

quite different from what it was originally described (such as a misidenti-
fied literary text). In the end, governments and courts must decide on the
legality and ownership of antiquities, and a better system of local compen-
sation for finds must be created to keep objects out of the hands of looters
and dealers. For their part, scholars must ensure that the artifacts are pre-
served and published. These goals are hardly contradictory and do not,
nor should they not, interfere with one another.[19]

The crisis in which we now find ourselves will hardly be resolved by
the uncompromising stance that some archaeologists and their organiza-
tions present. Lawrence Stager has characterized those archaeologists who
refuse to work with unprovenanced finds as "jihadists" because they take
the "ridiculous position" that scholars should refuse to undertake research
on such artifacts.[20] I concur fully with his assessment. We all share the
great and tragic loss that the looting of Iraq has created (and we should
not forget what continues to happen in Central Asia, Iran, Afghanistan,
Syria, Turkey, Greece, Italy, Egypt, the Sudan and Africa at large, South
and Central America, etc.). If this divisive policy persists, it will only ac-
celerate the loss of artifacts that have been scattered the world over. First
and foremost unprovenanced artifacts and inscriptions must be recorded
and published. At the same time concerted efforts also must be made by
local and international authorities to eliminate the organized looting and
smuggling of antiquities. Easier access by scholars must be assured to fa-
cilitate the cataloguing and publication of these materials so that the huge
volume of inscriptions and artifacts concentrated in the major museums
of the Middle East might be better known and utilized. Stopping or restrict-
ing publication is not going to serve anyone's purpose let alone curtail the
destruction of archaeological sites.[21]

NOTES

This is a revised and expanded version of two lectures delivered respectively
at the New York Public Library symposium, "Museums and the Collecting of
Antiquities Past, Present and Future" and at the 2006 Annual Meeting Amer-
ican Schools of Oriental Research, Washington, DC, special session, "Un-
provenanced Cuneiform Texts: Does Context Really Matter?" It also appears

in a modified version in my *Unprovenanced Texts Primarily from Iri-Saĝrig/ Āl-Šarrāki and the History of the Ur III Period*, NISABA 15 (Messina: Di.Sc.A.M., 2008).

1. Bendt Alster, "One Cannot Slaughter a Pig and Have It: A Summary of Sumerian Proverbs in the Schøyen Collection," *Orientalia* n.s. 75 (2006): 91n1.

2. Colin Renfrew, "The Great Tradition versus the Great Divide: Archaeology as Anthropology," *American Journal of Archaeology* 84 (1980): 287–98, on 289.

3. The sale of tablets on eBay continues as it does on sites of antiquities dealers, often allegedly from older collections. Since 2003 when I, along with the *Cuneiform Digital Library Initiative* (hereafter CDLI, http://cdli .ucla.edu/digitlib.html) and the *Base de Datos de Textos Neo-Sumerios* (hereafter BDTNS, http://bdts.filol.csic.es), began monitoring the Internet, fewer than five hundred genuine, as opposed to fake, tablets have been recorded, a far cry from the hundreds of thousands of tablets that certain archaeologists allege to have been smuggled out of Iraq. Wherever I have been able to identify texts in these sites they are posted on the CDLI and BDTNS sites. Many of them are being included in my publications even when the photos of tablets were not sufficiently clear to be read in their entirety. They are, therefore, documented and can be used for further research and subsequent identification by the authorities. I am grateful to Robert K. Englund at the CDLI and Manuel Molina at the BDTNS for their cordial cooperation. They too are making a concerted effort to record and make available all texts that are appearing in these and other venues.

4. See, among others, my *Neo-Sumerian Texts from American Collections*, Materiali per il Vocabolario Neosumerico, vol. 15 (Rome: Multigrafica Editrice; Unione Accademica Nazionale, 1991); "Cuneiform Texts in the Arizona State Museum, Tucson" (with Ewa Wasilewska), *Journal of Cuneiform Studies* 52 (2001): 1–53; "Cuneiform Texts in Utah Collections" (with Ewa Wasilewska), in *If a Man Builds a Joyful House: Studies in Honor of Erle Verdun Leichty*, ed. M. deJ. Ellis, Ann Guinan, and M. Walters (Leiden: Brill, 2006), 259–96; and most recently, *The Garšana Archives*, Cornell University Studies in Assyriology and Sumerology, vol. 3 (Bethesda: CDL Press, 2007), and *Uprovenanced Texts Primarily from Iri-Saĝrig/Āl-Šarrāki and the History of the Ur III Period*, Studi Assiriologici Messenesi Collana del Dipartimento di Scienze dell'Anticho dell'Università, hereafter NISABA 15 (Messina: Di.Sc.A.M., 2008), each of which publishes substantial new archival sources from sites hitherto undocumented or otherwise identified.

Some scholars now leading the crusade to suppress the publication of unprovenanced inscriptions have, in the past, used such texts to further their own research; e.g., E. C. Stone and D. I. Owen, *Adoption in Old Babylonian Nippur and the Archive of Mannum-mešu-liṣṣur*, Mesopotamian Civilizations 3 (Bethesda: CDL Press, 1991), although the texts that formed the basis of this publication were acquired before the 1970 date after which, in theory, Stone would have excluded them from this study. These, and numerous other, "unprovenanced" texts would have remained unknown or ignored had these efforts not been made. Such texts have provided, and continue to provide, significant and essential data for all periods of Mesopotamian history in spite of the fact that they are "unprovenanced" and devoid of archaeological context. In fact, they offer archaeologists a far better understanding of the sites they excavate by providing details of daily life; agriculture; trade and economy; social organization of cities, towns and villages; construction of buildings; and numerous other details that are impossible to recover from material remains alone. They also sometimes augment archives that were found in context. The assertion that "context is everything" is simply not valid, at least when it comes to cuneiform texts.

5. Such is the current case with the *Journal of Cuneiform Studies*, the major outlet for the publication of cuneiform studies in the United States, under the restrictive guidelines established by the executive committee of the American Schools of Oriental Research (ASOR), even though its editors unanimously support the publication of such inscriptions. Note the harsh criticism of the ASOR policy and strong support for the publication of unprovenanced West Semitic inscriptions expressed recently by Frank Moore Cross, *Bulletin of the American Schools of Oriental Research*, hereafter *BASOR*, 31 (2005): 58–60; Othmar Keel, "Defending the Study of Unprovenanced Artifacts," *BASOR* 31 (2005): 56; and Hershel Shanks, "Unprovenanced and Unpublished," *BASOR* 33 (2007): 64. Note also my comments in *Science* 309 (September 16, 2005): 1816, partially quoted in *BASOR* 32 (January/February 2006): 65. See also the eloquent albeit harsh criticism by John Boardman of the current archaeological position, "Archaeologists, Collectors, and Museums," this volume, chap. 5. I quote here one pointed remark, "I was brought up to believe that censorship is worse than theft, and especially so where scholarship is concerned." I could not agree more.

6. Not all archaeologists share this narrow viewpoint. It was reassuring to hear in the remarks of Robert McC. Adams at the opening session of the 51st Rencontre Assyriologique Internationale, Chicago, July 18, 2005, in

which he supported such publication given the current conditions in Iraq. The "context" issue was discussed in the special session, "Mesopotamia I," held at the annual meeting of the American Schools of Oriental Research, Washington, DC, November 16, 2006. The participants, P. Michałowski, D. I. Owen, M. Tanret, and R. Zettler, all support the publication of unprovenanced cuneiform texts. My paper, "Unprovenanced Cuneiform Texts: Does Context Really Matter?" was presented at this session and was a summary of many of the thoughts expressed here.

7. For a philosopher's sensitive perspective coupled with rational suggestions, see Kwame Anthony Appiah, "Whose Culture Is It?" reproduced in the current volume. This should be read by anyone interested in the concept of "cultural heritage" even if the article lacks an appreciation and understanding of archaeological methodology and context. The issues of cultural heritage, the acquisition of antiquities, and looting were discussed and debated in the public forums, "Who Owns Art," organized by the *New York Times* on March 6, 2006, at the New School and "Museums and the Collecting of Antiquities: Past, Present and Future," on May 4, 2006, at the New York Public Library.

Another myth frequently disseminated by archaeologists is that looters only select complete tablets and discard the majority of broken or fragmentary ones. If so, careful surveys of the looted sites should then produce these presumably numerous fragments and allow us to identify those sites from which the complete tablets derive. However, anyone who follows the sale of tablets on the Internet or has seen the photos of the boxes of fragments confiscated by the authorities knows immediately that the bulk of this material is, in fact, made up mostly of fragments. Furthermore, many of the seemingly "complete" tablets are often composed of fragments of different tablets pasted together to form what is supposed to look like complete texts to the untrained eye, all suggesting that the looters try to use whatever they dig up. This kind of misleading information is indicative of the statements often promulgated by certain archaeologists, notably McG. Gibson, E. C. Stone, and D. George, especially in the popular media, as documented by Alexander H. Joffe, "Museum Madness in Baghdad," *Middle East Quarterly* (Spring 2004), available at http: //www .meforum.org/pf.php?id= 609.

8. So McG. Gibson, 51st Rencontre Assyriologique Internationale, Chicago, July 18, 2005, opening session. His remarks did more to undermine his position than to promote any positive results. He echoes the statements of Matthew Bogdanos who maintains that looting supports terrorism without ever, so far at least, providing any solid evidence for this assertion

(cf. most recently his *New York Times* op-ed piece, March 6, 2007, where he states, without attribution, that "but what if they understood that the plunder of Iraq's 10,000 poorly guarded archaeological sites not only deprives future generations of incomparable works of art, *but also finances the insurgents* [my emphasis]?" Also, M. Bogdanos and W. Patrick, *Thieves of Baghdad* (New York: Bloomsbury, 2005), 249, and the critical review by Peter K. Tompa, "Specifically, Bogdanos buys into the claim that some big-ticket items were stolen based on some long-standing orders from moneyed collectors (p. 215) and then exaggerates a supposed link between collectors and terrorists (p. 249). It should give some pause to the reader that the source for the former allegation is none other than Ahmed Chalabi, the discredited purveyor of fabricated information about weapons of mass destruction, while the latter claim appears to be based solely on one seizure of some 30 artifacts from some suspected insurgents," http://accg.us/issues/news/ review1.

Similar assertions have been made also by Brian Rose (a University of Pennsylvania classical archaeologist and current president of the Archaeological Institute of America), via Katie Vasserman, "Archaeology professor gives troops lessons on preserving the past in Iraq, Afghanistan," *Daily Pennsylvanian*, February 15, 2006, who quotes Rose, "It's very much a part of terrorism. People sell these antiquities, and they use it to fund terrorist goals of their own," he said." Marines have found stolen antiquities together with whole caches of weapons and bombs."

There does not seem to be any reliable documentation for these assertions or any evidence that such finds are either widespread or even factual, as is evident from the most recent article by Susan Breitkopf, "The Looting of Iraq's Antiquities," *Museum News* (January/February 2007), where statements such as, "it is rumored," "sources say," "circumstantial evidence suggests," and such, abound. Of course the sources are almost always McG. Gibson, D. George, M. Bogdanos, and always without any specific details.

Gibson again, in a recent note, continues with these vague and undocumented statements: "*reports* [my emphasis] that some of the insurgency is being funded by the illegal trade in antiquities . . ." ("Nippur and Umm al-Hafriyat," *The Oriental Institute 2005–2006 Annual Report*, Chicago, 2006, p. 86). On the contrary, the recent *New York Times*, November 26, 2006, article by John F. Burns and Kirke Semple, "U.S. Finds Iraq Insurgency Has Funds to Sustain Itself," never once mentions antiquities as a source for terrorist financing. Nevertheless, although I have no doubt that such things might occur, it is true also that terrorists will steal and

sell virtually anything to further their goals as they wantonly destroy historic and sacred sites, life, and property, with seeming impunity. It remains to be determined if, specifically, the systematic looting and sale of antiquities are playing any significant role in the financing of terrorism and, if they are, should we be doing something more assertive to rescue and save those antiquities other than banning publications?! The suggestion by Bogdanos, via Breitkopf, that "Iraq needs 50,000–75,000 security and support staff, supplies such as vehicles, weapons, radios and fuel, and training and living quarters" to protect its sites is unrealistic and beyond the capacity of either the Iraqi or the American forces, which cannot even secure the cities.

 E. C. Stone speaking at the 49th Rencontre Assyriologique Internationale, London, July 7, 2003, as quoted in the *Guardian*, July 8, 2003 and in Joffe, "Museum Madness in Baghdad."

9. Laura de la Torre, "Terrorists Raise Cash by Selling Antiquities," *Government Security News* 4/3 (2006): 9–15.

10. The American Schools of Oriental Research, the Archaeological Institute of America, and the International Congress of the Archaeology of the Ancient Near East, and now the Deutches archäologisches Institut, will not accept any reports for their journals or even discussion of unprovenanced artifacts at their conferences no matter how significant; but they routinely accept articles from excavators who have not published final reports for years or even decades. As I have written elsewhere, "looting is the uncontrolled destruction of sites, excavation is the controlled destruction of sites. Without publication the end result is the same—loss of knowledge," a sentiment echoing that of Colin Renfrew quoted above in note 2.

 The large percentage of partially published or entirely unpublished excavated sites, the central problem in archaeology today, is rarely, if ever, addressed within the resolutions of archaeological societies and conveniently ignored in the current text of the Archaeological Institute of America (AIA) publications policy as amended in 2004. It reads: "As a publication of the Archaeological Institute of America, *American Journal of Archaeology* (hereafter, *AJA*) will not serve for the announcement or initial scholarly presentation of any object in a private or public collection acquired after December 30, 1973, unless its existence is documented before that date, or it was legally exported from the country of origin. An exception may be made if, in the view of the Editor, the aim of publication is to emphasize the loss of archaeological context. Reviews of exhibitions, catalogues, or publications that do not follow these guidelines should state that the exhibition or publication in question includes material without

known archaeological find spot. At no time was an attempt made to 'blame the object' or to prevent the scholarly discussion of archaeological objects or materials already in the scholarly record."

In the words of Naomi Norman, current editor-in-chief of the *American Journal of Archaeology*, "The clear intent of the policy was not to enhance the market value or importance of these objects by giving them the imprimatur of the AIA by publishing them for the first time in the AJA."

In clarification of the modified policy she stated: "The intent here is to keep the checkered past of an object out in the open and part of the continuing scholarly discussion of that piece. All too often, once a piece gets 'proper scholarly presentation' and the debate begins, scholars forget that the object is without archaeological context and may have come to the market illegally. . . . The point is to remind us all of how much information and value is lost when an object is illegally removed from its archaeological context" (*AJA* 109 [2005]: 136). Of course it does not mention how much more is lost by not publishing these new sources! There is not a word about the even greater loss when excavated sites are never published or how to deal with archaeologists who persist in excavating sites without producing any final reports. The recent article by Oscar White Muscarella, "The Excavations of Hasanlu: An Archaeological Evaluation," *BASOR* 342 (2006): 69–94, brings to the fore, in critical detail, the case of Hasanlu in Iran where inadequate or misleading preliminary publications have distorted scholarship, and the site effectively remains unpublished after a half century. Furthermore, no evidence is provided to demonstrate how scholarly publication of artifacts already in private collections enhances their market value when they have already been purchased and their value already established.

11. For example, the forthcoming *Jeremy Black Memorial Volume* (*Alter Orient und Altes Testament*, 2008). Ironically, E. Robson, one of the editors and an outspoken opponent of the publication of unprovenanced texts (e.g., see her review of A. R. George, *The Babylonian Gilgamesh Epic: Introduction, Critical Edition, and Cuneiform Texts*, 2 vols. [Oxford: Oxford University Press, 2003], in *Bryn Mawr Classical Review* 2004.04.21), recently published one such text (*Orientalia* n.s. 74 [2005]: 382–88), a journal obviously not subject to the pressure of archaeological societies, with the excuse that she convinced the owner not to buy tablets again! She obviously recognized this tablet was much too important to let it disappear and, according to her, was encouraged to do so by, among others, none other than the lamented Jeremy Black. Thus her conscience permitted her to publish it, albeit not in England, where it would not have been possible, but in a Vatican journal. I applaud her decision and support and encourage

such publication. I am pleased that others are supporting this position as well. Subsequently, Bendt Alster, coincidentally writing also in *Orientalia*, defended the publication of unprovenanced inscriptions (*Orientalia* n.s. 75 [2006]: 91n1, quoted above) and added another in his *Sumerian Proverbs in the Schøyen Collection*, Cornell University Studies in Assyriology and Sumerology 2 (*Manuscripts in the Schøyen Collection Cuneiform Texts* II) (Bethesda: CDL Press, 2007), xi.

Similarly, Jöran Friberg, in the acknowledgments to his *A Remarkable Collection of Babylonian Mathematical Texts* (*Manuscripts in the Schøyen Collection Cuneiform Texts* I) (New York: Springer Verlag, 2007), vii, writes that, "in an ideal world, unprovenanced texts coming from the antiquities market would not exist. In the real world, where such texts do exist, some people excitedly claim that serious scholars should have nothing to do with them, for various contrived reasons. However, one must keep in mind that great parts of most collections of non-European cultural heritage, even those of the greatest museums in Europe and the United States, are unprovenanced texts from the antiquities market or from private collections. Thus, for instance, the classical works about mathematical texts, *Mathematische Keilschrift-Texte* by Neugebauer, 1935–1937, and *Mathematical Cuneiform Texts* by Neugebauer and Sachs, 1945, would never have appeared if their authors had refused to work with texts without known provenance. Now, as then, the task of a serious scholar must be to attempt to make all kinds of texts publicly known and understood, and to try to trace the origin of the texts if it is not known."

Yet, in spite of the major importance that these new data provide for the history of mathematics, the editor of the *American Mathematical Monthly* (hereafter, *AMM*) refused to publish Friberg's summary article on these cuneiform texts because an anonymous, single reviewer stated that, "the subject of this paper is widely believed to have been illegally excavated and smuggled from Iraq. No reputable academic journal in archaeology or ancient Middle Eastern studies would consider it for publication." In a sharp rebuke to the editor of the *AMM*, the Cornell University distinguished mathematician, Anil Nerode, wrote that, "the manuscript you rejected (apparently based on a single referee's report that does not question the authenticity of the tablets or the correctness of the translations or the qualifications of the author, a referee who makes an unsubstantiated provenance allegation not corresponding to any legal claim made by any entity) is an account of the most spectacular find in Babylonian mathematics since the early days of 'Neugebauer' at Brown, or possibly ever. It pushes the Babylonian discoveries we (including me this semester) teach in our history courses back by a millennium. . . . This paper has

more significance than 999 out of 1000 papers published by *AMM*" (e-mail, March 2, 2007).

Thus certain journals are rejecting highly significant articles based not on scholarly merits but on unsubstantiated "beliefs" and misleading statements by an anonymous reviewer—e.g., that "no reputable academic journal . . . would consider it for publication"—when, in fact, the majority of major journals in the field of ancient Near Eastern studies not controlled by archaeological societies (such as *Orientalia, Zeitschrift für Assyriologie, Revue d'Assyriologie, Kaskal, Journal of the American Oriental Society,* etc.) regularly publish articles that include unprovenanced texts.

Nevertheless, more such publications and statements of support will surely follow as scholars recognize their professional and moral obligations to rescue this important material, before it is lost forever, against the well-intentioned, but misguided, objections of certain archaeologists and a minority of philologists.

12. The tragic situation in Iraq is different from many other places perhaps only by the current scale of its looting that, in fact, may not even be greater than what is happening in other countries. Noted above are the problems on Cyprus. But even lesser publicized areas such as Iran, Afghanistan, and Macedonia are being heavily looted. See, for instance, the recent article, "FYROM Treasures Looted," in *Kathimerini*, English edition, January 3, 2007, where it is stated that "Among the estimated 1 million artifacts to have been smuggled out of the country since independence in 1991 are jewelry, decorative ornaments, weapons and the armor of ancient foot soldiers, and statues." Clearly, Iraq is only a part of a much larger problem.

13. The deplorable role played by the media, misled by museum officials and particularly by archaeologists McG. Gibson, E. C. Stone, and J. Russel, was the subject of a highly detailed, well-researched, and very critical article on the events surrounding the looting of the Iraq Museum published by the archaeologist Alexander H. Joffe in his "Museum Madness in Baghdad." Joffe's documentation lays bare the distortions, unfounded rumors, and misleading statements promulgated by those archaeologists and by the former director of the Iraq Museum, Donny George. Joffe revealed the highly questionable and often unethical and immoral behavior that these and other archaeologists practiced to foster their own careers and ends while, at the same time, acting as if they were the ethical and moral compasses for their peers. As Joffe wrote:

> "Working in a wretched totalitarian country was a conscious choice for archaeologists as it was for businessmen. . . . But archaeologists submitted paperwork to the Iraqi State Board of Antiquities and

Heritage, knowing full well that staff lists would be vetted by Iraqi intelligence. European and American Jews, among the pioneers of Mesopotamian archaeology during the first half of the twentieth century, were systematically excluded from participation, as they still are in Syria and Saudi Arabia. No one protested.

The teams did their fieldwork under the watchful eye of government minders, came back, kept their mouths shut about whatever they might have seen or heard, and not infrequently sang the praises of Hussein, at least his treatment of archaeology. Access was everything . . . (*Middle East Quarterly* [Spring 2004], available at http://www.meforum.org/pf.php?id=609).

Of course this meant that nearly all Jewish colleagues and students, in addition to those colleagues with connections to Israel, were eliminated from participation in any excavation or research conducted in Iraq as well as from participation in the publication of the results of such work. These practices continued without any protest for, as Joffe wrote, "access was everything." One might add the near total silence by archaeologists over the Iraqi attempt to destroy the cultural heritage of Kuwait during its invasion of that country (for a view of the role of the Iraq Museum officials in the looting of the Kuwait Museum, see the article by Selma Al-Radi, "War and Cultural Heritage: Lessons from Lebanon, Kuwait and Iraq," *Actueel* [October 2003], available at http://www.powerofculture.nl/nl/artikelen/war and cultural heritage.html#).

The high ground on which certain archaeologists claim to stand is composed of very loose sand indeed.

14. For example, the greatly inflated number of objects looted from the Iraq Museum in Baghdad and the alleged "hundreds of thousands" of tablets being smuggled out of Iraq as often quoted in the media based on statements particularly by McG. Gibson and E. C. Stone; most recently, "since the invasion, the looting of Iraq's archaeological sites has continued unabated. Up to 15,000 objects are being taken from the ground daily, according to McGuire Gibson, a professor of Mesopotamian archaeology who has worked extensively in Iraq." In Susan Breitkopf, "The Looting of Iraq's Antiquities," *Museum News* (January/February 2007).

15. These include attacks on scholars, collectors, and museum officials. Note, for example, the gratuitous remark by McG. Gibson, "in effect, the site of Umm al-Hafriyat, for which we still do not know an ancient name, *unless cuneiform scholars who abet the collectors and dealers* [my emphasis] can suggest one, is lost to field research" (*The Oriental Institute 2005–2006 Annual Report*, Chicago, 2006, p. 86), this from someone who has

still not published the site thirty years after it was excavated! In any case, knowledge of its excavated finds remains unknown except, ironically, from those unprovenanced objects and tablets that have appeared on the market. So extreme have these attacks become that the New York University archaeologist, Randall White, proposed that his university reject the $200 million gift from the Levy-White Foundation, a foundation that has allocated millions of dollars to support excavations and to foster and underwrite long overdue archaeological publications. This gift not only established a half-dozen or more desperately needed academic positions in the field of ancient studies, but also has created perhaps the most important academic center for the study of Old World antiquity anywhere. White's proposed rejection was based on the fact that the foundation was established by collectors of antiquities. The fact that their wealth was obtained through recognized legitimate means and not from the illicit antiquities trade meant nothing to such a critic. It characterizes the extreme views of a very vocal minority. Fortunately, the university authorities ignored his demands. Note also that ASOR has accepted frequent donations from the same source as did the Oriental Institute in Chicago for the publication of their 1903–5 excavations at Bismaya (ancient Adab) (see *The Oriental Institute 2005–2006 Annual Report*, Chicago, 2006, p. 112). Are these conflicts of interest? I will let the reader judge.

16. Quoting again from Boardman, note 5 above: ". . . that, over the last fifty years, far less than 25 percent of material and results of professional archaeological excavations have been properly published, and the rest will never get beyond preliminary reports, if that (see editorial in *Antiquity* 75 [2001]: 233–240)." His views have been substantiated by Roger Atwood, in his "Publish or Be Punished: Israel Cracks Down on Delinquent Diggers," *Archaeology* 60, no. 2 (2007): 18, 60, 62, who details the long history of nonpublication (currently at ca. 70 percent, up from 90 percent a decade ago) of excavations in Israel, a history that is paralleled in Egypt and most other countries of the Middle East. Quoting Seymour Gitin (p. 60), "I've seen archaeologists who do beautiful work. They're wonderful excavators but then they never publish, and because they don't write, it's as if they had never excavated." He continues by quoting Gideon Avni (p. 60), who says, "digging is always more fun than writing, let's face it." And, further quoting Lawrence Stager (p. 62), "without the write-up, archaeology is little more than treasure-hunting. *We would be no better than looters* [my emphasis]." Ironically, Stager is as guilty for not publishing his own excavations as those he impugns.

Some archaeologists have been known to refuse to allow their epigraphists to divulge, even informally, any information from the texts

they deciphered prior to the publication of the archaeological data, something that often takes years or even decades, if ever, to appear. This anti-intellectual position often retards progress in the interpretation not only of related material but also that of their own excavated sites. I guess, to quote the archaeologist Kent V. Flannery, they "do it because archeology is still the most fun you can have with your pants on" ("The Golden Marshalltown: A Parable for the Archeology of the 1980s," *American Anthropologist* 84 [1982]: 265–78, on 278) whereas publication seems not to be a priority.

17. In his article about Greece and Cyprus, in his "Cyprus, the Mediterranean, and Survey: Current Issues and Future Trends," (in Maria Iacovou, ed., *Archaeological Field Survey in Cyprus: Past History, Future Potentials. Proceedings of a Conference Held by the Archaeological Research Unit of the University of Cyprus, 1–2 December 2000*, BSA Studies, 11 [London: The British School at Athens, 2004]), John Cherry, remarks (p. 31) that "by some estimates, if current trends continue, as much as 98% of all archaeological sites will be destroyed by the late 21st century." James Muhly, in his review of this volume (*Bryn Mawr Classical Review* 2006.09.14), raises many of the issues concerning the attitudes of the governments of Greece and Cyprus, local and foreign archaeologists, and the plight of archaeological sites that are rapidly being destroyed. The similar situation in Iraq is no less dire, although these issues are hardly, if ever, raised by archaeologists working there. To have done so would have effectively eliminated them from working in Iraq.

18. Take, for example, McG. Gibson, in his "Nippur and Umm al-Hafriyat" (*The Oriental Institute 2005–2006 Annual Report*, Chicago, 2006, pp. 86–88), who writes, "we had a very productive season there [i.e., Umm al-Hafriyat] in 1977 and hoped to return for at least one more season . . ." But now, after thirty years, we still await a decent report on a single excavation season at this important site. Gibson has gone on to excavate other sites in addition to his long-standing excavations at Nippur, but his work remains largely unpublished.

19. "Objects cannot be 'tainted' or 'illicit,' and could only be so described by scholars who do not understand them, or legislators. . . . The objects are testaments of antiquity, whether handled by a thief or scholar; their integrity must be respected and their safety assured. To suggest that they should even be destroyed rather than kept in a museum betrays an appalling vacuum of scholarly integrity and responsibility, even philistinism." So Boardman, note 5 above.

20. Quoted from an April 2006 *New York Times* article by Roger Atwood, *Archaeology* 60, no. 2 (2007): 60.

21. Similar sentiments are expressed in J. Boardman's closing remarks, "The
 situation is not one that is generally recognized or acknowledged, and it is
 time to speak out. It has been distorted by emotive accounts of willful
 destruction and theft, and has been contrived by some archaeologists
 and legislators, but it is not in the interests of either scholarship or the
 preservation of our global heritage."

Museums, Antiquities, and Cultural Property

The politics of nationalist and ethnocultural identities are putting tremendous pressure on museums, with regard to what they can collect, and how they identify and exhibit certain kinds of objects claimed by nations and indigenous peoples as their cultural property. Antiquities are increasingly subject to these constraints, often at the expense of their preservation and public access.

Essays in part one of this volume argued that museums and antiquities have value for what they can teach us about our common human heritage, and how knowledge and respect for our common past can lead to respect for and understanding of different peoples and cultures today. Those in part two argued that archaeology has inherent and self-imposed limitations with regard to our knowledge about antiquities and the ancient past. While the essays in this, part three, explore the nature of cultural heritage, the current political pressures restricting international access to it, and some of the underlying philosophical principles behind—and confused by—the claim that antiquities are a modern nation's cultural property.

Michael F. Brown considers the political and ideological constraints on museums seeking to collect indigenous peoples' cultural property, a slippery term for cultural expressions that increasingly include everything from objects to language, music, folklore, technical knowledge, and religious practices: essentially something, as he defines it, that "cannot be imitated, borrowed, or even discussed without doing violence to the group that claims it." Given the increasing influence of "identity claims" on the development of and debate about cultural property laws, a consideration of indigenous claims on cultural property and the manner of their presentation in museums is crucial to the subject of this book.

143

Derek Gillman considers three case studies—the Bamiyan Buddhas, Parthenon/Elgin Marbles, and the Lansdowne portrait of George Washington—for what they teach us about nationalist or culturalist claims on antiquities and works of art. In the first instance, the largest surviving early Buddhist figures in the world were severely damaged, in part destroyed, by the reigning Taliban authorities of Afghanistan. The international community was outraged. But didn't the Taliban, the legitimate authority in the region, have the legal and political right to do with the statues what they wanted? Can we assume that the Taliban, as conservative Muslims, had no claim on these Buddhist figures as their cultural property, or at least no less of a claim than the modern Christian Greek authorities have over the pagan Parthenon/Elgin Marbles? The Greek government has been calling for the return of the marbles to Athens on the basis that they are an integral part of "being" Greek, despite their having been in Britain for more than two centuries, since even before there was a Greek nation. The question is, on what basis can we accept that a cultural group has the character of a natural person and can be wounded by the loss of, or damage to, a national/personal symbol self-proclaimed as such.

Finally, John Henry Merryman proposes a "triad of regulatory imperatives" when considering constraints on the acquisition of antiquities. The first, and most basic, he argues, is preservation. How can we best protect the object and its context from impairment? Second is the quest for knowledge. How can we best advance our search for valid information about the human past, for "the historical, scientific, cultural, and aesthetic truth that the object and its context can provide." And the third is access. How can we best assure that the object is "optimally accessible to scholars for study and to the public for education and enjoyment." He calls this triad "preservation, truth, and access." Presenting this essay last in the current volume allows us to think back through the previous eight papers and ponder whether nationalist politics is in the service of protecting archaeological sites and antiquities or not. Merryman's sensible framework for considering the recent and current threats to our ancient material past is a fitting conclusion to this volume.

Exhibiting Indigenous Heritage in the Age of Cultural Property

Michael F. Brown

WILLIAMS COLLEGE

As Neil MacGregor reminds us in his essay in this volume, the encyclopedic museum was an institution of the Enlightenment, committed to the proposition that "through the study of things gathered together from all over the world, truth would emerge." A corollary belief was that museums would broaden the cultural horizons of the general public in ways that might foster greater understanding of human cultural diversity. For the past quarter-century, however, an array of social forces has called these principles into question and turned the encyclopedic museum into a site of conflict. Global processes of ethnic assertion and redefinition, changing ideas about the nature of democratic pluralism, the intensifying struggle over anything defined as cultural property—all have converged on the museum to cast doubt on its legitimacy and public mission.

Previous essays in this volume have largely directed their attention to ethical dilemmas raised by antiquities of unknown or controversial provenance. Here I wish to shift the spotlight from objects to the intangible expressions of heritage, everything from language and music to basic information about a people's way of life. Inseparable from this are questions about the right of one group to speak authoritatively about the lifeways of another, especially in an era when cultural heritage has come to be envisioned as a form of property that should remain under the exclusive control of its presumed creators and their descendants.

A proprietary attitude toward culture is hardly unique to our age. Religious adepts and craft guilds have assiduously protected secret knowledge

from time immemorial. Today, however, it is ever harder to define and defend the boundaries of culture. Traditional methods of controlling the movement of information—and thereby maintaining a reasonably stable social identity—often collapse under the pressure of an interconnected world. Just as the Enlightenment created the Universal Museum, the digital age seems to be spawning something that approximates the Universal Library. For small, beleaguered populations, the effects of this are not entirely negative. They may no longer feel as marginalized from the cultural life of metropolitan centers, and they may find it easier to publicize their concerns to a global audience. At the same time, however, their traditional knowledge all too easily diffuses beyond community boundaries, making it available to powerful outsiders who may use it for their own artistic or commercial or political purposes.

Conflicts over the control and representation of heritage have become especially impassioned when the communities in question are indigenous ones, that is, comprising descendants of the earliest inhabitants of the New World, Asia, Africa, Australia, Oceania, and isolated corners of Europe.[1] The comfortable assumption that experts from the metropole are qualified to speak or write about indigenous cultures is being challenged everywhere. Just as some nation-states are drifting toward insistence that they are the only legitimate stewards of ancient artifacts found within their borders, so indigenous peoples maintain that they should be the sole arbiters of their own cultural history. Insider knowledge, in other words, is the only kind that counts. This drive for control of cultural representations—reflected in the rise of local heritage museums and, in the great metropolitan museums, the popularity of what has come to be called *community curation*—has brought new voices to the museum world, with novel and sometimes inspiring results. Nevertheless, the experience of the latest wave of heritage museums suggests that they confront many of the same problems as their predecessors, with equally mixed success, and that their participatory requirements create dilemmas of their own.

In June 2006 the Musée du quai Branly opened in Paris to fanfare and controversy (fig. 7.1). The new museum aims to be one of the world's preeminent venues for the art of—well, there lies a problem. A few decades

Fig. 7.1. French President Jacques Chirac, second left, flanked by UN Secretary General Kofi Annan, left, greets Chief Laukalbi from Tanna of Vanuata Islands and his nephew Jerry Napat, right, during the inauguration of the Musée du quai Branly, Paris, 2006. In the background is museum curator Stephane Martin. AP Photo/François Mori.

ago it might have been called a museum of primitive art, but the pejorative connotations of "primitive" are clearly unacceptable today. "Tribal art" is scarcely better. So planners proposed the term *arts premiers*, a neologism that eventually foundered, in part, because of the difficulty of finding an English equivalent that doesn't sound patronizing. Hence the prudent decision to name the museum after its location.

This struggle over names is emblematic of more serious debate occasioned by the museum's inauguration, with more surely to follow in academic journals. Although the French government has tried to present the new museum as an expression of the nation's embrace of multiculturalism, cultural critics see it as a monument to France's reluctance to grapple with colonial history. They decry everything from the museum's decor,

said to be redolent of tropical exoticism, to the very idea of separating the indigenous art of Africa, Oceania, and the New World from European art. Some wonder why the French government didn't simply return the collections to the peoples whose ancestors produced it.[2]

The Musée du quai Branly may be the most recent target for rough treatment, but postcolonial and poststructural scholarship has subjected encyclopedic museums to unsympathetic scrutiny since the early 1980s. Critics insist that museums function primarily as theaters of power, deploying their cultural capital and sumptuous architecture to shape attitudes toward everything from artistic taste (thus ratifying the superiority of ruling elites) to the moral standing of the nation-state (thereby mobilizing public sentiment in favor of state power). Every cabinet, every elegant plinth, conspires to create what Tony Bennett, a professor of cultural studies, calls a "space of observation and regulation" designed to discipline a visitor's body and mind.[3]

What?

The prevailing image of the museum as penitentiary or Maoist reeducation camp is enough to make fretful parents consider rescuing their child from a school field trip to the National Gallery or the Met. But critiques of conventional art museums seem mild in comparison to the opprobrium heaped on institutions that traffic in art and artifacts from indigenous societies. It is invariably pointed out that the great natural history museums of Western Europe and North America arose in tandem with colonial empires. Efforts to organize, classify, and display the material culture of distant peoples therefore supported colonialist ideology. Or so it is argued, even if a compelling case also can be made that museums and disciplines such as anthropology played a key role in convincing citizens of the metropole that far-flung peoples possessed admirable qualities—tenacity, creativity, deep histories of self-governance, perhaps even an aesthetic or spiritual genius—that justified bringing their colonial subordination to an end.

Postcolonial scholarship on museums suffers from exasperating flaws. Its language is often overblown, depicting curators as foot soldiers in the trenches of colonial oppression. Its rhetorical strategy is tiresomely predictable: comb the archives for objectionable, racist declarations by long-dead museum employees, mix in a bit of authorial hand wringing

about a troubling exhibit label or two, flavor with a dollop of Foucault and *ha.* a dash of Gramsci, shake vigorously, serve. From the sinister confines of the museum and the grasping hands of its expert staff, heritage—everyone's heritage, it seems—must be "reclaimed" and "liberated."[4]

To observe that the critique of museums has shortcomings is not to say that it is entirely wrong. Exhibitions of the late nineteenth and early twentieth centuries *were* sometimes based on assumptions of cultural superiority that we now rightly deplore. Institutional inertia kept displays in place long after the ideas that animated them had been discredited. The durable, if dubious, distinction between art and artifact hindered Western recognition of the artistic sophistication of indigenous peoples.

All this began to change as indigenous peoples emerged as a force to be reckoned with, first in international forums such as the United Nations and then, with growing prominence, in the politics of advanced settler democracies, including the United States, Canada, Australia, and New Zealand/ Aotearoa. Indigenism, as it is sometimes called, takes distinctive forms in each region, but its general principles include the following:

- The original occupants of lands settled during the fifteenth through twentieth centuries were, almost without exception, cruelly dispossessed of their territory and political rights as sovereign peoples.
- It was long supposed that indigenous peoples would disappear as recognizable communities, either through physical extinction (advanced in some cases by explicit state policy) or assimilation into majority populations. This did not happen. The descendants of countless indigenous communities have survived, and they now demand political equality as well as recognition as distinct nationalities within the state.
- Acknowledgement of the survival of indigenous nations has inspired efforts to achieve reconciliation through policies of reparations, repatriation of lands and cultural property, and the restoration of some degree of self-determination.

In the museum world, indigenous-rights advocates have vigorously advanced laws that require repositories to repatriate human remains and

religious objects to indigenous communities should the latter wish them returned. The American Association of Museum Directors now recommends that art museums enter into good-faith negotiations with groups who believe that sacred objects in museum collections deserve special treatment. More broadly, museums are under increasing pressure to consult with indigenous communities when planning exhibitions in which such communities are deemed to have a moral stake.

My contacts with curators in a range of museums suggest that although they sometimes regret the politicization of their chosen field, most enjoy the increased contact with indigenous people that has characterized museum work since the 1980s. There is little question, though, that collaborating with people who often have limited prior exposure to the practicalities of museum work can lead to time-consuming negotiations in which all parties struggle to educate one another. In a not-uncommon scenario, as Paul Chaat Smith, a curator at the National Museum of the American Indian, puts it, "You go out into one of 'the communities' and ask people who'd never thought twice about museum exhibitry to design exhibits."[5] Inevitably, collaborative curation has narrowed the range of topics that museums are willing to tackle. Obvious sources of controversy, especially those involving now-abandoned practices regarded as repellent or morally troubling—slavery, ritual cannibalism, sorcery, cruel treatment of war captives, and the like—tend to be pushed to the margins in favor of exhibitions that focus on expressive arts, spirituality, or indigenous veneration of the land. When indigenous and nonindigenous curators are unable to agree about significant issues, a typical solution is to present their views side by side without attempting to reconcile them—hence the ubiquitous variations on the theme of "diverse voices." This often arises in connection with questions of cultural origins because indigenous oral traditions may deviate considerably from scientific understandings of historic migration patterns.

Curators and cultural critics who think of themselves as progressives see these shifts as inherently democratizing: by putting oral tradition and community sentiment on the same footing as professional expertise, indigenous peoples achieve something like cultural equality. Those committed to scientific rigor, in contrast, are likely to deplore the changes as

reflecting the triumph of relativism and identity politics over established fact. More centrist observers welcome the broader spectrum of views but often find themselves worried that by abandoning efforts to settle important historical or scientific questions museums are shirking their responsibility to provide the public with the best information currently available.

Strongly affecting contemporary debate about the representation of indigenous peoples is the relentless expansion of the concept of cultural property. A term originally applied rather narrowly to architectural monuments and portable items of national patrimony, *cultural property* is increasingly held to encompass intangible as well as material expressions of a distinct community, including its language, art styles, music, folklore, technical knowledge, and religious practices. Policy makers waffle about whether the expression *cultural heritage* is preferable to *cultural property*, but in practice the two amount to the same thing. Culture in all its manifestations is construed as something that cannot be imitated, borrowed, or even discussed without doing violence to the group that claims it.[6]

The current approach to intangible aspects of culture is inspired by policy reforms directed to human burials and objects of religious significance. The most familiar of these to Americans is NAGPRA, the Native American Graves Protection and Repatriation Act of 1990, which created a framework for the return of human remains, grave goods, and narrowly defined "items of cultural patrimony" when federally recognized Native communities request them and meet legal standards of prior affiliation or ownership. Public attention naturally focuses on high-visibility examples of repatriation, when looted objects or human remains are handed over to a Native community, usually with great ceremony. Less well known are the innumerable cases in which communities are content to establish title to collections while allowing them to remain in the care of museums. The most intriguing instances of this involve joint-stewardship agreements that permit the occasional use of artifacts for important ceremonies. Such arrangements are taxing for curators, but they also build relations of trust with indigenous people and enliven museums by drawing them into everyday Native life in ways never before imagined.

NAGPRA is hardly perfect legislation, and as museums and Native communities resolve the most straightforward repatriation claims they

will be forced to confront far more refractory ones. But the law's success has encouraged indigenous leaders to propose that knowledge and other intangible expressions of their cultures be subject to similar protection and adjudication. The conceptual link between tangible and intangible elements of heritage is foreshadowed in the work of Walter Benjamin. Benjamin famously observed that art objects possess an "aura" that in his view was undermined by technologies of mass production. Indigenous groups, especially those of North America, Oceania, and Australia, frequently complain that public display of objects held to be sacred—a term notable for its elasticity—violates their cultural rules and vitiates the objects' power. Information, which is far more reproducible than individual works of art, generates even greater anxiety because it can be circulated instantly through technologies such as the Internet. The unwanted movement of religious iconography or ritual knowledge generates a vague but persistent anxiety about the violation of social boundaries made increasingly porous by globalization and, among indigenous peoples themselves, by rising rates of interethnic marriage and bilingualism.

The intense emotions provoked by the dissemination of highly charged information were evident in an archivists' conference that I attended in Washington, DC in 2006. One speaker, a young professional woman from a federally recognized Indian nation in the western United States, described her tribe's efforts to assert control over tape recordings of songs performed by a now-deceased ritual specialist. The songs, recorded in a language that members of her tribe can no longer understand, are by virtue of their age and subject matter considered too powerful to be reproduced safely or even heard by unauthorized persons. In a tense moment at the same conference, a woman from another tribe complained because two non-Native speakers had presented music and images whose religious content, she insisted, potentially exposed her to spiritual harm. No matter that the information in question was from Australia and the Caribbean and thus bore no plausible link to her own religious tradition. Moments such as these dramatize the growing belief that knowledge—particularly religious knowledge, but other kinds as well—should reside only at its presumed point of origin.

The proprietary drift of ethnic assertiveness has led to demands that information held by repositories, including museums, be repatriated to the source communities said to be its rightful owners. Sharing copies of field notes, images, and audio tapes is judged insufficient; indigenous people want complete control over the material regardless of the competing claims of its author, be it folklorist, ethnographer, photographer, or missionary. This sensibility is captured in policy documents circulated among professional curators, archivists, and cultural-resource managers, who increasingly accept that claims of ownership by indigenous communities should be given greater weight than other factors when determining the uses to which documents can be put by the general public.[7]

Academic discourse has long wrestled with similar issues under the more ambiguous rubric of cultural appropriation, which in the most general sense signifies the transfer of cultural elements from a weaker group to a more powerful one. The range of situations in which critics now raise the red flag of appropriation is startling. A philosopher worries that European aesthetic or scientific ruminations on prehistoric rock art might be ethically questionable. Maori activists denounce the use of Maori tattoo motifs by tattoo artists abroad. The United Kingdom's Prince Harry becomes the focus of intense criticism because his paintings appear to be influenced by the art styles of Aboriginal Australians. The National Aquarium in Baltimore finds itself assailed because its indoor re-creation of a waterfall from Australia's Northern Territory allegedly constitutes an act of cultural theft, although no visitor could possibly mistake the replica, however dazzling, for the real thing.[8]

Accusations of cultural appropriation are appealing to their authors because they cast a shadow of moral and even legal doubt over the representation of indigenous heritage. This shadow has hardened into statute here and there. A First Nation in British Columbia has obtained "official mark" protection for ten ancient petroglyph images, thus removing them from the public domain. Australian law now limits the commercial use of images of the continent's most familiar natural feature, Uluru (Ayers Rock), which has been redefined as the intellectual property of its Aboriginal "owners"; public displays of some Uluru images have been successfully

contested by Aboriginal groups. As I write, the Waitangi Tribunal in New Zealand is deliberating the question of whether the Maori own the nation's indigenous plant and animal species. Much of what is at issue concerns intellectual property rights, but the breadth of Maori claims, at least according to government attorneys, raises the possibility that the Maori will be recognized as having exclusive control over everything from the propagation of native flora and fauna to the activities of field scientists who study them. The full impact of this propertization of culture remains uncertain, but there is little question that it has dramatically complicated the work of museums that represent the art and culture of indigenous peoples.

The move toward indigenous self-representation is reflected in the remarkable proliferation of museums focused on Native history and culture. These fall into two broad categories: local, community-level institutions that, in the words of James Clifford, "function as cultural centers, sites for community education, mobilization, and the continuity of tradition"; and regional or national museums, which try to bridge the primarily inward-looking quality of community-based museums and the encyclopedic ambitions of metropolitan institutions.[9] Examples of the latter include the new Paris museum, the Canadian Museum of Civilization, the Museum of New Zealand Te Papa Tongarewa, and the recently opened National Museum of the American Indian in Washington, DC.

An assessment of the hundreds of community-based museums and cultural centers focused on indigenous identity is beyond the scope of this essay. I believe it is fair to say, however, that when Native communities run their own museums, as they tend to in the United States and Canada because of a long (if checkered) history of self-governance, these institutions are likely to enjoy a high level of local participation and serve as catalysts for cultural renewal and collective pride. As James Clifford points out, they also offer a laboratory for innovative collaborations between anthropologists and the indigenous communities they have long studied. Clifford describes the catalog of one recent Alaska Native exhibition as "part genuine coalition, part respectful truce," which neatly summarizes many similar experiments in interweaving scientific and indigenous views.[10]

When a group's struggle for recognition turns on questions of cultural difference, local museums offer opportunities to display and perform difference under conditions the community controls. The pivotal role of these institutions in representing local culture may sometimes give rise to unfortunate side effects—among them, the exacerbation of internal divisions and promotion of the interests of an emerging indigenous elite. On balance, however, heritage museums under local management do a good job of reconciling the aspirations of their communities with the demands of regional tourism. Most of these local facilities are modest in scale; a handful are opulent. (In the latter category, the $193 million Mashantucket Pequot Museum and Research Center in Connecticut, funded largely from the Pequot tribe's gaming proceeds, stands at the zenith.) Their grass-roots orientation helps them do a better job of representing community sentiment in all its richness than can institutions at greater remove.

Where national museum bureaucracies control local heritage museums, as is the case in many parts of Asia and Africa, the picture is more ambiguous. Local experts are likely to be subordinated to professional administrators from the nation's capital, just as the celebration of local culture is subordinated to an ideology of modernization and nation-state unity. The now-familiar link between museums and development in tourist economies may lead to the creation of ersatz "village museums" that put the state in charge of a heritage that local people are presumed to be incapable of managing themselves. In such cases, heritage is almost completely commodified, to the detriment of the people whose culture is ostensibly being protected.

In contrast to locally run museums and cultural centers, metropolitan museums focusing on indigenous heritage usually enjoy more secure funding and more impressive facilities. Nevertheless, their scale, distance from Native communities, and obligation to serve multiple masters give rise to formidable challenges. How can an institution offer an upbeat picture of Native peoples while at the same time communicating their legitimate grievances? Will exhibitions be directed primarily to Native museumgoers or to the general public? If the museum is to be a site of performance as well as static display, how can such decontextualized events retain authenticity?

The National Museum of the American Indian (NMAI), whose principal facility opened on the Washington Mall in 2004, exemplifies this predicament. The NMAI's mission statement, as well as the many speeches and interviews given by its founding director, W. Richard West Jr., make clear that its ambition is to transform museums and museology. Authority is to be shifted from curators to Native communities. Exhibitions serve not just to educate museumgoers but also to redefine the way they relate to the hemisphere's indigenous peoples. Interior and exterior spaces are unified to express the link between people and the land, hence the museum's outdoor minienvironments, which include a field of Native cultivars (corn, beans, sunflower, tobacco), a wetland, and a forest. According to Amanda Cobb, a professor of American Studies, "The museum was expressly designed to celebrate—not to observe, study, or judge but to *celebrate.*"[11]

The successful completion of the NMAI's Washington museum is a tribute to the dynamism of the institution's leadership and the energetic support of Native leaders across the United States. By all accounts, the colorful ceremonies that marked the opening of the museum fulfilled public expectations. There the honeymoon ended, for early reviews of the opening exhibitions were mostly negative, and sharply so, although for reasons quite different from the complaints leveled at the Musée du quai Branly. Critics contended that the uniformly celebratory quality of the exhibits' message, when combined with their rejection of anything reminiscent of conventional scholarly depth or detail, reduced the majestic diversity of Native American cultures to a set of feel-good platitudes. As Edward Rothstein observed in the *New York Times,* "The result is that a monotony sets in; every tribe is equal, and so is every idea."[12] Other reviewers expressed disappointment that so much of the museum's space was given over to shops and a large restaurant. Among Native Americans, I'm told, there was frustration because certain Native nations seemed overrepresented—notably, the gaming tribes that were major donors to the NMAI—whereas far more populous tribes were scarcely to be seen in the opening-day exhibitions.

Such criticism evoked rejoinders that would delight even the most jaded connoisseur of irony. Native critics have long complained that when

museums present indigenous art purely for its aesthetic qualities, they decontextualize the objects and silence the many stories that give them meaning. Yet when the NMAI does the same thing, we are told by one defender that "the exhibits convey the 'big picture' whilst admitting the possibility of multivalent interpretations," because the objects are "freed from the over-arching curatorial voice." Another apologist justifies the amount of space devoted to retail activities as an important object lesson in the link between tourism and Native American cultural survival. The NMAI's spacious restaurant looks like a profit center to critics, but sympathetic observers portray it is a heartfelt expression of Native hospitality. Parisian intellectuals may be disconcerted by the Musée du quai Branly's identification of indigenous people with nature, but their counterparts in the United States praise the NMAI for its emphasis on the spiritual connection between American Indians and the land.[13]

Defenders insist, rather more convincingly, that the NMAI is venturing into new territory and therefore should be forgiven for losing its way once in a while. Early reviews also failed to note that the NMAI is not simply an updated, democratized version of a traditional museum. It has joined the ranks of institutions that offer what the historian Alison Landsberg calls "prosthetic memories," artificial remembrances transferred through the use of sophisticated audio-visual resources.[14] Objects are exhibited not to be contemplated individually but to serve as stage props for the creation of dreamlike understandings of the past. An example is an NMAI installation organized around the theme of the "storm" of conquest, missionary work, and indigenous resistance (fig. 7.2). It features a low display cabinet full of enigmatic objects, encircled by a dimly lit wall of video monitors that play endless film clips and a ghostly voice-over about the injustices visited upon Indian ancestors. During my time in the installation, other museumgoers drifted through, rarely spending more than a minute. I could only conclude that, like me, the installation taught them nothing specific, only that Native Americans are spiritual people who have survived despite great odds.

However praiseworthy the NMAI's ambitions, it faces the same harsh realities as museums elsewhere. Space, personnel, and funds for exhibition development are limited. This means that even in an ostensibly

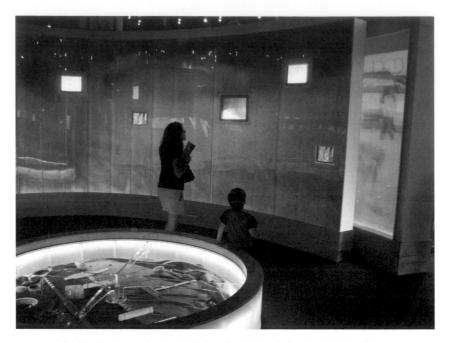

Fig. 7.2. "The Hurricane," a video installation in the exhibition *Our Peoples: Giving Voice to Our Histories*, which opened in 2004 at the National Museum of the American Indian, Washington DC. Photograph © Michael Brown.

democratic, community-oriented museum, administrators must make difficult choices about which communities are to be represented. Like other public museums, the NMAI needs a dependable revenue stream, leaving it little choice but to lure as many visitors as possible to its gift shops and café. "Community curation" is an admirable goal, but consultation cannot resolve all representational dilemmas or reconcile divergent opinions; Native people are just as likely to hide inconvenient facts and silence dissenting voices as any other human group. Finally, the proprietary impulse that now defines attitudes toward traditional knowledge makes it difficult to represent indigenous heritage in anything other than the blandest, most stereotyped terms. Basic descriptive facts, especially about religion, are deemed "culturally sensitive" and unsuitable for public discussion, leaving accounts of Native religion with little to report but generic spirituality. The NMAI and other museums devoted to the documentation of indigenous

heritage are thus faced with the awkward prospect of being obliged to say more and more about less and less.

The current passion for community-controlled museology is understandable in light of colonial history. Its insights have already injected new energy into the museum world. Regrettably, however, postcolonial scholarship gravitates to the conclusion that there is now only one defensible way for museums to deal with the objects and information entrusted to them. In the words of Amy Lonetree, a professor of Native American Studies, "If [museums] want to be part of the twenty-first-century museum world, they must produce their exhibitions with the full involvement of the Native communities they propose to represent and must involve them in all aspects of their development."[15]

The view that community curation is a universal panacea echoes the claim of dissident anthropologists of the 1980s and 1990s that ethnographers were obliged to renounce their authorial power by turning books over to their research subjects. This typically meant presenting field material as minimally edited dialogue and, whenever possible, avoiding synthesis or comparison, which were rejected as deplorable power plays on the author's part. A handful of these experiments proved interesting, the rest unreadable. Whatever truth emerges from them is what the German filmmaker Werner Herzog calls "the accountant's truth," an unprocessed collection of facts, which Herzog contrasts with deeper truths that must be laid bare by a writer, director, or scholar—who of course is ultimately accountable for a work's errors and excesses.

To reveal deeper truths in a museum setting, community involvement may be indispensable in some cases and little more than a distraction in others, especially when the goal of the exhibition is comparative and analytical rather than celebratory. Even in the most-participatory exhibitions, museumgoers have reason to expect tactful intervention by the "overarching curatorial voice" that the NMAI has thus far tried to silence.

If today's ferment in the museum world is about the promotion of diversity, why should the essentially therapeutic approach embraced by the NMAI be seen as the only acceptable model of museum practice? Don't institutions have a right, perhaps even a duty, to draw on their inherent strengths in the interest of promoting the widest possible public

discussion on important social issues? The strength of most natural history museums lies in their scientists and collections. For art museums, it is their expertise in formal aesthetics and global art history. This is not as inconsistent with indigenous views as it might seem. True, some Native intellectuals contend that indigenous art can be understood only when fully contextualized. Others go beyond that to assert that art itself is an arbitrary Western category incompatible with indigenous holism. Nevertheless, many Native artists insist that their work bears comparison to the best art produced anywhere in the world, and they welcome opportunities for it to be viewed and judged next to the work of their non-Native counterparts.

Contemporary indigenous art, in fact, reminds us of the extent to which creativity is the result of lively intercultural exchanges rather than the unfolding of a single society's distinctive vision. Few American Indian tribes had a developed tradition of painting on fabric or wood, and even fewer shared a notion that art should be undertaken for its own sake. The work of today's American Indian painters is as likely to have been influenced by German expressionism as by elements of Diné or Seneca or Haida heritage. An example of such hybridity is found in "traditional" Navajo rugs, an art form that emerged from the intersection of Old World animal husbandry (in the form of sheep and the wool they produce), weaving techniques learned from the Navajo's Pueblo Indian neighbors, patterns and color schemes suggested by Anglo traders, and the Navajo's own impeccable sense of visual harmony. There is every reason to admire this art as an expression of Navajo creativity, but that is only part of a bigger story of innovation inspired by contact and strategic borrowing.

The most vexing question provoked by the rise of a participatory museology that exalts identity above all else is how this advances an understanding of the larger We—the We of Canadians, Peruvians, and Australians, or, more important still, the We of humanity. In a recent appraisal of cosmopolitanism, Kwame Anthony Appiah refers to this as "connection not *through* identity but *despite* difference."[16] Like other observers who puzzle over today's identity politics, Appiah recognizes that local loyalties—to family, to community—are essential elements of global citizenship. In times of crisis, however, they readily slide into parochialism and xenophobia.

How can museums foster the optimal balance of the local and the global, admiration for one's own and openness to the virtues of strangers?

Questions of this sort tend to be dismissed by postcolonial scholars and indigenous activists alike. Appeals to universalism evoke a skeptical response because so much harm has been done to indigenous peoples in the name of allegedly universal values, including individual freedom and the right to private property. Where cultural heritage is concerned, the standard response is something on the order of, "When we're in full control of our cultural heritage once again, we'll talk about sharing it with the world on our own terms." The difficulty, of course, is that no one can specify exactly what it means to "control" heritage. There are reasons to doubt that *any* group can manage its cultural heritage in the sense the expression is used today, even if functionaries at UNESCO insist on talking about culture as if it were a rationally managed resource akin to water or electricity. Indeed, a handful of skeptics hold that once we have concretized the full range of human expression into a term like *cultural heritage,* the battle is already lost. By being pulled into the current mania for repatriation and cultural boundary drawing, David Lowenthal says, "things fluid by their very nature are ossified into factitious perpetuity." We endorse this process, he declares, "at our own personal and collective peril."[17]

I share Lowenthal's concern, if not his pessimism. When untempered by recognition of historical complexity or a willingness to compromise, the logic of heritage protection invites fantasies about returning to a mythical zero-point in which every culture is restored to a prior state of perfection. This is discernible in the frequently voiced opinion that the former colonial powers "should just repatriate all that stuff" to the descendants of its original owners. No matter that only a handful of advocacy groups demand wholesale repatriation of all artifacts held by the world's repositories. Most recognize that this would be both impractical and irresponsible. Far better that museums use inspiring works of art to define common ground and encourage a more nuanced appreciation of cultural differences.

As the critical fireworks occasioned by the opening of Musée du quai Branly fall back to earth, their energy spent, some observers are finding

themselves grudgingly won over by the new museum's presentation of indigenous art. The more thoughtful among them acknowledge that no consensus yet exists about how best to frame indigenous creations within the context of ongoing efforts to achieve political reconciliation with Native nations. Some innovative approaches, including community curation, show promise, but none has proven immune to failure. All that can be said for certain is that diverse strategies, rather than one-size-fits-all solutions, stand the best chance of promoting wider appreciation of indigenous heritage and encouraging frank public discussion about the enduring legacy of colonialism.

ACKNOWLEDGMENTS

Alexander A. Bauer, James Cuno, and participants in the weekly discussion seminar at the Oakley Center for Humanities and Social Sciences, Williams College, were kind enough to provide useful comments on an earlier draft of this essay. I am grateful to Anne-Christine Taylor, Director of Education and Research at the Musée du quai Branly, for facilitating my visit to her museum in 2008. None of these colleagues are responsible for the opinions expressed here.

NOTES

1. In this essay I use the terms *indigenous, Aboriginal,* and *Native* more or less interchangeably. In some countries one of these terms may be favored over the others; conventions about their capitalization also vary. Here I follow the most common usage in the United States in 2008.
2. On the political and ideological roots of the new Paris museum, see Sarah Amato, "Quai Branly Museum: Representing France after Empire," *Race and Class* 47, no. 4 (2004): 46–65, and Sally Price, "Art and the Civilizing Mission," *Anthropology and Humanism* 30, no. 2 (2005): 133–40.
3. Tony Bennett, *The Birth of the Museum: History, Theory, Politics* (London: Routledge, 1995), 24.
4. See, e.g., Christina F. Kreps, *Liberating Culture: Cross-Cultural Perspectives on Museums, Curation, and Heritage Preservation* (London: Routledge, 2003),

and Joy Hendry, *Reclaiming Culture: Indigenous Peoples and Self-Representation* (New York: Palgrave Macmillan, 2005).

5. Paul Chaat Smith, "The Terrible Nearness of Distant Places: Making History at the National Museum of the American Indian," in *Indigenous Experience Today*, ed. Marisol de la Cadena and Orin Starn (Oxford: Berg, 2007), 393.

6. For broad surveys of the links between developments in intellectual property law and indigenous politics, see, among others, Michael F. Brown, *Who Owns Native Culture?* (Cambridge, MA: Harvard University Press, 2003), and Mary Riley, ed., *Indigenous Intellectual Property Rights: Legal Obstacles and Innovative Solutions* (Walnut Creek, CA: AltaMira Press, 2004).

7. See the policy document "National Museum of the American Indian Policy Statement on Native American Human Remains and Cultural Materials," which states that along with human remains and religious objects, "all culturally specific information . . . must be treated as the sole property of the affected Native American culturally affiliated group." *Museum Anthropology* 15, no. 2 (1991): 25–28.

8. On petroglyphs, see Thomas Heyd, "Rock Art Aesthetics and Cultural Appropriation," *Journal of Aesthetics and Art Criticism* 61, no. 1 (2003): 37–46; on Maori tattoos, Ngahuia Te Awekotuku, "More Than Skin Deep: *Ta Moko* Today," in *Claiming the Stones, Naming the Bones: Cultural Property and the Negotiation of National and Ethnic Identity*, ed. Elazar Barkan and Ronald Bush (Los Angeles: Getty Research Institute, 2002), 243–58; on Prince Harry's art, Peter Shadbolt and Peter Collins, "Harry Paints His Way into Outback Row: Prince Accused of Stealing Aboriginal Motifs in Work," the *Guardian*, August 19, 2003, 3; on the controversy over the National Aquarium's new waterfall, David Lowenthal, "Why Sanctions Seldom Work: Reflections on Cultural Property Internationalism," *International Journal of Cultural Property* 12, nos. 3 and 4 (2005): 393–424, on 410.

9. James Clifford, "Four Northwest Coast Museums: Travel Reflections," in *Exhibiting Cultures: The Poetics of Museum Display*, ed. Ivan Karp and Steven D. Lavine (Washington, DC: Smithsonian Institution Press, 1991), 248.

10. James Clifford, "Looking Several Ways: Anthropology and Native Heritage in Alaska," *Current Anthropology* 45, no. 1 (2004): 5–30, on 19.

11. Amanda J. Cobb, "The National Museum of the American Indian: Sharing the Gift," *American Indian Quarterly* 29, nos. 3–4 (2005): 367; punctuation and emphasis in original.

12. Edward Rothstein, "Museum with an American Indian Voice," *New York Times*, September 21, 2004, E1.

13. Claire Smith, "Decolonising the Museum: The National Museum of the American Indian in Washington, DC," *Antiquity* 79 (2005): 424–39, on 429–30; Amanda J. Cobb, "National Museum of the American Indian," 372–73.

14. Alison Landsberg, *Prosthetic Memory: The Transformation of American Remembrance in the Age of Mass Culture* (New York: Columbia University Press, 2004).

15. Amy Lonetree, "Continuing Dialogues: Evolving Views of the National Museum of the American Indian," *Public Historian* 28, no. 2 (2006): 61.

16. Kwame Anthony Appiah, *Cosmopolitanism: Ethics in a World of Strangers* (New York: W. W. Norton, 2006), 135.

17. David Lowenthal, "Why Sanctions Seldom Work: Reflections on Cultural Property Internationalism," *International Journal of Cultural Property* 12, no. 3 (2005): 411–12.

Heritage and National Treasures

Derek Gillman

THE BARNES FOUNDATION

> Heritage creates a perception of something handed down;
> something to be cared for and cherished. These cultural
> manifestations have come down to us from the past; they are
> our legacy from our ancestors. There is today a broad
> acceptance of a duty to pass them on to our successors,
> augmented by the creations of the present.[1]

THE BAMIYAN BUDDHAS

"It is not a big issue. The statues are objects only made of mud or stone." Thus spoke Qudratullah Jamal on March 3, 2001 as the militia began its systematic annihilation of the Bamiyan Buddhas, the largest surviving early Buddhist figures in the world. The elimination of the two Buddhas by the Taliban regime in Afghanistan shocked many people, and especially those who highly value the material culture of Asia. "The destruction work is not as easy as people would think. You can't knock down the statues by dynamite or shelling as both of them have been carved in a cliff."[2] Destroying the "gods of the infidels" was evidently a pious act for Taliban soldiers drafted from outside the Bamiyan valley when local members refused, yet one cannot but think that the chief of the Taliban Foreign Ministry press department, Faiz Ahmed Faiz, was being somewhat disingenuous when he commented that: "This decision was not against anyone. It was totally a domestic matter of Afghanistan. We are very disappointed that the international community doesn't care about the suffering people but they are shouting about the stone statues of Buddha."[3] As indeed they were.

165

These extraordinary images had always been objects of wonder in the Buddhist world, visited by the celebrated Chinese pilgrim Xuan Zang at the beginning of the seventh century only decades after their construction.[4] Bamiyan was then part of a pancontinental Buddhist culture that stretched from west central Asia to China, lasting in Afghanistan until the early eleventh century when central Asia was overrun by Islamic tribes and the long-standing commercial routes to western China were severed. The two (originally three) colossi were a focus of individual worship and ceremonial practice and, though faceless, appear to have represented the historical Buddha, Shakyamuni.[5] They were not only inordinately impressive but also highly important to the documentation of central Asian material culture.

As the world was to learn, it wasn't just the Bamiyan Buddhas that were destroyed. All over Afghanistan, and within the Kabul Museum, Taliban authorities were endorsing a systematic iconoclasm to remove as much pre-Islamic sculpture as possible. The desire to maintain a context for this material was rapidly becoming less important than simply saving it from obliteration. An "Afghanistan-Museum in Exile" at Bubendorf, near Basel, Switzerland, had been set up to serve as a repository in trust for the country's material culture. It was defeated in its attempt to save much, however, by the technicalities of arranging for Afghanistan's artifacts to enter Switzerland in contravention of the 1970 UNESCO Convention on the Means of Prohibiting and Preventing the Illicit Import, Export, and Transfer of Ownership of Cultural Property. In March 2007, the some fourteen hundred items were sent back to Afghanistan and deposited at the National Museum in Kabul.

One outcome of the awful saga was the adoption by UNESCO in June 2001 of a resolution that condemned these acts as "crimes against culture," and as a "crime against the common heritage of humanity." Further, it invited competent bodies, including the World Heritage Committee, to identify the means of ensuring better protection of the "common heritage of humanity."[6] How can one argue against such noble sentiments, which see the Bamiyan Buddhas and other major monuments as a part of the common heritage? And yet this language leads us directly into a discussion that embraces not only the Bamiyan Buddhas but also issues

of export controls and of what goods countries should attempt to protect and promote.

Does the Afghani heritage comprise the heritage of all those who have ever lived there, or the heritage of those who live there now, or the heritage of some of those who live there now? It is clear that the Taliban didn't consider the Buddhas to be part of their heritage. Indeed, given the continuance of "Great Vehicle" Buddhism in both cultures, Tibetan and Japanese Buddhists might reasonably think that the Buddhas were more a part of their heritage. Thus there arises a question about the degree to which "other people's heritage" is also part of one's own. Certainly we can ask this about the Bamiyan Buddhas. After all, much is made of the importance to Afghanistan's present Muslim population of the region's Buddhist heritage, even though the religion has not been practiced there for a millennium.

Claims that a particular work of art or building or archaeological site belongs to some particular heritage are usually made when there is a perception of danger, either because something is going to happen (such as destruction, or looting, or sale overseas) or conversely something is failing to happen (such as conservation or upkeep). Calling on the "heritage of all mankind" is certainly useful if we want to stop destruction, looting, decay, or benign neglect, and where we want to signal to the agents of such change that they should think about values other than their own. But although claims to preserve important cultural things on behalf of all mankind may be noble and worthy of our support in principle, they frequently conflict with two other potentially competing social facts: that many things are claimed by particular cultures, and that many things are privately owned. The quick answer would be that all things are equally part of "world heritage" and a particular national or local heritage. But that is too fast. It satisfies symmetry but at the expense of the realities of possession and control.

THE PARTHENON/ELGIN MARBLES

The year 1981 might have seemed something of an annus mirabilis to a significant number of Greek citizens, particularly the disenfranchised.

At the beginning of the year Greece officially joined the European Community, and in October the Panhellenic Socialist Movement was elected on a platform of national self-determination and change, inspiring the idea of recovering the Parthenon/Elgin Marbles as the symbol of a more equitable society.[7]

The Parthenon sculptures are widely regarded as the finest surviving examples of early Greek art, the temple featuring prominently in the later stages of the battle fought during the late eighteenth and early nineteenth centuries over the superiority of Greek over Roman sculpture, since when opinion has echoed Plutarch's sentiment:

> As the works rose, shining with grandeur and possessing an inimitable grace of form, and as the artisans strove to surpass each other in the beauty of their workmanship, the rapidity with which the structures were executed was marvelous. . . . There is a certain bloom of newness in each work and an appearance of being untouched by the wear of time. It is as if some ever-flowering life and unaging spirit had been infused into the creation of them.[8]

Although the intellectual models of Renaissance Europe were found in Greece and Rome, prior to the late eighteenth century artists had little thought to imitate the actual sculptures of ancient Greece, taking as their models the remains of imperial grandeur scattered around Rome that, at best, copied much earlier and now lost Greek originals.[9] By 1800, however, the convention that Roman art represented the most appropriate model for inspiration and copying had been challenged by a new attention to the achievements of early Greece. In addition to their aesthetic value, Periclean Athens is valorized as civilized and harmonious, and the source of western democracy. Within this dual context, it is understandable why the sculptures acquired from Lord Elgin by the British Museum should have become a cause célèbre. In an interview given shortly before her visit to London in May 1983, the late Melina Mercouri, then Greek minister of culture, told the *Sunday Times* that: "The marbles are part of a monument to Greek identity, part of the deepest consciousness of the Greek people: our roots, our continuity, our soul. The Parthenon is like our flag."[10]

The Greeks won a famous victory over the Persians at the battle of Marathon on the east coast of Attica in 490 BC. In revenge, Xerxes led his Persian armies against the Spartans at Thermopylae in 481 BC, and then sacked Athens.[11] After a further two decades of war, the Persian threat was effectively eliminated, and Athens emerged as the hegemonic power among the Greek city-states. At midcentury Pericles persuaded the assembly to enrich the city-state's temples and public buildings, not only as monuments to the victory over "barbarism" but also as a physical manifestation of Athenian ascendancy; and so approval was given in 448 BC for construction of a Doric temple dedicated to the tutelary goddess of the city on the Acropolis site razed by the Persians in 480 BC.[12]

Standing within the Parthenon's *cella* was a monumental ivory and gold statue of the warrior maiden Athena Parthenos, symbol of the city's invincibility, created by Phidias who was generally responsible for the sculptural program. The high-relief *metopes* on the exterior (ca. 440 BC) celebrated the triumph of civilization and order over chaos and barbarism, represented through warring gods and giants, Centaurs and Lapiths, and Greek, Trojan, and Amazonian heroes. The two triangular pediments contained images of the birth of Athena, and her contest with Poseidon for Attica and the patronage of Athens. Around the upper edge of the outer wall of the *cella* was a low-relief frieze (like the pediments, ca. 438–32 BC) depicting gods, horsemen, and charioteers in a procession that pays homage to Athena and the gods, originally painted in vivid colors as was customary.[13] As semidivine heroes they had acquired the right to be depicted in the company of immortals.

In religious systems where the domain of the gods and ancestors is only thinly separated from humans, as was the case in ancient Greece, the realms connect not only through oracular or shamanistic communication but also through relics, cultic images, and sacred places. During the fifth century BC, the ritual focus of the Panathenaic festival was not the great chryselephantine figure of Athena in the Parthenon itself, but rather an ancient olive-wood figure of Athena Polias, housed eventually in the Erechtheion (the tomb of Erechtheus, built from 421 to 406 BC to replace an earlier structure destroyed also by the Persians).[14] To think of Pericles as motivated only by humanistic motives is to underestimate the degree to

which civic order was predicated on military success. Sir John Boardman is pointed about this: "In no way could the Parthenon be regarded as a monument to democracy and freedom, rather than to the military prowess of her people and the political and financial acumen and ruthlessness of their leaders."[15]

As much as the Periclean assembly is regarded as an paradigm of early democracy (although, as is often noted, it actually represented an autocracy of 35,000 male members over a population of about 300,000), the message of militarism was close indeed—not only in Sparta where it was celebrated, but also among the philosophers of ancient Athens, including Socrates and Plato. While the Athena Parthenos did indeed represent another, more glorious world beyond the mundane, the Parthenon as a whole seems to have been less a cultic building than an immensely dramatic tableau of Athenian martial prowess, hence the charge recorded in Plutarch, and quoted by Boardman, that in building it Pericles was diverting funds allocated by the Delian League to protect against the Persians, and "gilding and beautifying our city, as if it were some vain woman decking herself out with costly stones and statues and temples worth millions of money [sic]."

The first move on restitution of the sculptures removed to England by Elgin was made at the 1982 Mexico World Conference on Cultural Policies, organized by UNESCO and attended by ministers of culture. A recommendation was made that member states should view the return of the marbles as an instance of the application of the principle that elements abstracted from national monuments should be returned to those monuments. During the summer of the following year, a senior official from the ministry made the following statement to the General Assembly of the International Council of Museums (ICOM):

> We consider it right and just that the Parthenon marbles and those taken from the Erechtheum should be returned to Greece, the country in which they were created, in application of the principle—to quote— "that all countries have the right to recover the most significant part of their respective cultural heritage lost during periods of colonial or foreign occupation."[16]

The Greek government formally requested the return of the Parthenon/ Elgin Marbles on October 12, 1983, and the case has tested cultural relations between Britain and Greece since.[17] It is also regarded by many museums as a battleground between the cosmopolitan and the particular (or the global and the regional). Others see it as a contest between colonizers and the colonized, or the art poor and the art rich. By any definition, the marbles are a treasure, but a treasure of one or many nations?

A major focus for proponents of return is whether good title did indeed pass to Elgin, the more so since the common law does not recognize "good faith" acquisition. As David Rudenstine observes: "it almost seems as if the moral fervor that characterizes the dispute is largely—but not exclusively—dependent upon whether the Ottomans did or did not convey to Elgin legal title to the marbles."[18] I am going to pass on the detail of this for two reasons. Firstly, there now exists an extensive literature relating to the legitimacy of the *firman* (permission) that Elgin obtained, and to the removal of the marbles and their subsequent history in England, to which I would refer readers interested in assessing the likely direction of a court decision.[19] If a court determined that title did not pass to Elgin, then the question still remains of the validity of the Greek claim under the English statute of limitations. Secondly, I want to focus on the moral rather than the legal claim. If the circumstances of acquisition are such that it cannot clearly be determined that the possessor does not have good title, or alternatively if the possessor evidently has good title, then the claim is a moral one with the following form: because the claimant has a greater moral right to the property than the present individual or corporate owner, their claim should be enforceable through political channels or at international law. Such a claim might have several grounds, including remedying historical inequity, or that the overall utility will be greater in one place than another, or that there is a collective right to the property.

Over and above the economic benefit to the tourist industry of returning these sculptures to a new museum proximate to the Acropolis, the Parthenon/Elgin Marbles evidently represent an important political symbol for Greece.[20] The demand for restitution has continued for twenty years, now to the fore, now muted. At two conferences in 2000, in Athens and Sydney, the case continued to be made that the sculptures were an

inalienable part of Greek history and inherently belonged to Greece and the Greek people.[21] John Moustakas has proposed that certain things—the Parthenon/Elgin Marbles being the case in point—manifest the *personality of a group*, separate as it were from property merely owned by it. To qualify, "property for grouphood" must bear "substantial earmarks of relatedness to the relevant group." It must be substantially "bound up" with group identity, and its retention must not constitute "bad object relations" (fetishism).[22] He has a strong sense of what Samuel Scheffler calls "perceived obligations deriving from inherited affiliations."[23] This is a sense that underlies much thinking about heritage.

Moustakas predicates his argument on certain observations in Margaret Jane Radin's article "Property and Personhood," in which wholly fungible (interchangeable) property is contrasted with the intensely personal.[24] A person, argues Radin, cannot fully be a person without a sense of continuity of self over time. To maintain that continuity one must have an ongoing relationship with the external environment (things and people). Certain objects are "closely bound up with personhood because they are part of the way we constitute ourselves as continuing personal entities in the world."[25] While governments take fungible assets without compensation, as they do through taxation in order to generate higher overall welfare in which the individual can expect to share, for other losses at the personal end of the spectrum no compensation could be just. As Jeremy Waldron notes, this understanding of property and personhood carries an echo of Bentham:

> Every part of my property may have, in my estimation, besides its intrinsic value, a value of affection—as an inheritance from my ancestors, as the reward of my own labor, or as the future dependence of my children. . . . Thus our property becomes a part of our being, and cannot be torn from us without rending us to the quick.[26]

Radin also remarks that "some fragmentary evidence suggests that group property rights, if connected with group autonomy or association, are given enhanced protection" by courts in the United States, and she notes the evolving stance of federal and state governments toward Native

American claims.[27] From Radin's cue, Moustakas argues that group personalities are substantial, the people as a whole having personality in like manner to an individual. He takes the line that "the people" are the proper claimant to cultural things (as in "the Greek people"), seeing art and artifacts as a crucial link between group members and their ancestors and heirs; a relationship that satisfies a basic need for identity and also symbolizes shared values:

> The absence of works representing an "irreplaceable cultural heritage" is psychologically intolerable. Just as the destruction of the Statue of Liberty would diminish the bond between immigrants who shared the same first glimpse of the United States, or the toppling of Jerusalem's Wailing Wall would wound the spirit of world Jewry, Lord Elgin's removal of the Parthenon Marbles injures Greek groupness by having emasculated the greatest of all Greek art—the Parthenon. By destroying the Greeks' mana, the embodiment of their highest humanistic hopes and a measure of their existence, Lord Elgin harmed Greek grouphood by irreparably diminishing an integral part of the celebration of "being Greek."[28]

He is right—people would be very wounded by such acts, as they were by the destruction of the Mostar Bridge during the Yugoslavian civil war. There is a fear of disrespect toward such valuable properties, and hence to the people for whom they are especially meaningful. But does woundedness justify group rights? And who should represent the group? In restitution claims it tends to be states, and yet, while states are as much legal personae as natural persons, it is a major next step to regard a cultural group, or a people, as having the character of a natural person either by metaphor or analogy. The Parthenon/Elgin Marbles may be seen as a case where nation is set against nation, or a people against a people, but it is often the case that national representatives are set against a private individual or corporation. Although the Parthenon/Elgin Marbles case appears to be a government-to-government dispute, it is as much between the Greek government and the British Museum (a legal person), the trustees of which are constrained by an Act of Parliament that forbids deaccessioning

except where works are duplicates. While British ministers have the capacity to put political and economic pressure on trustees, the institution remains at arm's length from government.

THE LANSDOWNE PORTRAIT

To many advocates for their return to Greece, the Elgin Marbles have become an important symbol of the Greek contribution to political thought. In the United States another such symbol is the image of George Washington, who as general and then president of the world's first large-scale experiment in liberal democracy continues to appear widely on banknotes and other goods. Among the most renowned early images is Gilbert Stuart's 1796 full-length portrait of Washington, commissioned by Senator and Mrs. William Bingham for presentation to William Petty, first Marquis of Lansdowne (formerly Lord Shelburne).[29]

When America's newly founded National Portrait Gallery was approaching its opening in 1968, the primary version of Stuart's picture was hanging within Dalmeny House in West Lothian, Scotland, seat of Lord Primrose, son of the then octogenarian sixth Earl of Rosebery. The Smithsonian approached the earl both about lending the painting and also the possibility of a sale to the gallery. At first they were turned down, but finally, in response to a letter from Lord Mountbatten with whom his father had served during the war, Lord Primrose agreed to lend the Lansdowne portrait to the new gallery. The committee responsible for export licenses awarded a six-month temporary permit to Primrose (subsequently the seventh Earl), but in breach of its terms the picture stayed on loan at the Smithsonian for over three decades.[30]

Gilbert Stuart, the picture's painter, was one of the first major artists to emerge in the United States, and like other members of his generation received much encouragement from Benjamin West, the Philadelphian who succeeded Sir Joshua Reynolds as president of the Royal Academy. Moving to London in the year before the revolution, Stuart stayed there until 1787 before traveling on to Ireland to escape debts he had accumulated, and then in 1794 returned to America, where he established a

successful practice painting portraits of the newly independent American gentry and merchant classes. That he was commissioned in 1796 to paint the president's portrait for Lord Lansdowne was entirely natural: he was one of the new republic's most esteemed painters.

Lansdowne died in 1805 and in 1889 the picture was acquired by the fifth Earl of Rosebery, inheritor of the Rothschild collections at Mentmore through his marriage to Hannah, only child of Baron Meyer de Rothschild. A century later, in 1992, the seventh Earl (formerly Lord Primrose) passed title to his son Lord Dalmeny, who informed the U.S. National Portrait Gallery in October 2000 that he intended to sell it. Now while the United States has many import and export controls, it has yet to implement one that constrains the flow of art on the grounds of national interest, and is unaccustomed to rhetoric over the "loss of national treasures." It looked, however, as if this portrait "above all others" might elude the national collection. The gallery was given first option to purchase, with a six-month deadline that extended to April 1, after which, if it had failed to come up with the purchase price of $20 million, the Lansdowne portrait would be placed on the open market. Private appeals in late 2000 and early 2001 failed to produce the necessary funding, and so Marc Pachter, the gallery's director, went to the nation on Washington's birthday, four months after the clock had started, to alert people to the potential loss of a national treasure: "This is not the universe of art collectors but the universe of patriots. There are many patriots who are not associated with museums." In 2001 the Donald W. Reynolds Foundation became the nation's benefactor, in particular its chairman Fred Smith who, in Pachter's words, "brought this wonderful resolution to a patriotic emergency," encouraging his fellow trustees "to give back to the American people." Smith recalled their decision thus:

> We felt, as I am sure every American did, that it would be tragedy to lose this original portrait of our founding father. . . . Our benefactor, Donald W. Reynolds, believed that every American owed a debt of gratitude to those that came before us. He also felt that we have an obligation to keep the symbols of our country's principles for those in the future.[31]

The Reynolds Foundation–funded exhibition of the Stuart portrait and related works that the gallery sent around the country was titled *George Washington: A National Treasure*, which in its ambiguity neatly captured the interrelationship between painting and subject. Washington as the father of the country, Stuart's Lansdowne image, and the primary version of that image were all national treasures. In phrases that are redolent of Edmund Burke, principal progenitor in the English-speaking world of much cultural heritage language, Marc Pachter summed up the larger significance of the portrait for American citizens: "With the display of this portrait, we celebrate Washington's role in history, of course, but more than that, his effect on our own lives today, on the nation, and on the system we have all inherited. It is a precious legacy. And none of it must ever be taken for granted."[32]

Of course, given that it was commissioned for a house in London and remained in England or Scotland for close to two centuries, there might however have been a call for the portrait to be returned as a part of the British heritage.[33] The danger to the gallery was twofold: of it departing the government's official portrait collection for a wealthier museum or private collector, and of it leaving the country. For Americans concerned about patrimony the principal danger was surely the latter. But what *was* unusual for Americans was this call to arms over a potential loss and the strong use of heritage language, which suggests that the perceived danger was exile of the painting overseas. Did the great portrait of Washington need to stay in Washington, DC, embedded in the national collection, and how important was the integrity of that collection as a collection? Could it be in another city or even in a private collection within the nation's boundaries?

Certainly people in Washington might view its loss from a utilitarian perspective, claiming that the arts of Washington were thereby diminished, but calculating such utilities is difficult at best. Can the city be seen as a distinct culture, with unique social practices? Only in political satire. While its status as a region with local conventions cannot be doubted, Washington, DC hardly represents a different culture within America. So, had the painting been transferred to another American public collection its value to citizens would be maintained, as would that of public collections in general. What about the possibility of ownership by a private collector?

America has the strongest regime of natural property rights, which allows individuals greater license than almost anywhere else to do what they will with privately owned, culturally valuable things, including buildings. Millions of visitors have access to the picture in a public collection that, from a utilitarian perspective, is surely to be preferred over its being held in a private house. But is a private house in America preferable to a public collection overseas, for example the National Galleries of England and Scotland, both countries in which the picture had hung? Former chairman of the U.S. National Endowment for the Arts, John Frohnmayer, signaled that these are relatively new questions for Americans. In 1991 he described a recent public auction at which a Delaware businessman had bought a contemporaneous copy of the Declaration of Independence. Noting that the buyer could have been from overseas, he asked that if the original document had turned up at auction "would we be distressed by that?"[34] Going by the case of the Lansdowne portrait, the answer is clearly yes.

From the cases discussed above, it is evident that certain important works of art and architecture are symbolically valuable to nations, or even peoples. The Parthenon/Elgin Marbles and the Lansdowne portrait have all come to symbolize democracy and liberty, respectively, to the Greek and American peoples. They may also symbolize them for other peoples. Beyond that, they have histories that connect them to Greece and America, and of course in both cases also to Britain and the British. Certainly there are countless objects and buildings that relate to specific cultures, but the focus at present is on important ones, from the Bamiyan Buddhas to the Lansdowne portrait—those that stand out as exceptionally valuable. The important question to address, then, will be whether there is justification or not for moral claims to such symbols. And at what expense to the encyclopedic museum and all of its promise for the broadening of our understanding of and appreciation for the interrelatedness of the world's many, diverse cultures and common humanity?

NOTES

1. Lyndel V. Prott and Patrick J. O'Keefe, "'Cultural Heritage' or 'Cultural Property'?" *International Journal of Cultural Property* (1992): 311.

2. See *New York Times*, March 4, 2001, and M. Darrol Bryant, "The Tragedy of Bamiyan: Necessity and Limits of the Dialogue of Religions and Cultures," in *Bamiyan: Challenge to World Heritage*, ed. K. Warikoo (New Delhi: Bhavana, 2002), 185.
3. *New York Times*, March 26, 2001. See Andrew Solomon, "Art in Jeopardy," in *Who Owns the Past? Cultural Policy, Cultural Property, and the Law*, ed. Kate Fitz Gibbon (New Brunswick, NJ: Rutgers University Press, 2005), 243, and Richard MacPhail, "Cultural Preservation and the Challenge of Globalisation," in Warikoo, ed., *Bamiyan: Challenge to World Heritage*, 164–65.
4. Deborah Klimburg-Salter, "The Meaning and Function of Bamiyan in the 7th–8th Centuries," in Warikoo, ed., *Bamiyan: Challenge to World Heritage*, 33–39. Xuan Zang came at the invitation of the western Turkic ruler probably responsible for the construction of the Buddhas, Tong Shi hu Yabghu Khaqan, who was murdered before the pilgrim arrived.
5. Genghis Khan defaced the Bamiyan monuments in 1222. Earlier schools of Buddhism focused on the historical Buddha Shakyamuni, who lived in the sixth to fifth centuries BC in northwest India. A major development occurred around the beginning of the first millennium in which Shakyamuni was understood to be a particular manifestation of the cosmic Buddha principle. Northern India and central Asia embraced this new school, which called itself the Great Vehicle (Mahayana), and witnessed a proliferation of Buddhist texts and images of cosmic Buddhas ruling over myriad universes.
6. The World Heritage Committee is the intergovernmental organ established under the aegis of the 1972 UNESCO Convention Concerning the Protection of the World Cultural and Natural Heritage; see Jean Musitelli, "World Heritage, between Universalism and Globalization," *International Journal of Cultural Property* 11, no. 2 (2002): 323–36.
7. Richard Clogg, *A Concise History of Greece* (Cambridge: Cambridge University Press, 1992), 183, 205.
8. From the *Life of Pericles*; see J. J. Pollitt, *Art and Experience in Classical Greece* (Cambridge: Cambridge University Press, 1972), 66.
9. Richard Cocke discusses anxiety accompanying the incorporation of classical architectural and sculptural components into churches, *From Magic to High Fashion: The Classical Tradition and the Renaissance of Roman Patronage, 1420–1600* (Norwich: Mill Hill, 1993), 1–8.
10. Interview with Susan Crosland, *Sunday Times*, May 22, 1983. Mercouri recommended to the PASOK Cabinet the formal call for return. She was among those who had campaigned openly against the colonel's [Pattakos]

dictatorship, for which she was stripped of her nationality. Her husband, film director Jules Dessin, had himself experienced right-wing suppression when blacklisted by McCarthy.

11. The turning point in the Persian-Greek wars was a naval battle at Salamis in 480, after which Xerxes' land-based troops were annihilated in Plataea. Within two years the Delian league of Greek states had ousted all remaining Persian forces from the northern and eastern seaboard. Pollitt, *Art and Experience in Classical Greece*, 12–14.

12. Ibid., 64–95.

13. The traditional interpretation is that the frieze represents the quadrennial Panathenaic festival in honor of Athena's birthday. John Boardman suggests that the horsemen and charioteers in the Parthenon frieze represent not living participants in the Panathenaic festival but the 192 Athenian warriors killed by the Persians in the great Greek victory at Marathon (and, excluding gods and secondary images, the number of figures on the frieze is just that); see "The Parthenon Frieze—Another View," in *Festschrift für Frank Brommer*, ed. U. Höckmann and A. Krug (Mainz: Von Zabern, 1977), 39–49, cited in Paul Cartledge, "Archaeology in Greece," in *Greece Old and New*, ed. Tom Winnifrith and Penelope Murray (London: Palgrave Macmillan, 1983), 145–48. A more recent interpretation by Joan Breton Connelly draws on fragments from a lost play by Euripides, *Erechtheus*, to argue that the frieze depicts the myth of the sacrifice to Athena of Otionia, youngest daughter of Erechtheus, king of Athens. See also Robert Graves, *The Greek Myths* (Harmondsworth: Pelican, 1960), 1:168–69.

14. The originally separate cults of Athena Polias, an agrarian mother goddess, and Athena Parthenos were probably merged by the fifth century, see Pollitt, *Art and Experience in Classical Greece*, 71n2, and 131; also Betty Radice, *Who's Who in the Ancient World* (Harmondsworth: Penguin, 1973), 71–72; and Graves, *The Greek Myths*, sec. 25.

15. John Boardman, "The Elgin Marbles: Matters of Fact and Opinion," *International Journal of Cultural Property* (2000): 235, and Robert Browning, "The Parthenon in History," in Christopher Hitchens, *Imperial Spoils: The Curious Case of the Elgin Marbles* (New York: Hill and Wang, 1987), 17.

16. Made by the director of the Department of Antiquities; the General Assembly sessions were held over August 1–2, see Jeanette Greenfield, *The Return of Cultural Treasures* (Cambridge: Cambridge University Press, 1989), 77–78.

17. The request was rejected the following year, ibid., 84. A further request was made in January 1997; see Theodore Vrettos, *The Elgin Affair: The Abduction of Antiquity's Greatest Treasures and the Passions It Aroused* (New York: Arcade, 1997), 212.

18. David Rudenstine, "The Legality of Elgin's Taking: A Review Essay of Four Books on the Parthenon Marbles," *International Journal of Cultural Property* 8 (1999): 356–76. Rudenstine points out the formal difference between ownership and trusteeship, in "The Legality of Elgin's Taking," 371. The trustees of the British Museum are a body corporate with perpetual succession and a common seal, with duties toward the collections as adumbrated in the British Museum Act 1963.

19. See also William St. Clair, *Lord Elgin and the Marbles*, rev. ed. (Oxford: Oxford University Press, 1983); B. F. Cook, *The Elgin Marbles* (London: British Museum, 1984); John Henry Merryman, "Thinking about the Elgin Marbles," *Michigan Law Review* 83, no. 8 (1985): 1880–1923; John Henry Merryman, "Who Owns the Elgin Marbles?" *ARTnews* (September 1986): 100–109; William St. Clair, "The Elgin Marbles: Questions of Stewardship and Accountability," *International Journal of Cultural Property* 8 (1999): 397–521; Claire L. Lyons, "Cleaning the Parthenon Sculptures," *International Journal of Cultural Property* 9 (2000): 180–84; Ian Jenkins, "The Elgin Marbles: Questions of Accuracy and Reliability," *International Journal of Cultural Property* 10 (2001): 55–69; Kate Fitz Gibbon, "The Elgin Marbles: A Summary." in her *Who Owns the Past?* 108–21.

20. In March 2004, the newly elected New Democracy government delayed work on a museum for the marbles at the foot of the Acropolis, designed by Bernard Tschumi and Michael Photiades, on the grounds that its construction was adversely affecting the archaeological record.

21. Daniel Shapiro, "The Restitution of the Parthenon Marbles and the European Union: A Historical-Cultural-Legal Approach," *International Journal of Cultural Property* 9 (2000): 354–58; see also The Hon. E. G. Whitlam A.C., Q.C., *The Acropolis, The Parthenon, Elgin and the Marbles*, Seminar Papers (Sydney: Powerhouse Museum, 2000).

22. John Moustakas, "Group Rights in Cultural Property," *Cornell Law Review* 74 (1989): 1184.

23. Samuel Scheffler, *Boundaries and Allegiances: Problems of Justice and Responsibility in Liberal Thought* (Oxford: Oxford University Press, 2001), 127–28.

24. Margaret Jane Radin, "Property and Personhood," *Stanford Law Review* 34, no. 5 (1982): 957–1015, reprinted in Margaret Jane Radin, *Reinterpreting Property* (Chicago: University of Chicago Press, 1993).

25. Radin, *Reinterpreting Property*, 36, 64.

26. From Jeremy Bentham, "Security and Equality of Property," extracted from *Principles of the Civil Code*; see Jeremy Waldron, "Property, Honesty, and Normative Resilience," in *New Essays in the Legal and Political Theory*

of Property, ed. Stephen R. Munzer (Cambridge: Cambridge University Press, 2001), 27.

27. Radin, *Reinterpreting Property*, 66–67, and note 132, where she cites the case of *Pillar of Fire v. Denver Urban Renewal Authority*, 181 Colo. 411, 509 P.2d 1250 (1973). The Colorado state court ruled that a condemnor could not take a parcel sacred to a religious sect unless it could show no adequate alternative.

28. Moustakas, "Group Rights in Cultural Property," 1195–96.

29. The precise circumstance of the commission is discussed by Ellen Miles in Carrie Rebora Barratt and Ellen G. Miles, *Gilbert Stuart* (New York, New Haven, CT, and London: Metropolitan Museum of Art and Yale University Press, 2004), 166.

30. In its Thirty-First Report, in 1985, the reviewing committee made these remarks: "In general there have been very few problems with temporary exports. It is therefore with regret that we have to report the failure of a renewed attempt to obtain an undertaking from the Earl of Rosebery that the Gilbert Stuart portrait of George Washington will be returned to this country should he decide to sell it. The Earl of Rosebery was granted a temporary export licence for six months in 1969 to enable the painting to be exhibited at the Smithsonian Institute, Washington, where it has since remained on indefinite loan. We regard it as highly unsatisfactory that Lord Rosebery should persist in declining to give the required undertaking some sixteen years after the licence was granted." Cited in *Export of Works of Art 2000–2001, Forty-Seventh Report of the Reviewing Committee Appointed by the Chancellor of the Exchequer in December 1952* (London: HMSO, 2002), 8.

31. Marc Pachter, Richard Brookhiser, Margaret Christman, and Ellen Gross Miles, *George Washington: A National Treasure* (Washington, DC: National Portrait Gallery, Smithsonian Institution, in association with the University of Washington Press, Seattle, 2002), 74.

32. Pahcter et al., *George Washington: A National Treasure*, 9.

33. In 2000–2001, the Reviewing Committee commented on the "good, if sad" capacity of the export regulations to evolve "as a result of the reported decision of Lord Dalmeny to sell probably the greatest portrait of George Washington to the Smithsonian Institute. . . . We can only reiterate our regret that the seventh Earl of Rosebery did not comply with the terms of the original temporary export licence. Whilst we have been advised that there are no legal proceedings that can be taken at this juncture, we are glad to record that, as a result of changes in the law, if similar action was taken today, criminal charges could be preferred against those

involved. . . . We would add that the vendor, Lord Dalmeny, has informed the Minister of State that he had no knowledge of the past history relating to the temporary export of the portrait and had acted in good faith. He apologised for any embarrassment inadvertently caused. The Minister, rightly in our view, has accepted his explanation and apology." *Export of Works of Art 2000–2001, Forty-Seventh Report of the Reviewing Committee Appointed by the Chancellor of the Exchequer in December 1952, 8–9, and A Review of the Current System of Controls on the Export of Works of Art* (London: HMSO, 1991), 56.
34. David McKean, *Should the United States Protect Cultural Resources?* (Annenberg Washington Program in Communication Policy Studies of Northwestern University, 1992), 13.

The Nation and the Object

John Henry Merryman

STANFORD UNIVERSITY

THIS ESSAY ATTEMPTS TO ADD a second dimension to the traditionally one-dimensional discussion of cultural property policy.[1] It does so by addressing a central policy question: when, if ever, may museums, collectors, and dealers properly provide a market for cultural objects that have been exported from a foreign nation contrary to that nation's laws?[2] A related policy question is whether the legal authorities of one nation should enforce the cultural property export controls of another. Two different approaches to these questions lead to divergent results in some situations but are mutually reinforcing in others. We can call these approaches "nation-oriented" and "object-oriented." The policies of most source nations and the international dialogue about cultural property still are heavily nation-oriented. I suggest that the dialogue would be enriched and that institutional, national, and international cultural property policies would be improved by placing less emphasis on the nation and more on the object.[3]

THE BASIC POSITION

A nation's attitude toward the export of privately owned cultural objects has a domestic and an international face. The choice of an export policy and of a legal regime for its administration and enforcement are matters of domestic concern, to be decided according to internal political and legal criteria. For example, Italy, a nation whose cultural property regime might

seem to some people to be excessively retentive, is nevertheless free to persist in that regime or to change it as it sees fit. Should an Italian collector smuggle his Boccioni painting out of Italy in violation of the Italian cultural property export control law and take it to Japan, however, the Japanese authorities have no legal obligation to return it to Italy or to take any other action in response to the Italian export control law. Whether or not they will do so is for the Japanese to decide. Italy, by enacting a domestically valid export control law, cannot create an international obligation to enforce that law.

These truisms are summed up in international law in the concept of national sovereignty and in the related principle that the authorities of one nation will not enforce the public laws of another.[4] Nations may agree by treaty to enforce one another's export controls, but there are few such treaties.[5] In their absence, the importation of illegally exported cultural objects is legally permissible. The Italian who smuggled his Boccioni painting out of Italy and took it to Japan has not violated Japanese law, and Japan has no obligation under international law to enforce the Italian export control. This is "the basic position."

Source nations with retentive cultural property export controls dislike the basic position, and others are troubled by it. To avoid its effects, they have pursued two strategies. One is for the source nation to try to convert illegal export into theft by enacting legislation declaring that cultural objects are state property. This looks like it ought to work because the courts of all modern nations will order the return of stolen property to its owner (subject to periods of limitation and the rights of good faith acquirers).[6] The strategy is appealing because it is both politically easy— perhaps even politically profitable—and inexpensive; there can be little internal political opposition to a measure described as "protecting the nation's cultural patrimony," and it costs nothing to write a few additional words into the law book.

The difficulty is that many such nations have constitutions that require a special legal procedure and the payment of compensation in order to expropriate privately held property.[7] To carry out such legal procedures is laborious and time consuming, and to pay compensation to private holders of cultural objects is expensive. Further, such nations may lack

the additional physical (i.e., museums and storage facilities) and human (i.e., professional registrars, curators, and conservators) resources needed to acquire and care for the large quantities of objects held by collectors and dealers. To establish and maintain such physical and human resources is, again, expensive. It is accordingly common to find that the state ownership law is not applied within the enacting state; large numbers of cultural objects remain in the hands of domestic collectors and dealers, are openly traded among them, and are left at death to their heirs. The statute may say that the state is the owner, but that is not the way public officials or private collectors and dealers act. The empirical indicia of ownership—possession, use, and disposal—all are in private hands, and the state ownership law is, in practice, mere rhetoric.

The 1989 decision in *Peru v. Johnson* illustrates the problem.[8] Relying on such a statute, Peru claimed ownership of gold, ceramic, and fabric objects that allegedly had been removed from Peru without an export permit and had found their way into a private California collection. The collector introduced uncontroverted evidence that the statute was not applied within Peru and argued that enacting the statute alone was not enough to establish state ownership. The Court agreed:

> The domestic effect of such a pronouncement appears to be extremely limited. Possession of the artifacts is allowed to remain in private hands, and such objects may be transferred by gift or bequest or intestate succession. There is no indication in the record that Peru has ever sought to exercise its ownership rights in such property, so long as there is no removal from the country. *The laws of Peru could reasonably be considered to have no more effect than export restrictions* (emphasis added).

As we have seen above, one state does not, in the absence of a treaty obligation, enforce the export controls of another.[9]

Long before the *Peru v. Johnson* case arose, the drafters of the 1970 UNESCO Convention had to deal with the problem of rhetorical state ownership laws. They did so by defining theft (for the purposes of the Convention) in a precise and restrictive way. Under Article 7 (b) (i), parties

to the Convention agree to prohibit the import of, and to recover and return to the source nation: "cultural property stolen from a museum or a religious or secular public monument or similar institution in another State Party to this Convention, . . . provided that such property is documented as pertaining to the inventory of that institution." Similar language appears in Sec. 308 of the U.S. implementing legislation.[10] This language clearly excludes objects in private hands, as well as those in undiscovered and undocumented archaeological sites, from the "stolen" category.

The second strategy used by those who dislike the basic position is to urge the adoption of treaties and national legislation in which nations agree to enforce one another's cultural property export controls. The centerpiece of that effort, the 1970 UNESCO Convention, contemplates "concerted action" by the importing nations in order to be effective. Few importing nations (only Australia, Canada, and the USA) have, however, become parties to UNESCO 1970. Belgium, France, Germany, Great Britain, Japan, the Netherlands, the Scandinavian nations, and Switzerland, among others, all have declined to become parties, and the Convention, other than for its symbolic importance and the inspirational language in its preamble, is now generally considered to be a failure.

Accordingly, despite the adoption of state ownership laws in a number of source nations and little success in persuading importing nations to agree to enforce source nation export controls, the basic position described above continues to be the international norm. Since most would agree that the basic position fails to deal adequately with some kinds of recurring problems, it seems important to identify ways of modifying it so that source and market nations will find it more acceptable. We will return to that topic after a brief description of nation- and object-oriented cultural property policies.

NATION-ORIENTED POLICY: CULTURAL NATIONALISM

The basic position has been under concerted attack by source nations and by people sympathetic to their cause since the end of World War II. In that

attack, the dominant premise has been that of cultural nationalism: objects *belong* within the physical boundaries of the nations within which they are found or with which they are historically associated: the Elgin Marbles belong in Greece, Italian Renaissance paintings belong in Italy, Aztec codices belong in Mexico, and so on.[11] This assumption has provided the ideological basis of the export control legislation in source nations throughout the world. It is a major premise of the 1970 UNESCO Convention, the 1992 European Communities Commission Directive and Regulation, discussed below, and much other international legislation affecting cultural property, and it suffuses the literature and the international dialogue on cultural property policy.

The contemporary power of the cultural nationalism premise derives from Western intellectual history. Today, after more than a century and a half, our minds and emotions still are controlled by Byron and Goethe and Herder, by nineteenth-century Romanticism and nineteenth-century nationalism, and in the cultural property dialogue these forces powerfully coincide.[12] Often a nation's representative need only claim that an object is part of its "cultural patrimony" or "cultural heritage" to make the case for its retention within or return to the national territory. Instant, automatic sympathy for national cultural property claims is the conditioned response; the legitimacy of retentive legislation and of demands for "repatriation" of objects that have left the national territory is seldom questioned.

OBJECT-ORIENTED POLICY: PRESERVATION, TRUTH, ACCESS

In an object-oriented cultural property policy, the emphasis is on three conceptually separate but, in practice, interdependent considerations: preservation, truth, and access, in declining order of importance. The most basic is preservation: protecting the object and its context from impairment. Next comes the quest for knowledge, for valid information about the human past, for the historical, scientific, cultural, and aesthetic truth that the object and its context can provide. Finally, we want the object

to be optimally accessible to scholars (for study) and to the public (for education and enjoyment).[13]

Applying an object-oriented policy, whether it would be proper for a museum or collector or dealer to acquire an object depends first on whether its export is likely to endanger the object or its context; second, on whether through its acquisition the object's truth is more or less likely to be fully revealed; and third, whether as a result of the acquisition the object will be more or less readily available to scholars for research and to the public for education and enjoyment.

THE POLICIES CONTRASTED: THE CLEVELAND POUSSIN

A French collector who owned a Poussin painting, *The Holy Family on the Steps*, sold it to Sherman Lee, then director of the Cleveland Museum of Art, who brought it to the United States without requesting an export permit from French officials and hung it in the museum. Mr. Lee had been advised by eminent French and American counsel that the French export control law made an export permit unnecessary in this case. The French government, adopting a contrary interpretation of the law, reacted vigorously, indicting Mr. Lee for various crimes, making strong representations to the U.S. government and demanding the Poussin's return.[14] From a nation-oriented posture the French position is easily justified: the painting was made by a Frenchman; it is part of France's "cultural patrimony"; it was removed from France without France's permission; it should be returned.

From an object orientation, however, things look different. This is an illegal export case. There was no theft; the owner of a painting in a private collection in France willingly sold it to the Cleveland Museum of Art. Moving the painting from a private collection in France to the public collection of a great American museum did not endanger the work. The painting was not torn from context, and no larger work was dismembered to move it; no serious argument can be made that historical truth or other meaning was impaired. The painting will be better preserved in the museum

than in the French private collection and will be significantly more available for study by scholars and for enjoyment by viewers.

To the French government's dramatic claim that the French people have been deprived of an important piece of their cultural heritage—a familiar cliché of cultural nationalism—the obvious response is that the French people had no access to this painting in the French private collection. If this work was so central a part of the French cultural patrimony, why did the French government not acquire it from its French owner and hang it in the Louvre, where it would be professionally restored, preserved, and protected and be vastly more available for study and enjoyment by the French than it was in the private collection? In fact, the Louvre already held another (and, in the opinion of many, better) version of the same subject by Poussin. But in that case, even if we apply nationalist criteria, how seriously can we take the complaint that the French cultural heritage was impaired? Finally, after the painting is exported, in what sense can it be said that the French have "lost" the Poussin? What, besides location, has changed?

If the Aztec Calendar Stone were in a museum in Paris it would still honor the Aztecs, just as the Parthenon Marbles in the British Museum in London honor the artistry of classical Greek sculptors and the culture in which they lived and worked. To speak of the "loss of cultural heritage" means one thing when cultural objects are destroyed or suppressed. It means something entirely different when what is "lost" is location within the national territory. In the Cleveland Museum of Art, the Poussin is still a Poussin.[15]

Overreaching claims based on cultural nationalism often go to even greater extremes, as when the French government, in 1992, refused to allow a privately owned Van Gogh painting (discussed below) to leave France. France is of course not the only or even the worst example; in recent years the Italian government has refused to allow a Van Gogh painting, a Matisse painting, and a group of watercolors by Adolf Hitler, all sold or offered for sale by their owners, to leave the national territory.[16] A number of Central and South American nations classify *all* pre-Columbian and colonial objects, including many that are by any standard redundant, as inalienable national patrimony and totally prohibit their export, even though the national authorities are unprepared to provide the material and

human resources necessary for their proper excavation, preservation, study, and display.

FURTHER ILLUSTRATIVE CASES

Case 1. D, an American dealer, hires local workmen to hack a stela from a Mayan temple in the Guatemalan jungle and bribes local police and customs officers to permit its removal and export.[17] D imports the stela into California and offers it for sale to a major museum. The director of the museum would like to add the stela to the collection and has a trustee willing to put up the money.

Here the two approaches to cultural property concur. On the one side, nationalist values clearly are offended. The foreign dealer and the local workmen, customs officers, and police all have violated Guatemalan law and policy, which prohibit unauthorized excavations and removals and damage to cultural monuments and sites. And from an object orientation, any possible increase in accessibility of the stela is far outweighed by impairment of the higher values of preservation and truth. These people have damaged the temple (and, in all probability, the stela). Unless the temple with the stela in place had been thoroughly studied and documented, information about the human past has been irretrievably lost; the stela is now a decontextualized orphan, the temple an amputee. Cases of this kind present the strongest case for international cooperation between source and market nations, although they leave substantial space for disagreement about the means to be used to deal with the problem.[18]

Case 2. The director of a great French museum is offered an Andean feathered cape that the curator would like to add to the museum's collection of Andean textiles and costumes. The dealer bought it from its owner, a private collector in Peru.

This case exemplifies the regrettably common case in which, under prevailing policy, object-oriented values are sacrificed to cultural nationalism.

Peruvian law prohibits export of the cape, and the application of nation-oriented cultural property policies would prohibit the French museum from acquiring it. That would be so even if were shown that the fragile object would be far less well preserved, would yield no greater truth, and would be less accessible to scholars and to viewers in the Peruvian private collection than in the French museum.

> *Case 3.* A German museum is offered a stone head of Buddha that appears to have been severed from a larger sculpture, probably of a standing Buddha. The collector who offers it to the museum bought it from a dealer in Singapore during a recent Asian voyage and has no information about its source. The museum's curator has little hope of identifying its specific origin. The head would be a spectacular addition to the museum's Asian art collection.

In Case 3, there would appear to be no nation-oriented impediment to acquisition. But suppose an inquiry to the Chinese Ministry of Culture revealed that the head once was part of an identifiable sculpture that now stands headless in the museum in Xian, where the collection receives a high standard of protection and active preservation. The stone head is not fragile; united with the body, it will offer more historical and aesthetic meaning than the sum of the separated parts; large numbers of people will see and enjoy the sculpture there, and it will be freely available to scholars for research. Even if the Chinese authorities made no claim to the head, there is a strong object-oriented case for urging the curator to work with the dealer and the Chinese to reunite the head with the body, either in Xian or in the German museum.

> *Case 4.* A French collector buys a Van Gogh painting in Switzerland in 1955 and brings it to his home in Paris. In 1989 he decides to sell the work through a London auction house. The competent French official denies permission to export the painting, and that decision is affirmed in the courts. The collector may keep the painting or may sell it within France but may not export it.[19] The collector smuggles the painting out of France in violation of French law and consigns it

for auction in London. A Japanese museum would like to add the painting to its collection.

This case resembles the Poussin case, discussed above, in which nation-oriented and object-oriented approaches suggest divergent outcomes. A similar analysis applies here, perhaps with even greater force, since here the artist was not French (though the painting was made in France). Such cases, in which cultural nationalism justifies export control but object-based considerations would permit or encourage export, exemplify a much larger range of cultural property than easel paintings. Similar considerations apply to tapestries, drawings, prints, photographs, sculptures, ceramics, jewelry, coins, stamps, books, manuscripts, maps, musical instruments, furniture, and many other movable objects whose owners are, under present law and policy, prohibited from exporting them. Normally the only justification for such export controls is, as in the Poussin and Van Gogh cases, nationalist retentionism, unrelated to any object-based concerns.

> *Case 5.* A disgruntled junior member of the royal family of the Kom, a tribal society in Cameroun, removes a revered sculpture called the Afo-A-Kom from the royal compound and sells it to a French dealer. An American dealer eventually acquires the sculpture and offers it for sale at his New York gallery. In an emotional press conference, the cultural attaché (a Kom) of the Cameroun embassy in Washington states that the Afo-A-Kom is a religious and ceremonial object "beyond money, beyond value. It is the heart of the Kom, what unifies the tribe, the spirit of the nation, what holds us together." The Cameroun ambassador, who is not a Kom, is on the contrary unenthusiastic. Cameroun is trying to build a nation. Glorification of tribal customs and loyalties divides rather than unites the diverse groups that compose the Cameroun people and makes nation-building more difficult.[20] The curator of tribal art at a major American museum would like to have the Afo-A-Kom in the collection—"It would be a spectacular accession."

Case 5 illustrates a problem that has only recently received discriminating attention from policy makers: what is to be done with claims by

tribal groups (not, be it noted, nations) for the return of ritual, ceremonial, religious objects?[21] In many cases the objects, if returned, will be exposed to the elements or consumed or otherwise destroyed or, if protected, will be kept in secret places, available for viewing only by a select few and generally unavailable for scholarly purposes or public enjoyment. Should the objects be returned—for example, from the Smithsonian Museum in Washington to an American Indian tribal group in South Dakota—even though object-oriented values will consequently be seriously impaired? And if the answer is yes, what justifies this sacrifice of object-oriented values?

One easy way to deal with the question is to treat removal of the Afo-A-Kom from the royal compound as theft, bringing into play the principle of public order, already discussed, that condemns theft and requires return of the stolen object to its owner. Suppose, however, that the Afo-A-Kom were not treated as stolen; why does it seem right that it be returned to the Kom despite the consequent impairment of object-oriented values? How is such a case different from the French government's refusal to permit export of the Van Gogh or its demand for return of the Poussin? Is there something here that transcends mere Byronism, or is this just cultural nationalism all over again in more exotic form?

There are three significant distinguishing factors. In the Afo-A-Kom case (and the same would be true in the case of ceremonial objects claimed by American Indian tribal groups and analogous cases in a variety of traditional societies in other parts of the world): (1) the culture and belief system from which the object came were still alive; (2) the object was made to be used in religious/ceremonial ways by that culture according to that belief system; and (3) if returned, the object would again be put to that use. It is the concurrence of these considerations that explains why it seemed right that the Afo-A-Kom return to the Kom.

In most cultural property cases, however, the attempt to make such an argument would seem strained and artificial. The relics of earlier cultures in Egypt, Greece, China, and Mexico have little or no contemporary religious or ceremonial function. People who live in those nations today may place a high value on such relics for other reasons, but even if they originally were made to serve some ceremonial or religious function they

no longer do so. Most important, the specific cultural value of the relics—for example, as testimony of the way of life of a vanished people, as great works of art of a specific time and place, as evidence of the genius of a great artist or a great culture—is independent of location within the national territory. In the Cleveland Museum of Art, the Poussin serves the same kinds of functions it would serve in a French museum.

It may be that there are moveable cultural objects whose retention within the national territory is important to the people of that nation in the way that the Afo-A-Kom was said to be important to the Kom or that ritual objects are important to American Indian tribal groups. Perhaps the Liberty Bell for the Americans or the Crown of St. Stephen for the Hungarians are examples of objects whose presence within the national territory has that kind of "tribal" significance to the people of their nations.[22] But the catalog of such objects is likely to be extremely short for any nation, and such cherished objects normally are already owned by the nation or by some major public institution within it and are not for sale. In the rare case in which such an object is privately owned, it can and should be acquired by the state; to allow it to remain in private hands seems inconsistent with the argument that the object is in some way essential to the spiritual life of the nation. In short, the problem we are discussing—how to deal with the voluntary but illegal export of privately owned objects—is highly unlikely to involve cultural property of this transcendently national "tribal" kind.

CONCLUSION

Emphasis on the object and on object-based values shakes one's faith in cultural nationalism as the measure of cultural property policy and changes one's view of the proper outcome in commonly recurring cultural property cases. Some readers may find this emphasis on the object novel and will prefer to cling to the more familiar, and simpler, one-dimensional cultural nationalism. In fact, however, object-oriented concerns are far from new to the discussion of cultural property policy, ethics, and law.

The field archaeologists' persistent campaign to protect sites and monuments against clandestine excavation and removal is quintessentially object-oriented; it seeks to preserve objects and contexts and the opportunity for their professional documentation and study.[23] Even retentive national legislation is often referred to as "protective" by its advocates and defenders, thus attributing to it an object-oriented purpose.[24] The Hague Convention on the Protection of Cultural Property in the Event of Armed Conflict of 1954, although it contains some concessions to cultural nationalism, is a primarily object-oriented document. The preamble states its purpose:

> The High Contracting Parties, . . .
>
> *Being convinced* that damage to cultural property belonging to any people whatsoever means damage to the cultural heritage of all mankind, since each people makes its contribution to the culture of the world;
>
> *Considering* that the preservation of the cultural heritage is of great importance for all peoples of the world and that it is important that this heritage receive international protection; . . .
>
> *Being determined* to take all possible steps to protect cultural property;
>
> Have agreed. . . .

It is a short step from Hague 1954, limited in application to the threat to cultural property during armed conflict, to a more general recognition of the importance of object-oriented values in international cultural property policy.

That step has been taken in the Preliminary Draft UNIDROIT Convention on Stolen or Illegally Exported Cultural Objects.[25] The relevant provisions are found in Article 5, dealing with the return of illegally exported cultural objects. Article 5 (2) requires a state's request for the return of an illegally exported cultural object to "contain all material information regarding the conservation, security and accessibility of the cultural object after it has been returned to the requesting state." Article 5 (3) states

that the court shall order the return of the object only if the requesting state:

> proves that the removal of the object from its territory significantly impairs one or more of the following interests:
> (a) the physical preservation of the object or its context,
> (b) the integrity of a complex object,
> (c) the preservation of information of, for example, a scientific or historical character,
> (d) the use of the object by a living culture,
> (e) the outstanding cultural importance of the object for the requesting State.[26]

These novel provisions, with their emphasis on preservation and truth, have had a mixed reception. The strongest objections to them come from source nations that continue to demand that other nations enforce their export controls, whether or not such controls are shown to be consistent with some internationally validated cultural property policy. It seems unrealistic, however, to suppose that major importing nations will ever give unqualified deference—what is sometimes referred to as a "blank check"—to source nation demands. This is shown by the refusal of all but a few market nations to accede to the 1970 UNESCO Convention (even though its provisions are tempered by substantial restrictions on cultural nationalism) and by their demonstrated reluctance to join in bilateral cultural property treaties with source nations.

In fact, the center of gravity in the international cultural property policy dialogue already has significantly shifted. The injection of object-oriented values into the UNIDROIT draft proposal for international legislation dealing with the export of cultural property is merely one among many indicators of a movement away from primary reliance on cultural nationalism among those most concerned with the development of policy.

Contemporaneous developments within the European Communities, unfortunately, must be seen as a regression or, at best, a lost opportunity. In preparation for the establishment of the free movement of goods within the Community, the council has promulgated a Directive and Regulation

that, in effect, call for unconditional Community-wide enforcement of national export controls ("the aim is mutual recognition of the relevant national laws").[27] Neither the Directive nor the Regulation contain any reference to object-oriented values. The council's definition of "cultural objects," which provided an opportunity for the limitation of overreaching national retentionist policies, has instead been made so general as to leave such policies relatively untouched.

The dialogue about the international movement of cultural objects accordingly continues, as it should. Applicable policy, ethics, and law are, in their present states, crude and incomplete. The quality of the dialogue will only be improved, and progress in solving international cultural property problems will only be measurably advanced, by denying legitimacy to the excesses of cultural nationalism and by insisting on appropriate attention to the preservation of, the truth about, and access to the objects that, in the words of the 1954 Hague Convention, constitute "the cultural heritage of all mankind."

NOTES

1. A subsequent article will argue for the introduction of a "third dimension" into cultural property policy discussions, one that recognizes the legitimate interests of the museum/collector/dealer complex and the importance of a licit traffic in cultural objects.
2. It is clear that museums, collectors, and dealers should refuse to acquire *stolen* objects. I here address an entirely different kind of question: the effect to be given to foreign legislation that inhibits the *export* of cultural objects without regard to their ownership. An extreme example is described in Case 4, in which France refused an export permit to the owner of a Van Gogh painting.
3. For an earlier effort to broaden the cultural property policy discussion, see my "Two Ways of Thinking about Cultural Property," *American Journal of International Law* 80 (1986): 831.
4. The two leading decisions are English: *Kingdom of Italy v. de Medici* (1918) 34 T.L.R. 623 (Medici papers exported from Italy and offered for auction in London); *Attorney General of New Zealand v. Ortiz* [1982] 1 Q.B. 349, [1982] 3 W.L.R. 571 (Court of Appeal), [1983] 2 W.L.R. 809 (House of Lords) (Maori carved wood panel exported from New Zealand and offered

for sale in London). The black-letter principle that one nation will not en-
force the public laws of another has been the object of some scholarly
criticism. See P. Lalive, "Sur l'application du droit public etranger," *An-
nuaire Suisse de Droit International* 103 (1971); P. J. O'Keefe and L. V.
Prott, *Law and the Cultural Heritage*, vol. 3, *Movement* (Abingdon: Profes-
sional Books, 1989), 652ff.; M. Frigo, La protezione dei beni culturali nel
diritto internazionale (Milan: Giuffrè, 1986), 332ff.

5. The UNESCO Convention on the Means of Prohibiting and Preventing
the Illicit Import, Export, and Transfer of Ownership of Cultural Property
of November 14, 1970 was an attempt to fill this lacuna. For an authorita-
tive discussion of the Convention and its drafting see Paul Bator, "An
Essay on the International Trade in Art," *Stanford Law Review* 34, no. 2
(1982): 275. The Convention has been widely adopted among source na-
tions, but few market nations (specifically, Australia, Canada, and the
USA) have ratified and implemented it. The U.S. legislation enacted to
implement its adherence to the Convention is the Cultural Property
Implementation Act of 1983, 19 U.S.C. §§2601ff.

6. This rule is never questioned. For recent examples of its application see
Kunstsammlungen zu Weimar v. Elicofon, 678 F. 2d 1150 (2d Cir. 1982)
(court-ordered return of two stolen Albrecht Dürer portraits to East Ger-
man museum); *Autocephalous Greek Orthodox Church of Cyprus v. Gold-
berg*, 917 F. 2d 278 (1990) (court-ordered mosaics stolen from early Chris-
tian church in Cyprus returned to plaintiff); J. P. Verheul, "Foreign Export
Prohibitions: Cultural Treasures and Minerals," *Netherlands Yearbook of
International Law* 31 (1984): 419–27 (discussing, at pp. 420–22, a Dutch
decision ordering the return of a stolen sculpture to its French owner).

7. Most Central and South American nations, for example, have constitu-
tions containing such provisions and supreme courts with the power to
refuse to apply legislation that conflicts with constitutional limitations on
legislative/administrative powers. The only published decision on the
point to come to my attention is a decision of the Supreme Court of Costa
Rica, Boletín Judicial No. 90 of May 12, 1983. The Court found the Law
on the National Patrimony of December 28, 1981 unconstitutional as an
attempt to expropriate private property without observing the procedures
or providing the compensation required by the Costa Rican Constitution.
The infrequency of reported litigation on the constitutionality of similar
state ownership laws may simply indicate that attempts to apply them in-
ternally are unusual.

8. *Government of Peru v. Benjamin Johnson*, et al., 720 F. Supp. 810 (C.D. Cal.
1989). The case is noted in *International Journal of Cultural Property* 1

(1992): 169. The court found three independent bases for rejecting Peru's claim: (1) Peru did not prove that the objects it claimed were removed from Peruvian territory; (2) Peru did not prove that the objects were removed at a time when Peruvian legislation claiming state ownership was in force; and (3) the Peruvian legislation was, as indicated in the text, effectively merely an export control. The decision was affirmed by the U.S. Court of Appeals of the 9th Circuit in a brief memorandum opinion that referred solely to the finding that Peru had "failed to prove that the objects originated in modern-day Peru." The Court of Appeals, however, ordered that its decision be "unpublished" (meaning that the opinion does not appear in the official reports of the Court's decisions and may not be cited to or by federal courts in the 9th Circuit. The "unpublished" decision is published in 1991 U.S.App. Lexis 10385). The trial court's opinion thus stands as the authoritative discussion and disposition of the case.

9. *Peru v. Johnson* is one of the few reported decisions in which the rhetorical nature of state ownership laws has been effectively argued. The same kind of argument was made and rejected in *U.S. v. McClain*, 593 F. 2d 658 (5th Cir. 1979) (prosecution for violation of U.S. law prohibiting importation of stolen property; removal of antiquities covered by Mexican state ownership law treated as theft), but the case can be distinguished. In an analogous Italian case, *Republica del Ecuador c. Danusso*, 18 Rivista di diritto internazionale privato e processuale 625 (1982) the court ordered illegally exported cultural objects returned to the government of Ecuador because such a statute made them state property, but there is no indication in the opinion that the point was argued.

10. Cited above, note 4.

11. For a full discussion of the Greek claim to the Parthenon sculptures, see my "Thinking about the Elgin Marbles," *Michigan Law Review* 83, no 8 (1985): 1880.

12. For a fuller discussion of cultural nationalism, see my "The Retention of Cultural Property," *University of California at Davis Law Review* 21 (1988): 477, 489ff.

13. The notion of public accessibility of cultural objects naturally raises the question: which public? In a French museum in which thousands of visitors see an Aztec artifact, relatively few of the viewers will be Mexicans. In making a judgment on accessibility does one count the thousands of viewers or only the relatively few Mexicans? The cultural nationalist easily and naturally assumes that the Mexicans are the relevant public, while to the object-oriented person the number of interested viewers, regardless of their nationality, is the significant figure.

14. These events received a good deal of newspaper publicity at the time but no case was brought before an American court. Eventually the matter was resolved by agreement between the Cleveland Museum of Art and the French authorities, and the French criminal charges against Mr. Lee were dropped. See Lisbet Nilson, "Poussin's Holy Family Feud," *ARTnews* 78 (February 1982); "Dispute over Cleveland Poussin Flares Again," *ARTnewsletter* 3 (July 10, 1984); *New York Times*, March 28, 1987, L11, col. 4.

15. Merryman, "The Retention of Cultural Property," 477, 498.

16. In another case, involving another Matisse painting from an Italian private collection, a distinguished American judge commented on the slender connection between the object and the culture of the nation of whose cultural patrimony it was claimed to be an important component. In *Jeanneret v. Vichey*, 693 F. 2d 259 (2d Cir. 1982), the dispute centered around a Matisse painting that had been exported from Italy without a permit (which was probably not required) by the deceased collector's heir and taken by her to New York, where it was subsequently sold to Marie Louise Jeanneret, a Swiss dealer. Having failed to resell the work at the price she sought, Ms. Jeanneret visited an Italian friend who worked for the Ministry of Culture in Rome. Shortly thereafter the Ministry began inquiries about the work's Italian history and export and eventually a declaration issued stating that the Matisse was of "particular artistic and historical interest" to Italy. Ms. Jeanneret used this *ex post* classification and the ambiguity about the necessity of an export permit as the basis for an action for rescission and damages for breach of warranty of warranty of title. In reversing and remanding a lower court judgment for the plaintiff Circuit Judge Friendly commented:

> The somewhat surprising conclusion that exportation of a painting by a prolific French post-impressionist master would represent "a tremendous loss to the national heritage" of Italy was sought to be justified on the grounds that it had been shown at the Venice Biennale in 1952 "in the large exposition dedicated to art" and "because it is part of the era of 'a return to normalcy' which pervaded all Europe at the end of the first world war, characterized by a return to classic and Renaissance motifs particularly evident in this balanced, well-composed painting by a master of contemporary art and specially rare among Italian collections of significant works of that period." One is tempted to wonder why if Italian collectors do not care enough for Matisse to buy his paintings, one of these, not claimed to be an outstanding masterpiece, should be thought to constitute such an important part of the Italian national heritage (note 6, p. 263).

And at another point Judge Friendly referred to ". . . the tenuous nature of the claim that a not especially notable painting by a French twentieth-century master who was testified to having left a thousand paintings constituted an important part of Italy's patrimony . . ." (p. 267).

17. The facts are similar to those in *U.S. v. Hollinshead*, 495 F. 2d 1154 (9th Cir. 1974), in which the dealer, Hollinshead, was criminally convicted for violation of the U.S. National Stolen Property Act. A companion civil action brought by Guatemala was settled before trial and, after a period of display at the Los Angeles County Museum of Art, the stela was returned to Guatemala. This happy outcome would not have been possible had the field archaeologist Ian Graham not drawn and photographed the stela in place in a temple at the Machiquila site shortly before its clandestine removal by Hollinshead.

18. Even if clandestine excavation and looting of archaeological sites and monuments to feed an international market (and the local market, which in some source nations is substantial) were the only agenda item, a conference among source and market nations would have a number of related questions to discuss: how to deal realistically with the existence, and the difficulty of controlling, the black market in antiquities; how adequate are the source nation's protection of sites and monuments and the funding and training it provides for its relevant police and customs services; how willing is the source nation to reduce the demand for illegally excavated objects by permitting the export of redundant objects, whether by sale, exchange, or on loan to foreign museums; how well-equipped is the source nation to conserve, display, study, and publish cultural objects that it retains or that are returned to it; and so on. A market nation's agreement to try to control the entry of such objects, even if it were more successfully implemented than other attempts to control the import of forbidden objects or substances, would deal with only one facet of the problem.

19. These are the facts in a 1992 decision of the Conseil d'Etat: Cons. d'Etat 10e et 2e sous-sect., 31.7.92, req. n. 111758 et 120294, Walter; Sem. Jur. 7.10.92 (Actualitès). There is a discussion of this and companion litigation in the *Art Newspaper*, vol. 4, no. 27 (1993): p. 1. The Conseil affirmed the denial of an export permit to the owner. It also held that the owner was not entitled to compensation, even if he could show that forbidding export, and thus limiting sale of the painting to the French market, substantially reduced its market value. However, a subsequent decision of the Paris Tribunal d'Instance of May 28, 1993 held the state liable to the owner for the difference between the national price and the international price. That decision will probably be appealed.

20. The Afo-A-Kom case, which was settled without litigation by the return of the sculpture to the Kom, is briefly described in John Henry Merryman and Alfred E. Elsen, *Law, Ethics, and the Visual Arts*, 2nd ed. (Philadelphia: University of Pennsylvania Press, 1987), 56–58.

21. In the United States a comprehensive federal law, the Native American Graves Protection and Repatriation Act of 1990, 25 U.S.C. 3001ff., was enacted to deal with these and related matters (e.g., unauthorized excavations and removals from Indian and federal lands) as they affect American Indian and Native Hawaiian groups.

22. I do not purport here to address the claims of nations for the return of objects improperly removed from them during the age of imperialism: for example, the many objects, including Benin bronzes, taken from Nigeria during the British Punitive Expedition that remain in London or the masterpieces of painting and sculpture appropriated by Napoleon during the Italian Campaign and still held by French museums.

23. The classic American discussion of the clandestine excavation and removal problem is by Professor Clemency Coggins, a field archaeologist and art historian: "Illicit Traffic of Pre-Columbian Antiquities," *Art Journal* 29, no. 1 (1969). Dr. Coggins described the mutilation and loss of information resulting from the clandestine removal of monumental sculptures and reliefs from sites in Mexico and Central America. Her widely read and discussed article is generally credited with galvanizing American concern and action, leading to the 1970 Treaty of Cooperation between the United States of America and the United Mexican States Providing for the Return of Stolen Archaeological, Historical, and Cultural Properties, 22 U.S.T. 494, TIAS No. 7088, and to the Regulation of Importation of Pre-Columbian Monumental or Architectural Sculpture or Murals Act of 1972, 19 U.S.C. §§ 2091–2095. Archaeologists' concerns, as expressed in Dr. Coggins's article, also influenced U.S. participation in drafting, and eventually ratifying, the 1970 UNESCO Convention.

24. The practice of referring to cultural property export controls as "protective" implies that their object is the preservation of cultural property. This usage, commonly encountered in the cultural property dialogue, has crept into a variety of international instruments. But when the purpose is merely to prevent the voluntary export of objects under circumstances that offer no threat to preservation, truth, or access, "protection" becomes merely a euphemism for retention. Of course it will not do to protest that retention equals protection. In some cases it may, but in many others retention would be, and has been, more dangerous to cultural property than export. There is no necessary relation between the two concepts.

25. International Institute for the Unification of Private Law, Preliminary Draft Unidroit Convention on Stolen or Illegally Exported Cultural Objects (1991). The Draft was prepared, at the request of UNESCO, by an international group of experts convened by the Institute. As this essay is written, three conferences of governmental experts to discuss the Preliminary Draft Convention have been held, and a fourth was planned for late 1993.

26. The drafters' intention for (d) and (e) was to capture the considerations summed up in the discussion of case 5, above.

27. Council Directive 93/7 of March 15, 1993, JOCE (L) March 27, 1993, on the return of cultural objects unlawfully removed from the territory of a Member State, enforces source nation export controls within the European Community. Council Regulation No. 3911/92 of December 9, 1993, JOCE (L) December 31, 1992, on the export of cultural goods, enforces source nation export controls at the Community's external borders.

Select Bibliography

Association of Art Museum Directors. "Report of the AAMD Subcommittee on Incoming Loans of Archaeological Materials and Ancient Art." February 2006, available at www.aamd.org.

———. "Report of the AAMD Task Force on the Acquisition of Archaeological Materials and Ancient Art." June 2004, available at www.aamd.org.

Atkinson, John A., Iain Banks, and Jerry O'Sullivan. *Nationalism and Archaeology.* Glasgow: Cruithne Press, 1996.

Atwood, Roger. *Stealing History: Tomb Raiders, Smugglers, and the Looting of the Ancient World.* New York: St. Martin's Press, 2006.

Bator, Paul M. *The International Trade in Art.* Chicago: University of Chicago Press, 1983.

Brodie, Neil, Jennifer Doole, and Colin Renfrew, eds. *Trade in Illicit Antiquities: The Destruction of the World's Archaeological Heritage.* Cambridge: McDonald Institute for Archaeological Research, 2001.

Brown, Michael F. *Who Owns Native Culture?* Cambridge, MA: Harvard University Press, 2003.

Chang, Kwang-Chih. "Reflections on Chinese Archaeology in the Second Half of the Twentieth Century." *Journal of East Asian Archaeology* 3, nos. 1–2 (2001): 5–13.

Clément, Etienne. "Some Recent Practical Experience in the Implementation of the 1954 Hague Convention." *International Journal of Cultural Property* 1, no. 3 (1994): 11–26.

Coggins, Clemency Chase. "Archaeology and the Art Market," originally published in *Science* 175 (January 21, 1972): 263–66; reprinted in *Who Owns the Past? Cultural Policy, Cultural Property, and the Law,* edited by Kate Fitz Gibbon, 221–29. New Brunswick, NJ: Rutgers University Press, 2005.

———. "Illegal International Traffic in Art: Interim Report." *Art Journal* 30, no. 4 (1971): 384.

————. "Illicit Traffic of Pre-Columbian Antiquities." *Art Journal* 29, no. 1 (1969): 94, 96, 98, 114.

————. "Observations of a Combatant." In *Who Owns the Past? Cultural Policy, Cultural Property, and the Law*, edited by Kate Fitz Gibbon, 231–37. New Brunswick, NJ: Rutgers University Press, 2005.

Cuno, James. "Art Museums, Archaeology, and Antiquities in an Age of Sectarian Violence and Nationalist Politics." In *The Acquisition and Exhibition of Classical Antiquities: Professional, Legal, and Ethical Perspectives*, edited by Robin F. Rhodes. South Bend, IN: University of Notre Dame Press, 2007.

————. "Museums and the Acquisition of Antiquities." *Cardozo Arts and Entertainment Law Journal* 19, no. 1 (2001): 83–96.

————. "Museums, Antiquities, Cultural Property, and the U.S. Legal Framework for Making Acquisitions." In *Who Owns The Past? Cultural Policy, Cultural Property, and the Law*, edited by Kate Fitz Gibbon, 143–58. New Brunswick, NJ: Rutgers University Press, 2005.

————. "U.S. Art Museums and Cultural Property." *Connecticut Journal of International Law* 16, no. 2 (2001): 189–96.

————. "View from the Universal Museum." In *Imperialism, Art, and Restitution*, edited by John Henry Merryman, 15–36. Cambridge: Cambridge University Press, 2006.

————. *Who Owns Antiquity? Museums and the Battle over Our Ancient Heritage.* Princeton, NJ: Princeton University Press, 2008.

DuBoff, Leonard D., et al. "Proceedings of the Panel on the U.S. Enabling Legislation of the UNESCO Convention on the Means of Prohibiting and Preventing the Illicit Import, Export, and Transfer of Ownership of Cultural Property." *Syracuse Journal of International Law and Commerce* 4 (1976): 97–139.

Eakin, Hugh. "Notes from Underground." *New York Review of Books*, May 25, 2006. Review of Peter Watson and Cecilia Todeschini, *The Medici Conspiracy: The Illicit Journey of Looted Antiquities, from Italy's Tomb Raiders to the World's Greatest Museums.* New York: Public Affairs, 2006, and the exchange of letters between Watson/Todeschini and Eakin in *New York Review of Books*, July 13, 2006.

Fitz Gibbon, Kate, ed. *Who Owns the Past? Cultural Policy, Cultural Property, and the Law.* New Brunswick, NJ: Rutgers University Press, 2005.

Fitzpatrick, James. "A Wayward Course: The Lawless Customs Policy toward Cultural Properties." *New York University Journal of International Law and Policy* 15 (1983): 857, 860–61.

Gathercole, P., and D. Lowenthal, eds. "The Politics of the Past," *One World Archaeology*, vol. 12. London: Unwin Hyman, 1990.

Greenfield, Jeanette. *The Return of Cultural Treasures.* Cambridge: Cambridge University Press, 1989.

Hallman, Robert. "Museums and Cultural Property: A Retreat from the Internationalist Approach." *International Journal of Cultural Property* 12, no. 2 (2005): 201–25.

Hoffman, Barbara T., ed. *Art and Cultural Heritage: Law, Policy, and Practice.* Cambridge: Cambridge University Press, 2006.

Kohl, Philip L., and Clare Fawcett, eds. *Nationalism, Politics, and the Practice of Archaeology.* Cambridge: Cambridge University Press, 1995.

Kouroupas, Maria Papageorge. "U.S. Efforts to Protect Cultural Property: Implementation of the 1970 UNESCO Convention." *African Arts* 28, no. 4 (1995): 32–41.

Merryman, John Henry. "Cultural Property Internationalism." *International Journal of Cultural Property* 12 (2005): 11–39.

———. "A Licit International Trade in Cultural Objects." *International Journal of Cultural Property* 1 (1995): 13–60.

———. "The Nation and the Object." *International Journal of Cultural Property* 4 (1995): 61–76.

———. *Thinking about the Elgin Marbles.* London: Kluwer Law International, 2000.

———. "Two Ways of Thinking about Cultural Property." *American Journal of International Law* 80, no. 4 (1986): 837–38.

Merryman, John Henry, ed. *Imperialism, Art, and Restitution* (Cambridge: Cambridge University Press, 2006).

Merryman, John Henry, and Albert E. Elsen. *Law, Ethics, and the Visual Arts.* London: Kluwer Law International, 1998.

Messenger, Phyllis Mauch, ed. *The Ethics of Collecting Cultural Property: Whose Culture? Whose Property?* Albuquerque: University of New Mexico Press, 1989.

Meyer, Karl E. *The Plundered Past.* New York: Ath;eneum, 1973.

Patterson, Thomas C. *Toward a Social History of Archaeology in the United States.* Fort Worth, TX: Harcourt Brace College Publishers, 1995.

Pearlstein, William. "Cultural Property, Congress, the Courts, and Customs: The Decline and Fall of the Antiquities Market?" In *Who Owns the Past? Cultural Policy, Cultural Property, and the Law,* edited by Kate Fitz Gibbon, 9–32. New Brunswick, NJ: Rutgers University Press, 2005.

Phelan, Marilyn, ed. *The Law of Cultural Property and Natural Heritage: Protection, Transfer, and Access.* Evanston, IL: Kalos Kapp Press, 1998.

Prott, Lyndel. "The International Movement of Cultural Objects." *International Journal of Cultural Property* 12, no. 2 (2005): 225–48.

Prott, Lyndel V., and Patrick J. O'Keefe. "'Cultural Heritage' or 'Cultural Property'?" *International Journal of Cultural Property* 2 (1992): 307–20.

Renfrew, Colin. *Loot, Legitimacy, and Ownership: The Ethical Crisis in Archaeology.* London: Duckworth, 2000.

Robin F. Rhodes, ed. *The Acquisition and Exhibition of Classical Antiquities: Professional, Legal, and Ethical Perspectives.* South Bend, IN: University of Notre Dame Press, 2007.

Robson, Eleanor, et al. *Who Owns Objects? The Ethics and Politics of Collecting Artefacts.* Oxford: Oxbow Books, 2006.

Scarre, Chris, and Geoffrey Scarre, eds. *The Ethics of Archaeology: Philosophical Perspectives on Archaeological Practice.* Cambridge: Cambridge University Press, 2006.

Shanks, Michael, and I. Hodder. "Processual, Postprocessual, and Interpretative Archaeologies." In *Interpreting Archaeology: Finding Meaning in the Past,* edited by Ian Hodder et al. London: Routledge, 1995.

Shanks, Michael, and C. Tilley. *Social Theory and Archaeology.* Cambridge: Polity Press, 1987.

Smith, Bruce, ed.. *Ethics in American Archaeology: Challenges for the 1990s.* Washington, DC: Society for American Archaeology, 1995.

Smith, Laurajane. *Archaeological Theory and the Politics of Cultural Heritage.* London: Routledge, 2004.

Trigger, Bruce G. *A History of Archaeological Thought.* Cambridge: Cambridge University Press, 1989.

Tubb, Kathryn W. *Antiquities: Trade or Betrayed? Legal, Ethical, and Conservation Issues.* London: Archetype Publications, 1995.

Watkins, Joe. "Cultural Nationalists, Internationalists, and 'Intra-Nationalists': Who's Right and Whose Right?" *International Journal of Cultural Property* 12, no. 1 (2005): 78–94.

Watson, Peter, and Cecilia Todeschini. The Medici Conspiracy: The Illicit Journey of Looted Antiquities, from Italy's Tomb Raiders to the World's Greatest Museums. New York: Public Affairs, 2006.

Contributors

Kwame Anthony Appiah is the Laurance S. Rockefeller University Professor of Philosophy and the University Center for Human Values, Princeton University. He has held teaching positions at Yale, Cornell, Duke, and Harvard universities. His many books include *In My Father's House* (1992), which deals, in part, with the role of African and African American intellectuals in shaping contemporary African cultural life; *Color Conscious: The Political Morality of Race*, with Amy Gutmann (1996); *Dictionary of Global Culture*, with Henry Louis Gates Jr. (1997), with whom he also edited the *Encarta Africana* CD-ROM encyclopedia, published by Microsoft; *The Ethics of Identity* (2005); and *Cosmopolitanism: Ethics in a World of Strangers* (2006). He is a member of the American Philosophical Society.

Sir John Boardman is Emeritus Lincoln Professor of Classical Art and Archaeology at Oxford University and a staff member of the Beazley Archive, a research unity of the Oxford Faculty of Classics. He is widely regarded as the world's greatest living authority on ancient Greece vase painting. He has excavated at Smyrna, Crete, Chios, and Libya, and served as Assistant Director of the British School in Athens. Among his many books are *The World of Ancient Art* (2006), *The Archaeology of Nostalgia: How the Greeks Re-Created Their Mythical Past* (2003), *The History of Greek Vases* (2001), *Persia and the West* (2000), and *The Diffusion of Classical Art in Antiquity*, The Andrew W. Mellon Lectures at the National Gallery of Art, Washington DC (1994). Twice, papers have been published in his honor: G. Tsetskhladze, A. J. N. W. Prag, and A. M. Snodgrass, eds., *Periplous: Papers*

on Classical Art and Archaeology Presented to Sir John Boardman (2000) and
G. Tsetskhladze and F. DeAngelis, eds, *The Archaeology of Greek Colonisation: Essays Dedicated to Sir John Boardman* (1994). He is a Fellow of the
British Academy.

Michael F. Brown is Lambert Professor of Anthropology and Latin American Studies at Williams College. Among his many publications are *War of Shadows: The Struggle for Utopia in the Peruvian Amazon*, with Eduardo Fernández (1991); *The Channeling Zone: American Spirituality in an Anxious Age* (1997); *Who Owns Native Culture?* (2003); "Can Culture Be Copyrighted?" in *Current Anthropology* (1998); "Heritage as Property," in Katherine Verdery and Caroline Humphrey, eds., *Property in Question: Value Transformation in the Global Economy* (Oxford: Berg Publications, 2002); and "Heritage Trouble: Recent Work on the Protection of Intangible Cultural Property," *International Journal of Cultural Property* (2005).

James Cuno is the President and the Eloise W. Martin Director of the Art Institute of Chicago. Previously director of the Courtauld Institute of Art, University of London, and the Harvard University Art Museums, Cuno has published and lectured often on the subject of U.S. art museums and the acquisition of antiquities, most recently with his book *Who Owns Antiquity? Museums and the Battle over Our Ancient Heritage* (Princeton University Press, 2008) and essays in *Imperialism, Art, and Restitution* (John Henry Merryman, ed., 2006) and *Who Owns The Past: Cultural Policy, Cultural Property, and the Law* (Kate Fitz Gibbon, ed., 2006). He edited and co-wrote the book, *Whose Muse? Art Museums and the Public Trust* (2004). He is a Fellow of the American Academy of Arts and Sciences and past president of the Association of Art Museum Directors.

Derek Gillman is Executive Director and President of The Barnes Foundation. From 1999 until 2006 he was President, CEO, and the Edna S. Tuttleman Director of the Pennsylvania Academy of the Fine Arts. From 1995 until 1999 he served as Deputy Director of the National Gallery of Victoria in Melbourne, Australia. Educated at Magdalen College, Oxford, where he read Philosophy and Chinese Studies, he holds a Master

of Laws degree from the University of East Anglia. His book, *The Idea of Cultural Heritage*, was published by the Institute of Art and Law, University of Leicester, England, in 2006.

Neil MacGregor is Director of the British Museum. He was previously Director of the National Gallery, London, 1987–2002. He is a Fellow of New College, Oxford, a fellow of Birkbeck College, an Honorary Fellow of the British Academy, and an Honorary Member of the Royal Scottish Academy. He is a member of the United Kingdom's Arts and Humanities Research Council, and is the Chair of the State Hermitage Museum International Advisory Board. From 1987 to 1997, he was Chairman of the UK National Museums Directors' Conference and of the European Commission Steering Committee for multimedia access to European cultural patrimony. He has served on selection panels and juries concerned with the rebuilding of the Museuminsinsel, Berlin, the remodeling of the Louvre, and the reorganization of the Venice museums.

John Henry Merryman is Sweitzer Professor of Law and Affiliated Professor of Art, Emeritus, at Stanford University and the author of numerous important articles on cultural property law. His books include the edited volume *Imperialism, Art, and Restitution* (2006); *Law, Ethics, and the Visual Arts*, 4th ed., with Albert E. Elsen (2002); and *Thinking about the Elgin Marbles: Critical Essays on Cultural Property, Art, and Law* (2000). He has served on the editorial board of the *International Journal of Cultural Property*.

Philippe de Montebello was for thirty years, until his recent retirement, Director of the Metropolitan Museum of Art, the world's most encyclopedic art museum. Its permanent collections, housed in seventeen curatorial departments, embrace more than two million works of art spanning five thousand years of world culture, from prehistory to the present, from every part of the globe. Among his recent initiatives are the ongoing renovation, expansion, and reinstallation of the Metropolitan's Greek and Roman galleries and focusing on the museum's Roman Court and Etruscan galleries that opened in 2007. He has written and lectured extensively on museums issues, often on the questions of museums' acquiring antiquities,

and has received many honors, including Chevalier de la Légion d'Honneur in 1991 and the National Medal of Arts, awarded by the president of the United States, in 2003. He is a trustee of the Association of Art Museum Directors and a Fellow of the American Academy of Arts and Sciences.

David I. Owen is the Bernard and Jane Schapiro Professor of Ancient Near Eastern and Judaic Studies in the Department of Near Eastern Studies at Cornell University. From 1961 to 1989 he was actively engaged in archaeological research in the Mediterranean, first at the University of Pennsylvania Museum undersea excavations at Yassi Ada in Turkey, then at Gordion, Turkey (1965); Inandik Tepe, Turkey (1966); Porto Cheli, Greece (directed the Harbor Survey, 1965); Kyrenia, Cyprus (assistant director, Kyrenia Ship Excavation, 1968–69); the excavation of a Classical Greek shipwreck at Porticello, Italy (1971–72); and director of the Cornell Summer Field Excavation Programs in Israel (1978–87), during which time he excavated at Tel Aphek/Antipatris for eight seasons and at Tell Hadar for two. He has written and edited or coedited more than thirty books and over two hundred articles, reviews, and notes.

James C. Y. Watt (Qu Zhi-ren) is Brooke Russell Astor Chairman of the Department of Asian Art at the Metropolitan Museum of Art. He has also served as Curator of the Department of Asiatic Art at the Museum of Fine Arts, Boston, and Chairman of the Board of Studies in Fine Arts, at the Chinese University of Hong Kong, among other positions. He has organized and contributed to the catalogues of a number of exhibitions at the Metropolitan Museum of Art, notable among them: *East Asian Lacquer* (1991); *Splendors of Imperial China*, with Wen C. Fong (1996); *When Silk Was Gold*, with Anne Wardwell (1998); *China: Dawn of a Golden Age, 200–750 AD* (2004); and *Defining Yongle: Imperial Art in Early Fifteenth-Century China*, with Denise P. Leidy (2005).

Index

Note: Page numbers in italic type indicate illustrations.

access to antiquities: audience for, 199n13; cultural property policy and, 187–88; excavation sites and, 61; obligation concerning, 55–56, 82–83

acquisitions: considerations in, 32; dates established by museums for, 4, 11, 69–70; museum practices in, 3, 12–13, 70, 118; policies on, 4, 11, 56–57, 69; role of, 56–57

Adams, Robert McC., 132n6

Afghanistan, 80–82, 108–9, 116, 165–67

Afo-A-Kom, 192–93, 202n20

Africa: civil war in, 48, 50; cultural exchange in, 54; European perceptions of, 51–52; origins of civilization in, 44

AIA. *See* Archaeological Institute of America

Alster, Bendt, 137n11

American Association of Museum Directors, 150

American Association of Museums, 15

American Journal of Archaeology, 135n10

American Mathematical Monthly, 137n11

American Schools of Oriental Research (ASOR), 10, 34n11, 132n5, 135n10, 140n15

ancient Greece: comparative study of, 42–43; cultural development of, 27–28; European art and architecture influenced by, 168; Parthenon/Elgin Marbles, 167–74

ancient Rome: comparative study of, 42–43; cultural development of, 27; European art and architecture influenced by, 168

Annan, Kofi, *147*

antiquities: debate over, 1, 3–4, 12–14, 64–70; intrinsic (non-archaeological) qualities of, 7–8, 14–15, 60, 65–67, 93, 106, 112–13, 121–23; minor, 111; museum acquisition of, 12–13; terminology of, 16; trade in, 70, 108, 111, 114–15, 118, 126, 129, 131n3. *See also* cultural property

Antiquities Dealers Association, 118

antiquities with incomplete provenance: criticisms of acquiring, 31; criticisms of not acquiring, 70, 77–78, 108, 111, 118; legal issues raised by, 76; looting and, 64, 66–67; as meaningless, 2, 7–8, 13–14, 60, 65, 87, 113, 120; publication of, 125–30, 132n4, 136n11; sources of, 65; trade in, 64, 67, 69; value of, x, 2, 5–11, 14, 28–31, 67, 69, 110–11, 117–18

Appiah, Kwame Anthony, 27, 29–30, 38, 160

archaeological contexts: cuneiform texts not dependent on, 127–28, 132n4; debate over, 59–61; destruction of, x–xi, 3–4; historical period as factor in, 89; limitations of, 91–106, 113, 120–22; original,

213